Hanji

Everything You Need to Know about
Traditional Korean Paper

Hanji:
Everything You Need to Know about Traditional Korean Paper

First edition 30th March 2012
Second edition 30th May 2019
Published in KOREA by Hyeonamsa Publishing Co., Ltd.

Address 35, Donggyo-ro 12an-gil, Mapo-gu, Seoul city, (04029)
Tel 82-2-365-5051, **Fax** 82-2-313-2729
E-mail editor@hyeonamsa.com
Homepage www.hyeonamsa.com

ISBN 978-89-323-1618-5 03600

KOREA **KF**
FOUNDATION

The Korea Foundation has provided financial assistance
for the undertaking of this publication project.

Everything You Need to
Know about
Traditional Korean Paper

Hanji

Lee Seung-chul

Translated by
Sohn Da-yeon and S. I. Gale

HYEONAMSA

Heartfelt congratulations on publishing this book

While I was researching art history, I realized that the materials used in artwork significantly affect the quality of pieces produced. I have taught the importance of this to numerous students majoring in art over the last three decades. Professor Lee Seung-cheol belongs to a much smaller group devoted to exploring how materials open up endless artistic possibilities.

Professor Lee attended my Korean Art History, Eastern Art History, and Painting Theories classes while he was taking his undergraduate and master's degrees at Seoul National University. Not only did he enthusiastically and quickly endorse my theories and arguments concerning the impact that materials have on artwork, but he also clearly expressed his ambition to thoroughly research Korean paper (hanji), brushes, and the ink stick (紙筆墨), the three tools that provide the foundation for eastern painting. He later went on to establish his own hanji factory where he produced his own paper. The paper produced was colored with dyes he had obtained from plants he had harvested himself. Afterwards, he chronicled his experiences in a book about traditional dyes and dyeing processes.

His latest book on hanji covers the complete production process, recounts the essential history, and details practices, benefits and future possibilities associated with hanji. I firmly believe that a deeper knowledge of hanji is necessary to fully understand and appreciate Korean painting. So I wholeheartedly welcome the publication of this gem of a book. Congratulations!

Gaheon Choi Wan-su

Hanji: Korea's Hidden Treasure

Most of us have used paper in numerous ways for as long as we can remember: we've written on it, painted on it or decorated it, using two dimensional sheets or three dimensional goods made of paper. However, the majority of us take paper for granted precisely because it is so abundant. We don't give much thought to the substance itself while using it, although most of us would agree that paper is an integral and necessary feature of modern-day life.

There are many types of paper available, and the types differ according to use, production, history and essential characteristics. Paper was invented in East Asia, was revered there for centuries, and was only later introduced to the West. Over time it was used for manufacturing a wide variety of products, from fireworks to flooring. Koreans have had a special affinity with their traditional paper, known as hanji. Throughout history, generations were born on paper and spent their lives surrounded by paper. Households used paper for flooring, walls, ceilings, and window screens. The deceased were wrapped in hanji and buried.

Perhaps only Koreans have been so devoted to the stuff: laying paper carpet (yellow-colored jangpanji), wearing paper clothes, erecting military tents made of yudunji (油芚紙) to shield themselves from the wind, making arrow-proof armor out of gapuiji (甲衣紙), or producing a vast array of household items out of paper, including bedpans, shoes, raincoats, closets, bookshelves, embroidery baskets, and even candlesticks.

Many of us have forgotten about hanji; most of us take it for granted just as we take the air we breathe for granted. We tend to lose respect for familiar things that are abundant. We have become complacent in this regard.

I have studied hanji for more than 25 years. I started my research after majoring in oriental painting at Seoul National University. After all, hanji serves as the canvas

for traditional painting. My research into hanji began in earnest while writing my master's thesis ("The Impact of Hanji on Painting") at Seoul National University. It was at this point that I recognized the moribund state of hanji production in Korea, so I subsequently established and ran my own hanji factory for six months. I recreated many traditional types of hanji there. I also started my first serious collection of hanji relics while working as a researcher for the Kansong Art Museum in the early 1990s. What had started as a private collection for purely academic purposes quickly built up over the following 25 years. I recently donated 8,000 pieces to the History Museum in Wonju (my hometown) because I wanted to give the public an opportunity to appreciate and learn more about hanji. I didn't see the point in simply hoarding what I had amassed.

This book came about because I felt the need to summarize and give order to the mountain of research I had done over the years. It should be viewed like a guidebook on the subject of hanji instead of an academic research paper revealing new findings. My main objectives were to present hanji to a much larger audience, to illustrate its unique qualities, and to show the pivotal cultural role it has played throughout history. So this edition is meant to promote the marvel that is hanji to millions of English speakers throughout the world.

The modern world seems captivated with leveraging ancestral culture and knowledge for short-term gain. Parallels can be drawn with the manner in which we exploit ancient fossil fuels. This is why I want to establish and preserve a hanji culture that will be passed down to future generations. I firmly believe that the quality of any given culture belongs to those who appreciate it and live by its merits on a daily basis; culture doesn't belong to its creators.

Finally, I'm deeply grateful to Sohn Da-yeon and S. I. Gale for translating my book into English. I'd also like to thank Philip Gant for providing useful feedback.

Lee Seung-chul

Contents

IV. Hanji's superiority

V. Hanji's applications

VI. The future of hanji

韓紙

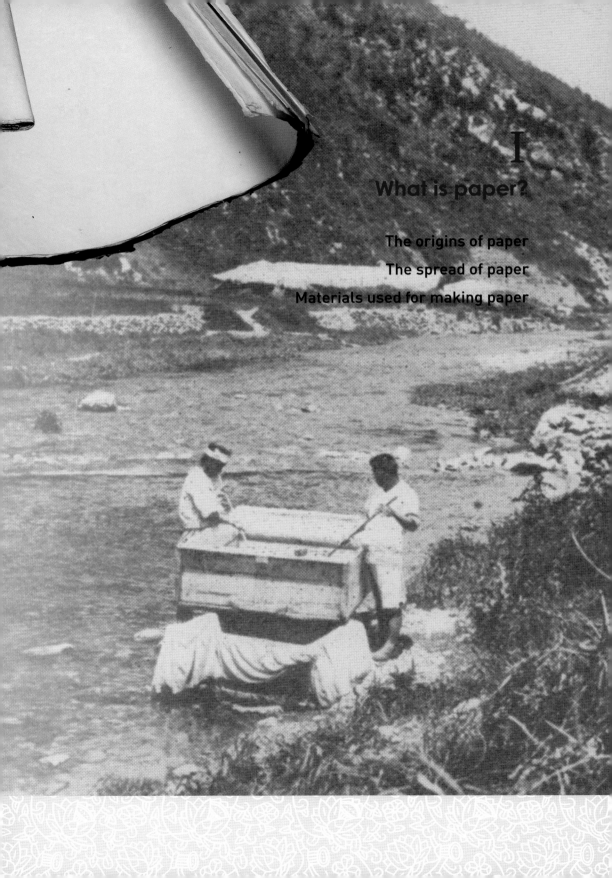

The origins of paper

Before the invention of written language and paper as means of communication, people used facial expressions and other body language to express thoughts and ideas. In general, we communicate in three ways: we use body language (facial expressions and hand gestures), verbal language, and written language (where meaning is conveyed visually via a combination of letters or objects). Language may take any of these forms, whereas the use of written language remains the most common form of record. Prior to the invention of paper, written characters were recorded on bark, stone, ceramics, earthenware, stoneware, turtlebacks, bronze, steel bowls, bamboo sticks, wood, lambskin parchment, vellum, and silk. Early writers and scribes realized inconve-

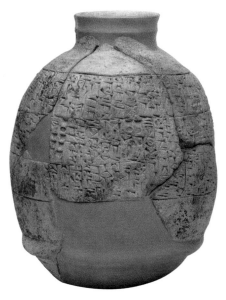

Characters engraved on pottery fragments.

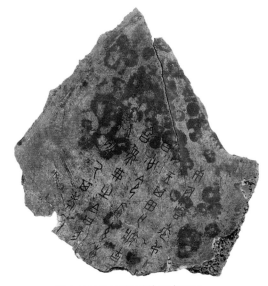

Characters engraved on bones or tortoise carapaces.

Papyrus sheets.

niences associated with such materials, which were too heavy, too large, too difficult to produce, or too costly. Paper solved these problems, leading to the rapid, accelerated and unprecedented spread of information and knowledge.

It is a common misconception that papyrus was the first type of paper. It is true that some 5000 years ago ancient Egyptians peeled the inside of papyrus plants, layered them in a crisscross fashion, pressed them, and flattened the fibers. Papyrus could be used for drawing and writing. But it was neither made using pulp nor formed using moulds. Instead, it was made by joining layers of plant bark. The product, process and skills required to make papyrus were totally different from papermaking. As such, paper's origins lie outside of Egypt.

Ts'ai Lun (蔡倫)'s work, which is referred to in *Huhanseo* (後漢書, *Hystory of the Later Han*), provides a comprehensive record of paper's origins. It details how Ts'ai Lun created paper using plant fibers such as bark, hemp, iris or nets during the reign of Hwaje (和帝, a monarch of the late Han dynasty). While it is not clear what kind of papermaking method he used, experts agree that

Making parchment.

Parchment paper (music sheet, C16).

Papyrus plants.

Bangmatanji (放馬灘紙).

he probably softened fibers in a millstone. This type of paper and papermaking spread across China within the next couple of centuries. Jabaek (子邑), from the Jin dynasty's Shandong area, developed the papermaking method further, and soon after well-developed papermaking methods were adopted by the late Han dynasty. The warm southern areas inhabited by the Jin dynasty suited plants used for making fiber. Paper made from fermented plants was called cheukriji (側理紙). This type evolved into hwaseonji. By the late second century, paper quality had improved greatly while costs had fallen. This combination popularized paper for writing, calligraphy and other artistic pursuits.

The accepted view that paper was invented by Ts'ai Lun has been challenged in recent times. In 1943 Chinese archaeologists Nogan (勞幹) and Seokjangyeo (石璋如) discovered a stack of paper and wooden tablets in China's Gansu Province during an excavation. The tablets listed the names of eras dating back to the sixth year of the Hwaje's reign. Given that the paper was discovered beneath the excavation depth of the tablets, archaeologists agree that the paper must have been produced before the time of Ts'ai Lun. More compelling evidence was dug up in 1957, when pagyoji (灞橋紙, hemp paper commonly used during the reign of Emperor Wu, circa 140-87 BC) was discovered in suburban Anxi (Shaanxi Province, China). This discovery is cited as one of the oldest samples of paper used for wrapping important objects instead of for writing (e.g. wrapping mirrors). Therefore, we can conclude that paper before

Ts'ai Lun's time was not refined enough to be used for writing or painting.

Even though Ts'ai Lun is widely considered to have invented papermaking in China, he actually adopted and refined existing papermaking methods. His achievement lies in the fact that he came up with the idea of using cheap and readily available plant fibers to produce and distribute paper cost effectively. Therefore, he deserves recognition for introducing paper to the masses who could take advantage of it as their cultures developed.

Here, I define paper as a thin sheet made from plant fiber that has been separated, macerated, matted, and dried. The Korean word for paper is *jongi*, and derives from the Chinese *jeopi* (楮皮). The first syllable *jeo* (楮) translates as "paper mulberry" and jeopi means mulberry bark. Etymologists have also linked jeopi, *jobi* and *johae*, in turn giving more clues to hanji's origins.

In China, the word for paper is pronounced as "juh". The character 紙 (pronounced as "ji") is a combination of two others: 絲 means thread and is pronounced as "sa"); 氏 translates as "of the same tribe" and is pronounced as "shi"). From here, experts deduce that the first types of paper were made from either fishing nets or threaded material. The characters 紙 and "帋" are interchangeable perhaps because some types of paper were made from ground cotton or ground hemp. The Japanese word for paper is かみ. It is pronounced as "kami" and sounds identical to the Shinto word meaning deity. One possible explanation for this is that the characters for spirits, natural forces and gods were made using paper. English "paper", German *papier* and Spanish papel are all derived from the Greek *papuros* and the Latin *papyrus*. "The Bible" derives from the Greek *biblos* or *biblia* (bubloi translates as "papyrus stem").

The spread of paper

In China, papermaking methods gradually improved once Ts'ai Lun made paper affordable around AD 105. The most common types of paper in circulation before the Chinese Northern and Southern dynasties were seolmyeonji (雪綿紙), cheukriji (側理紙) and jamgyeonji (蠶繭紙). Supiji (樹皮紙), maji (麻紙) and jukji (竹紙) became the most popular types during the dynasties. During the Tang dynasty, seoldojeon and sagongjeon (謝公牋) were common, whereas the Five Dynasties and South Tang predominantly produced jingsimdangji (澄心堂紙). After the Five Dynasties period, publishing developed and demand for paper skyrocketed, leading to the rapid emergence of papermaking factories nationwide. Papermaking knowledge and skills gradually spread eastward through Korea to Japan, and westward across Central Asia to Europe.

Details about the introduction of paper to Korea are sketchy, but *Ilbonseogi* (日本書紀, *The Chronicles of Japan*) states that Damjing , a monk from Goguryeo, arrived in Japan around AD 610 with a fellow monk Beopjeong (法定). Their mission was to teach *Ogyeong* (五經, *The Five Classics*), painting, and making handcraft art, paper, and ink stone. So we can deduce that papermaking was already common in Korea by that time. Papermaking was introduced to the West in AD 751 during the Tang dynasty-150 years after Korea introduced it to Japan. The Tang army (headed by General Goseonji, a migrant from Goguryeo) fought the Saracen army in AD 751. The Saracens learned papermaking methods from Chinese prisoners of war. Subsequently, a papermaking factory was set up in Samarkand, which used Chinese papermaking

methods. This later led to the introduction of Samarkand paper (the first western type). Muslims used paper primarily to record and publish the Koran. Islamic papermaking techniques were learned and adopted by Europeans during the Crusades. In Europe these methods advanced rapidly with the advent of machines. The first paper factory was established in America in 1690 near Philadelphia. Nicholas-Louis Robert, a French inventor, created the continuous papermaking machine in 1798. In England in 1807, the Fourdrinier brothers designed an improved version. In 1809, John Dickinson invented a continuous mechanized papermaking machine to help meet the increasing demand for paper. In 1840, wood was first used for making paper, which heralded the beginning of an unprecedented paper culture in the West during the twentieth century.

In summary, paper originated in China and spread to the West. Its current forms evolved out of distinct papermaking methods and ingredients. Mass production methods and machinery then spread eastward. The first western-style paper factory to open in East Asia was established in China in the early 1800s; the first one appeared in Japan in 1872, and the first in Korea opened in March 1901.

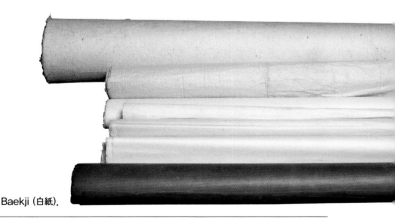

Baekji (白紙).

How paper spread

Westward

C8 Chaehuji → Dangji → Samarkand Paper → C10 Egyptian flax paper → C11 Europe (using reed as pulp) → C12 Greece → Present-day Italy → C14 Use of metal-type printing in present-day Germany, France, England → C19 The Fourdrinier brothers invent a continuous papermaking machine in 1804 → John Dickinson invents a continuous mechanized papermaking machine → Late-C19 China and Japan adopt mechanical papermaking → C20 Korea adopts mechanical papermaking

Eastward

chaehuji (AD 105) → hanji (AD 372-600) → hwaji (AD 610)

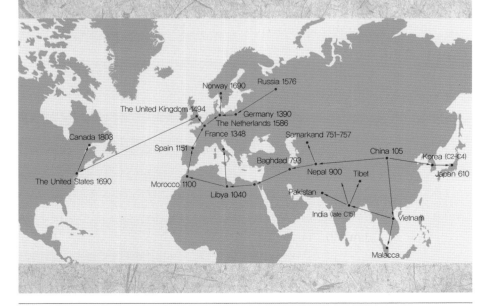

Materials used for making paper

Traditional papermaking and mechanical papermaking use different materials.

- seed fiber: cotton, cotton linter
- bast fiber: flux, hemp, ramie, jute, paper mulberry, white mulberry, Daphne
- leaf fiber: esparto grass, manila hemp
- grass: straw, giant nettle
- wood: bamboo, lumber, machine pulp, chemical pulp, used paper pulp
- others: corn stover, nettle, wheat straw, pineapple leaves

A wide variety of materials is available at present. The main ingredient in paper is fiber cellulose, which can be found in all kinds of paper. This consists of carbon, oxygen, and hydrogen ($C_6H_{10}O_5$), which every plant gets through photosynthesis. The cellulose, hemi-cellulose and lignin are the three major constituents of plants. Papermaking materials favored in the East (e.g. paper mulberry, white mulberry and Daphne) contain very little lignin. Cellulose content gives each type of paper its strength, softness, texture, color, and absorption rate. Therefore, choosing the appropriate source was as important as using the most suitable papermaking technique. Natural fiber cellulose varies in length from 1.5mm in broadleaved trees to 3mm in evergreens; 0.02mm-0.03mm in diameter. Cellulose is flexible, but can be solidified if it is mixed with hydrogen. Each sheet of paper that is removed from water and dried consists of eight or nine layers of fiber.

H ·········· O: This represents the hydrogen bond.

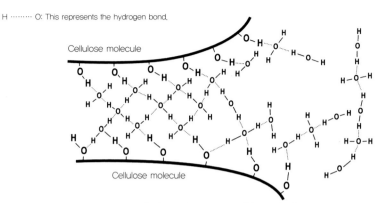

Cellulose molecule

Cellulose molecule

H_2O molecules exist between two cellulose molecules.
The hydrogen bond is irregular.

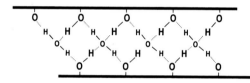

A monofilm of H_2O exists between two cellulose molecules.
The hydrogen bond is formed.

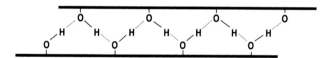

H_2O molecules have been removed completely from between two cellulose molecules,
resulting in a direct hydrogen bond.

The hydrogen bond between fibers.

The chemical structure of cellulose.

Seed fiber

This was used mostly in western papermaking. Nowadays it is reserved for finest quality paper.

Cotton

Cotton is almost pure cellulose so it does not require additional artificial treatment. The plant originated in the Indus valley, before being adopted throughout China, Southeast Asia, Korea and Japan. It spread westward to Persia, Egypt and then Europe. However, it was only around the tenth century AD that Europe started to cultivate cotton and textile methods, after they were introduced by the Moors as they emigrated from north Africa to Spain. It then spread to present-day Italy in the twelfth century, present-day Germany and northern Europe in the fourteenth century, taking off in the rest of Europe by the fifteenth century as the main material for papermaking.

Cotton fiber is 2mm-4mm long, is U-shaped, and has a rough surface. It is a suitable material for paper because its fibers are strong and flexible, but thick enough to lend the paper a soft, smooth texture.

Cotton.

Cotton linter

Cotton linter, the mass of short fibers created during weaving, is boiled and washed before being sold in the form of blotting paper. To ensure the requisite paper quality, cotton linter should be prepared (by teasing the fi-

bers) beforehand. It is still the key ingredient of handmade paper in Europe today.

Bast fiber

This long-fibered material has been used in papermaking for longer than any other in eastern cultures. Minerals and lignin are removed during the preparation stage to ease the production process.

Flax and linen

The cultivation of flax started around 5000 years ago in Egypt and Mesopotamia. In the wild it is beige or yellowish brown, but is bleached white as part of the refining process. There are over one hundred varieties of flax. Its surface is glossier than cotton, its absorption rate is high, it swells instantly and tautens after coming into contact with water, and it dries quickly. It is also durable and dirt-resistant thanks to the flat surface of the fiber. The downside is that, like other bast fibers, it reacts badly to oxidizing agents or bleach, so careful attention is needed during the bleaching process. Furthermore, it lacks flexibility and malleability once it is fixed or creased.

Hemp

Hemp, the oldest paper fiber, consists of herbal bast fibers. Some varieties are cultivated to produce

Sun-dried paper mulberry bark.

marijuana. Although it originated in the Middle East, hemp has adapted well to different climates and is now cultivated in subtropical areas all across the world. Because it was already in use during the Three Kingdoms period (along with silk and wool), we can assume it was harvested commercially before then. It is damp-resistant and extremely durable, but it has a tendency to inadvertently split lengthways during beating. Its hardness makes it ideally suited for rough-surfaced paper.

Ramie

Ramie is what Koreans often refer to as *mosi*. A perennial plant, ramie originated in China, India, and the Himalayas. In Korea, it is mostly cultivated in Southern Chungcheong Province and Jeolla Provnices. In the wild it is light brown or yellowish brown, but is bleached white as part of the refining process. It has a bright surface and is extremely absorbent. Furthermore, it is the strongest and least perishable of all bast fibers, protecting it against damage from water, chemicals or sunshine.

Jute

Jute is an herbaceous annual whose bast fiber was cultivated first in the Bengal region of India. The fibers are about 2mm long; the shortest among the bast sources. Jute is usually yellowish brown, but better quality varieties are often lighter brown or even white. Although it is stronger than cotton, it is weaker than other bast fibers.

Paper mulberry

Paper mulberry (*dak* in Korean; *kozo* in Japanese) is indigenous throughout Korea, Japan, China, Taiwan and Thailand. It grows 2m-5m tall, best in mild

Oriental paper bush (samjidaknamu).

Paper mulberry (daknamu).

climates with average rainfall. Paper mulberry was traditionally favored as a base material for handmade paper because of its durability and strength. It is used for making thin yet strong paper, and is said to be durable enough to last more than 1,500 years. Paper made from paper mulberry was traditionally used for making drawing paper, kites, umbrellas, and paper money.

Wild paper mulberry

Wild paper mulberry (*anpi* or *gampi* in Korean) has long been a preferred material for making traditional paper. In East Asia, there are eight or nine varieties available. It grows to a height of 1.5m, and grows in temperate climates. It is grown commercially in Korea, China and Japan, but has become less common because cultivation costs have risen. It is often used for making

handcraft work, dolls, wallpaper, and plain fans. Since it is one of the thinnest yet strongest bast fibers, it is also used as stencil paper. Wild paper mulberry helps to spread the fiber evenly when it is mixed with paper mulberry to make paper.

Oriental paper bush

A number of oriental paper bush varieties (*samjidak* in Korean; *mitsumata* in Japanese) grow throughout East Asia. Growing 1m-3m in height, it is thinner, shorter, and weaker than other bast fibers. However, it is extremely resilient and elastic. These characteristics make it ideal for making paper money, gold and silver foils, and calligraphy paper. In particular, oriental paper bush was used as the base material for Japanese banknotes. In fact, 100% of it was exported to Japan in the 1970s, which led to its nickname donnamu ("money tree").

Daphne

Commonly known as the Nepalese paper tree, Daphne is grown and used in Nepal and other Himalayan regions. The fiber has sharp ends and grows to various lengths.

Cheongdanpi

This shrub grows in various Chinese regions. It is the main material used for making seonji and finest-quality Chinese paper.

Leaf fiber

Esparto grass

Esparto grass grows in abundance throughout north Africa and southern Spain. It is short and has soft tubular fibers. Paper made from Esparto is delicate.

Manila hemp

Also known as Abaca, this plant is indigenous to the Philippines. Manila hemp is also one of the main materials used for making rope. It grows 4.5m-6m tall, has a light brownish color, and boasts a dense frame of branches and leaves. Fibers are 1mm-3mm long, have a regular shape and density, and look glossy. Manila hemp is as strong as other bast fibers, but has the added benefits of being relatively elastic and durable. Recently it has replaced paper mulberry as the main ingredient of hanji.

Manila hemp.

Grass

Giant nettle

The giant nettle originated in India and neighboring countries, growing to a height of 1.8m. It belongs to the same genus as the European nettle. It is often used for making paper in Nepal.

Rice straw

Rice straw is common throughout the breadbaskets of Korea, Japan and Southeast Asia. It was once widely considered to be a substandard material for papermaking, but is still used to a lesser degree. Its fibers are thin, short and sharp-tipped. It is delicate and has good absorbency. It is often mixed with other fibers because it is inexpensive.

Rattan

Rattan, a type of creeper, is grown throughout Korea and China to make paper and furniture. However, it is used less frequently nowadays because it is unprofitable and difficult to process.

Bamboo

Bamboo, which was used in the earliest days of papermaking, is still widely available in Korea, Japan, China, and Southeast Asia. It grows 6m-30m tall and up to 60cm wide. Its short, needle-shaped, beige fiber is very absorbent. The Chinese traditionally fermented bamboo to make paper. In Korea, bamboo's inner fiber was used for making jukji (竹紙, a type of fine-quality paper), although the supply in Korea has often been severely restricted owing to the labor-intensive nature of the harvesting process.

Wood pulp

Western paper producers used wood pulp from the outset because of a shortage of alternative materials. The first wood-pulp paper was created in 1840 in present-day Germany, using a ground-wood-pulp technique. A number of wood-pulp companies provided a stable and cheap supply of it to the papermaking industry. Advances have been made in recent years to improve the quality of pulps by using alpha-cellulose, although wood pulps continue to be machine-made and mass-produced. Each pulp is classified according to the production process it goes through:

Mechanical pulp

Wood is ground without any chemical treatment.

• **Ground-wood pulp** (GP)

Wood is pressed by a rotating millstone.

• **Refiner** (GP)

Wood is cut into small pieces and refined.

Wood pulp material used for making western paper.

• **Thermo-mechanical pulp**

Small strips of wood are steamed before being refined.

Chemical pulp (CP)

All non-fibrous material in the wood is removed through chemical treatment.

• **Kraft pulp (KP)**

Strips of wood are boiled in a soda solution (including caustic soda) in order to remove any non-fibrous material from the wood. Bleached varieties are classified as Bleached Kraft Pulp (BKP). Pulps made from hardwoods are classified as HBKP; pulps from softwoods are SBKP.

• **Sulfite pulp (SP)**

This refers to pulp boiled in sulfite [$Ca(HSO_3)_2$ or $Mg(HSO_3)_2$] in order to remove non-fibrous material from the wood. Even though it produces a slightly better yield than kraft pulp, this type has its drawbacks: it has weak fibers, it can only be made from certain types of wood, and it is difficult to later remove the chemicals used in the process from the paper. These three factors have led to a decline in the number of factories producing chemical pulps.

• **Semi-chemical pulp (SCP)**

Part of the non-fibrous material is removed from the wood, boosting production yields by 60%-95%. It is known as neutral sulfite semi-chemical pulp (NSSCP).

Waste paper stock

Pulp from waste paper is often praised as a green option because it helps to preserve and protect resources; nevertheless, the world recycles only 5%-55%

Hanji waste stock.

Used lining paper (under wallpaper).

of used paper.

- **Gray stock**

Only dirt is removed from used paper, newspaper, whitepaper boards, and corrugated cardboard.

- **De-inking pulp** (DIP)

Ink and dirt are removed from newspaper and other printed paper products.

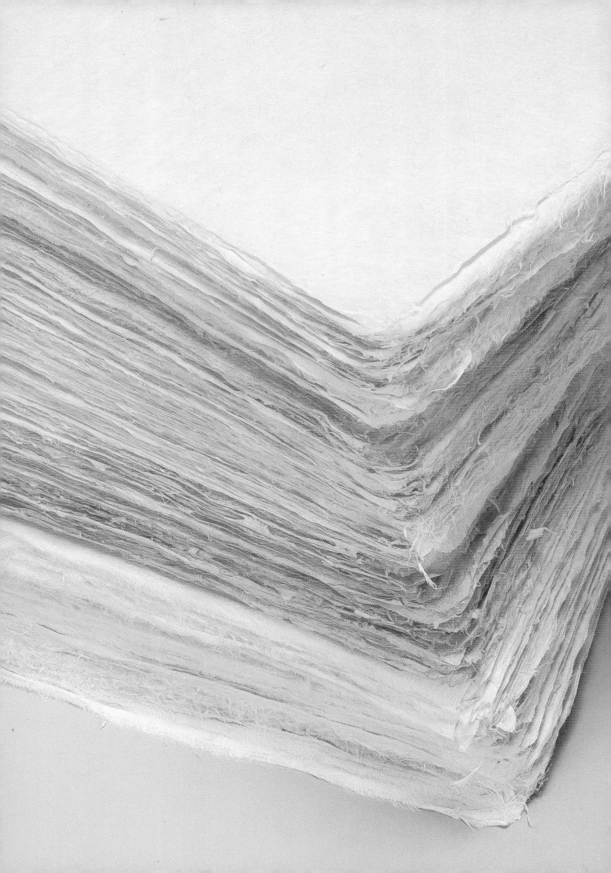

II

The history of hanji

Hanji's origins

Two types of paper are produced and used in Korea today. These are hanji (韓紙, traditional Korean paper) and yangji (洋紙, paper of western origin). Hanji falls into one of two subcategories: the first is subuji (手浮紙, which translates as "handmade paper"). It is highly regarded as one of Korea's ancestral crafts and is renowned for its oriental gracefulness. It is also known as suchoji (手抄紙). The second kind is machine-made hanji, which is designed for mass production but incorporates many of the original techniques used in handmade hanji. While records no longer exist to help us pinpoint the specific origins of Korean hanji, it is widely accepted that the papermaking techniques and technologies adopted and adapted over centuries are unique to Korean culture.

The origins of the word *hanji* are uncertain. Some authorities argue that its name merely derives from yangji to help distinguish it from foreign papermaking, just as the prefix "han" circulated (hanbok, hanbong, hanok, hanui). Others contend that "han" translates as "cold". Traditional paper has almost always been made from paper mulberry harvested during the Korean winter, after which it is soaked in ice-cold water to improve quality. A third school of thought claims that Korean subuji was given the name hanji, to differentiate from Chinese hwaji (華紙) and Japanese hwaji (和紙). Other scholars argue "han" was first adopted from *Daehanminguk* (大韓民國, "Republic of Korea") by the late Dr. On Du-hyeon. He was awarded his Ph.D. from Waseda University, was once president of the Korea Technical Association of the Pulp and Paper Industry, and was a professor at Chonbuk University.

The oldest record of detailed hanji terms can be traced back to 1950. Before that, many Koreans used to simply refer to Korean paper as jongi. However, it has had many different names, depending on material used, method of production, location of production, use, and size. As such, hanji has also been referred to as Joseon jongi, changhoji, munjongi, chamjongi, dakjongi, and jeoji, among others. It is possible that hanji originated during a period of western influence as a way to differentiate Korean paper from foreign types. As new products arrived on the peninsula, these had an impact on the cultural environment, as was the case in Japan. After the Meiji Restoration, not only did the Japanese *hwaji* (literally "the great Japanese people's paper") promote traditional Japanese paper, but it also served to distinguish it from machine-made western paper. Japan's modern-day machine-made hwaji may exhibit traditional features but it is has gradually but increasingly been mass-produced in factories. Koreans now consider hanji to be a unique Korean term that represents all types of traditional paper.

Baekji (白紙) from the Joseon dynasty.

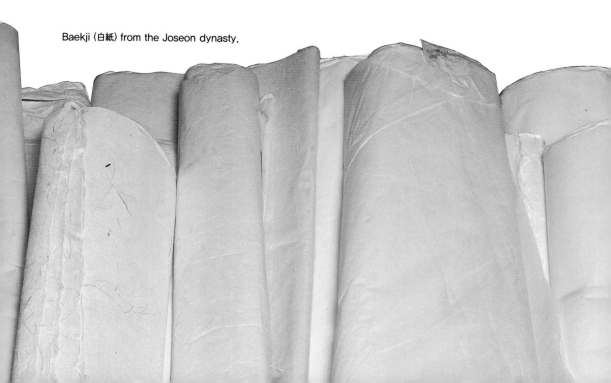

The introduction of hanji

As mentioned previously, it is not entirely clear when Koreans started producing paper; however, the consensus is that Korea has had a quality papermaking industry for many centuries, perhaps before the introduction of Chinese papermaking techniques. Leading scholars point to evidence provided by *Mugujeonggwang daedaranigyeong* (無垢淨光大陀羅尼經, *The Pure Light Dharani Sutra*), which is thought to be the finest and oldest example of an historic woodblock print. Using all available artifacts and techniques, a large body of experts now estimate hanji originated between AD 200 and AD 700.

Those who support the theory that hanji emerged in the second century AD argue that we need only look to *dak* (the mulberry tree) for evidence. This is the main raw material used for making hanji, and was known as *tag* in China between 200 BC and AD 200. Supporters argue that *dak* was introduced to and used in Korea when it was referred to as *tag* in China. Therefore, they conclude that the name and a papermaking method using mulberry trees must have emerged in Korea around AD 200.

A different theory asserts that paper and papermaking methods were imported toward the end of the Han dynasty, circa AD 300. One piece of evidence cited to support this claim is Chaehyepchong (彩篋塚), an ancient tomb from the Lelang period, located at Namjeong-ri, Dae-

dong-gun, in Southern Pyeongyan Province. In 1931, an historic Joseon site was excavated that revealed dozens of important relics from Chaehyepchong artifacts, including chaemunchilg wontong (彩文漆卷筒, lacquered container), osujeon (五銖錢, ancient coin), and chaehwachilhyeop (彩畵漆篋, painted bamboo box). At the time, archaeologists discovered a wet and fibrous matted material in one of the lacquered containers. Some observers deduced that it bore an uncanny resemblance to mulberry paper used during the Han dynasty, although others were more cautious in their assessment. Another argument presented states that Chinese papermaking skills are likely to have passed through the Baekje Kingdom (one of the Three Kingdoms of Korea) to Japan in tandem with the passage of Chinese characters. The latter was documented in AD 285, 180 years after the invention of papermaking by Ts'ai Lun. Many authorities believe Baekje artisans would have learned papermaking by this point in time. The third argument put forward draws our attention to the flood of Chinese refugees who swept into Korea to escape war-torn China in the third and fourth centuries AD. Historians argue that some of the new arrivals must have been papermaking artisans, and that they must have passed on skills and knowledge.

Mugujeongwang daedaranigyeong
(無垢淨光大陀羅尼經, *The Pure Light Dharani Sutra*).

Some scholars maintain *Cheonjamun* (千字文, *Thousand-Character Classic*) and *Noneo* (論語, *The Analects of Confucius*) may have been made out of paper, as recorded in *Ilbonseogi*. We do know they were offered as gifts to Japan by Baekje's Ajikgi (阿直岐) in AD 284. Given that *Cheonjamun* was presented to Japan 180 years after the invention of papermaking, it is plausible that papermaking methods had already spread to Korea by the end of the second century AD. As far as this line of argument goes, there is enough combined evidence to support the theory that papermaking could have emerged in Korea between AD 200 and AD 400.

Those who contend papermaking began at the end of fourth century AD propose that Marananta (摩羅難陀), the Eastern Jin Buddhist monk, most probably passed on papermaking books, methods, skills and knowledge while teaching Buddhism in the Baekje Kingdom in AD 384. Historians concur that the spread of papermaking and the emergence of Buddhism are undoubtedly linked. Buddhism was first introduced to Korea during the second year of King Sosurim's reign (Goguryeo dynasty, AD 372), when the Jin's monks Sundo (順道) and Ado (阿道) brought Buddhist books and statues into the country. A demand for more Buddhist literature led to an increased

demand for paper. Many scholars support the theory that papermaking emerged in Korea around AD 372, because they know it was already being used as a tool to spread information for various purposes.

Others argue that papermaking emerged at the end of the sixth century AD, and certainly before the beginning of the seventh century AD. This conclusion is based on three premises. First, in the sixth century AD, there was a lot of communication between the Tang and Silla dynasties, mainly through students and monks studying abroad in Tang. Many academics infer that ink, the calligraphy brush, and subsequent papermaking methods were first introduced to Korea during this period. Second, the *Mugujeong-gwang daedaranigyeong* scroll, which was discovered in Bulguk Temple (佛國寺)'s Seokga Pagoda (釋迦塔), is thought to have been placed there in AD 751, during the pagoda's construction. Therefore, scholars argue that papermaking techniques must have been available at the time. Third, *Ilbonseogi* states that in AD 610, Damjing (a monk from Goguryeo) taught the Japanese how to produce colors, paper, ink and millstones. Given that a millstone was discovered at the tomb of Ts'ai Lun (the father of paper), Korea would also have adopted the millstone to make paper, just as the Chinese had originally. AD 751 serves as a useful historical reference point that we can use to differentiate Chinese hwaji and Korean hanji. For example, hanji produced after AD 800 involved gohae (叩解, a process of beating used to shorten fibers) whereas hwaji fibers were ground. Experts agree that the oldest hanji available, used to make the Goguryeo dynasty's *Myobeop yeonhwagyeong* (妙法蓮華經, *The Saddharma Pundarika Sutra*), appears to have undergone gohae. In addition, judging from the high quality of *Beophwagyeong* (法華經, *The Lotus Sutra*), which was published afterward, papermaking before the seventh century AD appears to have been fairly advanced. Therefore, Korea's papermaking

techniques could have adopted Chinese methods very early on.

Among the aforementioned theories, the most plausible is the one proposing the emergence of papermaking in, or not long before, the eighth century AD. This conclusion is based on evidence that shows Korean artisans had by then already established a unique papermaking system.

Saekji (色紙) scroll.

The Three Kingdoms period

The Three Kingdoms period marks the infancy of Korean hanji production, before which only Chinese paper, Chinese papermaking techniques, and respective homegrown imitations existed. Given that all entombed plant-based products from the period have long since decayed, we have few clues available to help establish the extent of papermaking skills present during the Three Kingdoms period; lime-washed walls offer the most meaningful archaeological insight into the Goguryeo and Baekje kingdoms' production methods because no actual books remain. Indirect evidence does however suggest that the dynasties' books were relatively refined.

Regional influences played their part in the development of Korean paper production and papermaking techniques over the course of six centuries (AD 200-AD 800). For example, the abundance of hemp in colder areas north of Hangyeong (now known as Seoul) made it a useful alternative to paper mulberry, which was much scarcer in the north than in southern climes where artisans could take advantage of the warmer weather to harvest quality mulberry in large volumes. Historians claim that Goguryeo learned how to use hemp from Lelang, whereas Baekje artisans adopted papermaking techniques using paper mulberry from southern China's artisans. This is supported by historical records that show the people of Jiaozhou (交州, southern China), made paper using mulberry trees. Since demand for paper at that time would have come from aristocrats based in or near the capitals of Goguryeo, Baekje, and Silla, these cities would also have become papermaking hubs. While Korean records of paper or papermaking of that period

have long since disappeared, Chinese documentary evidence does exist: texts highlight the quality of paper produced in Gyerim (now known as Gyeongju), the capital city of the Silla Kingdom. We also know that Damjing, a famous monk from Goguryeo, passed on papermaking techniques to the Japanese. Therefore, we can assume that some of papermaking skills had already been acquired throughout Korea during the seventh or eighth century AD.

Goguryeo

The Goguryeo Kingdom established and then maintained continuous diplomatic relations with neighboring China. In AD 197, during the reign of Gogukcheonwang, hordes of Chinese refugees arrived in Korea to avoid the turmoil in China, and it is assumed that paper was introduced during the waves of migration. Myeongdojeon (明刀錢, ancient Chinese money) has also been discovered. If the emigrants brought this type of money with them, they could have brought paper books as well. According to *Samgukyusa* (三國遺事, *Memorabilia of the Three Kingdoms*), texts were produced in Goguryeo since its earliest beginnings. The dynasty's historians wrote and compiled the 100-volume *Yugi* (留記, *The*

Myobeop yeonhwagyeong (妙法蓮華經, *The Saddharma Pundarika Sutra*). Published using paper from the Goguryeo Kingdom; the sutra is kept in North Korea.

Complete Chronicles), which was abridged into a five-volume edition by Lee Mun-jin. However, historians have yet to establish if *Yugi* was written on paper or bamboo. *Ilbonseogi , The Chronicles of Japan*, mentions Goguryeo paper, referring both to Damjing's trip to Japan as part of delegation on behalf of King Yeongyang (circa AD 610), and to his teaching Japanese the arts of papermaking, ink-making, millstone-making and painting. Therefore, it is conceivable that Koreans had learned papermaking skills by the time Damjing arrived in Japan. Paper made during the time of the Goguryeo Kingdom is noted for its smooth surface and fine texture. The paper was also bleached to a high standard. The quality of workmanship is exemplified by *Myobeop yeonhwagyeong* and *Beophwagyeong*. There is little doubt that such feats required a wealth of experience and a great deal of effort. We can conclude that Korean artisans adopted the Chinese system of papermaking until the early seventh century AD (before the creation of *Mugujeonggwang daedaranigyeong*). This involved grinding all materials with a grinding stone.

Baekje

Ancient Korea acted as a cultural conduit between China and Japan. During the Three Kingdoms period, the Baekje Kingdom had closest ties to Japan. As such it introduced Chinese and Korean culture to the Japanese. Details are provided in *Ilbonseogi*. From early on, Buddhist artifacts such as gilt bronze Buddha statues and Buddhist texts were brought to Japan. In AD 285 Wangin (王仁) took 10 copies of *Noneo* and a copy of *Cheonjamun* to Japan, which happened to be the 52nd year of King Goi's reign of Baekje (and 180 years since the invention of papermaking by Ts'ai Lun). The consensus among historians is that the Baekje Kingdom first encountered Chinese papermak-

ing during the thirteenth year of King Goi's reign in AD 246 when Wei invaded Goguryeo. In a strategic move during the conflict, King Goi ordered General Jinchung to marshal all residents living along the border of Lelang. This would have eventually led to cultural integration and the acquisition of papermaking skills by the Baekje artisans. Papermaking had been widely encouraged by emperors throughout China since its invention there in AD 105. So it is plausible that paper and the papermaking skills commonplace in Lelang would have been learned and adopted in the Baekje Kingdom after the new arrivals relocated and integrated.

Silla

Once the Silla dynasty unified the Three Kingdoms in AD 668, it made huge strides to adopt aspects of the Tang dynasty's culture. One of those key elements was the advanced papermaking skills of the Tang artisans; however there is a lack of extensive documentary evidence remaining in the form of books or paintings. What we do have is a reference to Silla paper in ancient historical texts. One text written by Jo Wi states that: "… during the twenty-first year of Seongjong, a monk named Hakjo found 43 pages of Silla text between crossbeams while fixing one of the halls in Haein Temple (海印寺)." The original texts from the Silla dynasty no longer exist. Other texts also refer to paper during the Silla dynasty, as well as references made to a paper kite during Queen Jinseong's reign in AD 648. While Silla was not the most culturally advanced of the Three Kingdoms, it did leave us beautiful Buddhist artifacts: *Mugujeonggwang daedaranigyeong* is one of the most famous historical relics made of paper. During the recent restoration of an ancient Korean royal box at Shōsōin (正倉院) in Japan, an ancient document from

Silla was discovered layered within one of the box's walls. Unfortunately, the document was sealed back in place by restorers before Korean experts had an opportunity to examine it further.

Baekji (白紙).

Unification of the Three Kingdoms

Gyeongju was the center of papermaking during the Three Kingdoms period, and most of its paper output was used for meeting administrative demand. The most sought-after paper at the time was baekchuji (白揯紙), which was popular at home and abroad because of its high quality. A sample of paper exhibiting this outstanding quality was discovered lining the coffin that was found within an ancient tomb. *Mugujeonggwang daedaranigyeong* (National Treasure No.126) was discovered to have been printed on mulberry paper produced before the year AD 751. Part of the Hoam Art Museum Collection, *Daebanggwangbul hwaumgyeong* (大方廣佛華嚴經, *The Avatamska Sutra*; National Treasure No. 196) was also made of mulberry paper in AD 755 during the 14th year of King Gyeongdeok's reign. Another paper relic from

Daebanggwangbul hwaumgyeong (大方廣佛華嚴經, *The Avatamska Sutra*). On display as part of a collection at Hoam Museum.

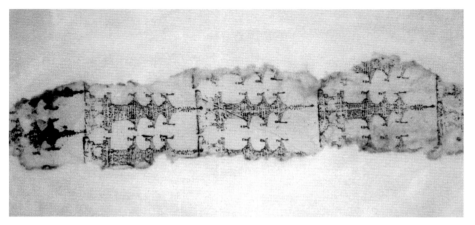

Baekjimukseo darani (白紙墨書陀羅尼). Found by the stone pagoda in Hwaum Temple (華嚴寺).

Wangocheonchukgukjeon
(往五天竺國傳, *Hye Cho Diary*)

this period is *Wangocheonchukgukjeon* (往五天竺國傳, *Hye Cho Diary*), written by the Silla monk Hyecho (慧超) during his travels across India 1,200 years ago. It was found in a scroll of Buddhist scriptures during an excavation at the largely unheard of Qiafodong (千佛洞) in Dunhuang. Nevertheless, it is still unclear whether or not the paper was produced in the Silla Kingdom.

The Goryeo dynasty

From the outset, the Goryeo dynasty coveted the Silla's dominance, and therefore developed and maintained solid diplomatic ties and trade relations with China's newly-established Song dynasty in its efforts to tip the balance of power in its favor. The kingdom imported and developed woodblock-printing, in addition to studying the teachings of Chu-tzu. The eleventh and twelfth centuries AD saw a publishing boom in Buddhist and historical texts. Two of the best known are *Palman daejangkyeong* (八萬大藏經, *Tripitaka Koreana*) and *Samguksagi* (三國史記, *The Chronicles of the Three States*).

Korean papermaking blossomed during the Goryeo dynasty: artisans steadily improved the papermaking skills adopted from China, before developing goryeoji (繭紙, meaning Goryeo paper), which later became synonymous with "quality paper" among Chinese artisans and buyers. We can draw clear parallels with Korean inlaid celadon, which also gained an excellent reputation once word spread of Korean artisans' superb celadon-making skills and unique style. The four treasures of the *munbangsabo* (brush, ink, ink stone, and paper) were also admired. The Goryeo dynasty's papermaking and stationery products proved incredibly popular during the Song dynasty.

The papermaking industry saw a decline toward the end of the Goryeo dynasty. As the nation's power and influence waned, artisans lost much of their social status and mulberry tree production dwindled. This is supported by an excerpt from an appeal submitted during the 10th year of Tae-jong's reign (early Joseon dynasty): "Less than 1%-2% of the land is designated for mulberry." The papermaking industry was crippled by the end of the

Goryeo dynasty.

The raw materials used to make goryeoji included both paper mulberry and long-fibered rattan. Lime was used to boil strips of paper mulberry bark, after which the contents were rinsed in caustic soda and lime. Tools included a huge cauldron, a tub for bleaching and a mould, which came in a wide variety of sizes.

The method of treating the paper was called dochimbeop (搗砧法), which literally translates as "smoothing paper by beating it on stone". The method was also referred to as chujibeop (搥紙法), a paper treatment technique designed to produce the most even surface possible and a glossy sheen to the paper. This technique compensated for the material's natural tendencies to absorb too much water and to become too fluffy owing to its long fibers. Therefore, hanji masters know how to use the optimum amount of water, and have perfected a method of beating the paper with a huge hammer. The Chinese had an insatiable appetite for white, reflective, silky paper- qualities produced by papermakers from the Silla and Goryeo dynasties. Combined, these qualities have come to characterize hanji from the mid-seventh century AD onwards. Chujibeop is cited in a number of historical texts. The method is described as follows:

"Place one wet sheet of paper on top of 10 sheets of dry paper. Repeat this process several times. Stack 100 sheets of paper on a board. Cover the stack with a flat plank, onto which a large stone should be placed. Leave this overnight. Examine the stack the following day. All of the sheets should have absorbed the desired amount of moisture. Beat the stack with a large hammer 200-300 times. This will allow about half of the sheets to dry, while keeping the other half moist. Next, shuffle the sheets and beat the set a further 200-300 times. Dry the beaten sheets in the shade for around six hours,

Seoganji (書簡紙), gwaji, sohoji (小好紙).

before placing them on the board and beating them a few more times. All the sheets should have dried by this point. Having followed this process- and depending on the quality of the paper- the paper will feel similar to oil-paper. This arduous technique relies solely upon the persistent efforts of the artisan, who needs to repeatedly beat and rearrange the stack."

Paper made using this method is durable, smooth, and does not become fluffy easily. This allows artisans to apply a smooth brushstroke. Sizing, a modern papermaking technique, prevents unwanted ink spread. However, this traditional Korean method uses products that do not harm the quality of the paper at all, and should not be confused with calendering.

A site was discovered recently in Mongolia that is thought to have been the paper factory where Goryeo's papermaking artisans worked after they had been captured by an invading Yuan army. A stone drainpipe and mill-stones used to grind materials for paper were abandoned at the location, proving that captured artisans from Goryeo produced paper there.

Types of goryeoji

There are many types of goryeoji: sanghwaji (霜華紙) is clean, strong, thin and slick, whereas another type, gyemunpyoji (啓文表紙), is as thick and as tough as leather. Seonjaji was used for making paper fans, while baekmyeonji (白綿紙) was as silky and soft "as a beautiful woman's touch". Seokchuji, gyeonji and acheonji (鴉青紙) were favored by Chinese emperors; these types continued to be made well into the Joseon dynasty. Gyeonji, which was made from the bark of paper mulberry, was offered as an alternative to hard labor. *Gyeon* translates as "silk" and is derived from its silken, glossy surface. Baekchuji was one of the best known types of paper used in the Silla dynasty, having a thick, tough and shiny surface produced by meticulous drying and beating. Other types included sangbaekji (桑白紙), sahonji (死婚紙), samcheopji (三貼紙), gyeonyangji (見樣紙), cheongjaji (青磁紙), geumbunji (金粉紙), and cheongji (青紙). A Buddhist text published during the Goryeo dynasty described one book that comprised 15 kinds of paper. This illustrates the variety of paper available at the time.

Goryeoji was mainly used to make books covering Buddhism, medicine or history. It was also used to make paper money and gifts. Regional authorities often used it to influence or bribe powerful families. Different types were used for different uses: yudunji (油芚紙) was favored for tent-making on the battlefield; hwangji (黃紙) and gamji (紺紙) were commonly used for making historical or Buddhist scriptures, since they weathered well, and provided better resistance to insect attack. Seokchuji, gyeonji, and acheongji were used to make fans, umbrellas, and book covers because they were robust types, making them popular tributes or wedding presents for Chinese officials.

Goryeoji was mainly produced in Gyeongju, Yecheon, Punggi, and

Cheongdo in Gyeongsang Provinces. Gongju was another papermaking hub, producing pyojeonji (表箋紙), bongbonji (奉本紙), bubonji (副本紙), seogyeolji (書潔紙), pyoji (表紙), suryeonji (水蓮紙), sehwaji (歲畵紙), anji (眼紙), jeojuji (楮注紙), jeosangji (楮常紙), gyemokji (啓目紙), chojuji (草注紙), jukcheonji (竹青紙), and sijeonji (詩箋紙). Nohwaji (蘆花紙) was produced throughout wider areas of Gyeonggi Province. Gojeongji and hwangmaji were produced in temples by monks.

Records of goryeoji

There are records that refer to goryeoji in a number of Chinese books. They are as follows:

Jeonggye (程棨), in his book *Samryuheonjapji* (三柳軒雜識), states that the quality of goryeoji was unrivalled even in China. Jinyu (陳摛, Northern Song dynasty) discussed paper products in his book *Buheonyarok* (負暄野錄). In his

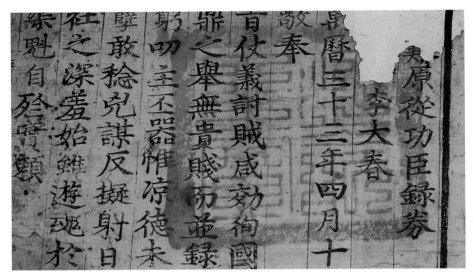

Gongsin nokgwon (功臣錄券, A document detailing rewards given to a vassal).

book *Gyerimyusa* (鷄林類事), Sonmok (孫穆, Song dynasty) praised baekchuji, Goryeo's mulberry paper, for its sleek, smooth and endearing qualities. Seogung (徐兢) mentioned in *Goryeodogyeong* (高麗圖經) that goryeoji is made not only with paper mulberry but also with rattan. He goes on to recount numerous anecdotes about the quality of goryeoji. In the book *Munbangsagodoseol* (文房肆攷圖說) from the Tang dynasty's Byeonggyun, it records: "Wang Xizhi's book *Nanjeongseo* (蘭亭序) used paper made from silkworm, and it is goryeoji." Another record goes on to say: "Gyeonji-a type of goryeoji-is made from cocoon cotton so it is so white and silken to touch. Writings on this paper reveal beautiful ink colors. This is not something created in China, which makes it even more valuable." A similar record can be found

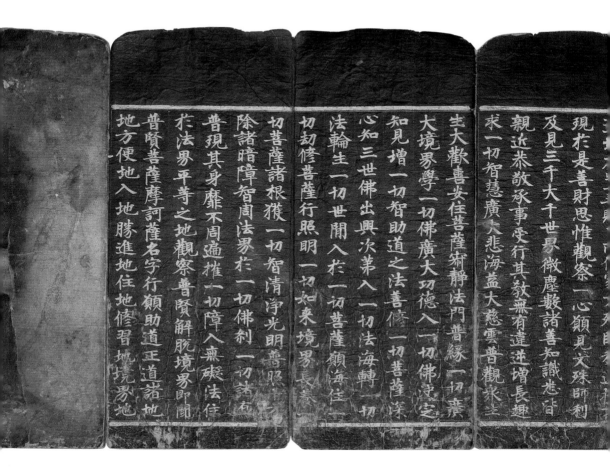

in *Dongcheoncheongrok* (洞天靑綠) written by Chohuigo (趙希鵠, Song dynasty). This testifies to the fact that the Chinese mistakenly believed goryeoji was made from silk owing to its quality. They later realized that goryeoji was made from mulberry paper when *Dongwol* (董越, Ming dynasty) discovered its plant-based origins after observing it burn.

Goryeoji's excellent qualities were praised in poems too. Hanjachang (漢子蒼, from the Song dynasty) wrote in a poem: "The paper I was given, samhanji, is so shiny it illuminates my desk". Leedeokmu (李德懋) wrote in his book:

"Jangjong (章宗, the Jin empire) used cheongjaji (靑磁紙) from the Goryeo dynasty. During the second year of Emperor Hongwu, the historians used chuiji (翠紙) from Goryeo for the covers of their history books. They are

Gamjigeumni daebanggwangbul hwaumgyeong (大方廣佛華嚴經, *The Avatamska Sutra*).

both equivalent to present-day acheongji (鴉靑紙)."

There is also a record stating that Leegang (李綱, Southern Song) wrote Du Fu's poem when a man named Wanginyeong took out his goryeoji and asked for a sample of calligraphy.

Goryeoji did not escape criticism, however. "Yeonam" Park Ji-won (燕巖 朴趾源), a famous Korean scholar, pointed out some drawbacks in his book *Yeolhailgi* (熱河日記, *An Essay on Travels through China*):

"In terms of paper, how well it absorbs ink and brings out the style of writing are most important. Nevertheless, not all types of goryeoji are of good quality, according to Xu Wei. Only thick goryeoji is of acceptable quality. The problem is that mostf goryeoji is too rough for writing if it isn't beaten, yet too slippery to absorb ink if it is beaten. Therefore, goryeoji is inferior to good-quality Chinese paper."

Notwithstanding Park Ji-won's criticism, numerous Chinese emperors and poets favored and imported goryeoji because they believed in its superior quality.

Relics

The oldest samples of goryeoji are located in Japan: *Daeansipneon* (大安十年), *Suchangwoneon* (壽昌元年), and *Yeonmilchojeong* (演密抄井) reside in the Eastern Great Temple (Tōdai-ji) in the city of Nara. Other excerpts of Buddhist writings are maintained in Nanzen-zi in Kyoto. In particular, those maintained in the Eastern Great Temple are thought to have been taken to Japan immediately after the publication of Uicheon's *Dokjangpan* (讀欌板). They were roughly pieced together to form a scroll without any grafting, and therefore exhibit mould tracks. Most of the existing goryeoji samples

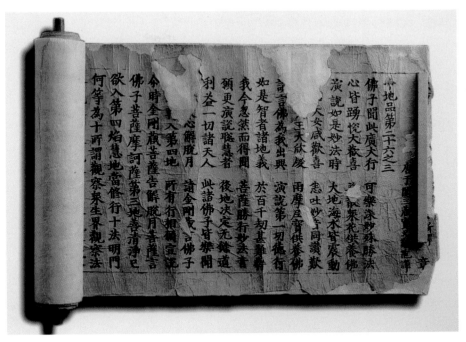

Daebanggwangbul hwaumgyeong (大方廣佛華嚴經, *The Avatamska Sutra*), Jubon (周本), No. 36. Part of the collection at Hansol Paper Museum.

are from the latter part of the Goryeo dynasty. These are books, Buddhist texts or Buddhist paintings. The most prestigious book surviving from the Goryeo dynasty is *Jikjisimcheyojeol* (直指心體要節), which is also the world's oldest metal-print book. The remaining volume is one of the best examples from the Goryeo dynasty, and is currently on display at the National Library of France. Parts of *Sokjanggyeong* (續藏經, National Treasures No. 90, No. 204, No. 205, No. 206, No. 207) are printed in *jangyeongji* (藏經紙, goryeoji). Another notable goryeoji artifact is an announcement letter by King Gojong from 1821, now located at Songgwang Temple (松廣寺) in Korea (National Treasure No. 43).

The Joseon dynasty

Papermaking during the Joseon dynasty spanned two distinctive halves separated by the Japanese invasion of 1592. The first half marks the heyday of Korean papermaking; the second charts its gradual decline.

The first half of the Joseon dynasty

This was a very important period of papermaking, which saw institutional oversight, quality controls, improvement in technique, more experimenta-

Various types of saekji (色紙) and baekji (白紙) scrolls.

tion, and the adoption of new materials. Consequently, an increasing number of people started using paper. It was produced throughout the country for various uses. Major paper-producing cities included Jeonju and Namwon in Jeolla Provinces, in addition to Gyeongju and Uiryeong in Gyeongsang Provinces. In 1415, during the reign of Taejong, a national papermaking center, Jojiso, was established. Efforts were also made to create currency from the mulberry tree, using mulberry paper as bills. During the reign of Sejo (1456), the name of the papermaking center was changed from Jojiso to Jojiseo (造紙署). Successive kings attempted to produce paper materials, standardize paper, and improve paper quality through a network of institutions coordinated by Jojiseo (the headquarters that coordinated supporting *Jiso*, the regional centers). Jojiseo's role was most prominent during the reign of Sejong. He adopted an active publication policy, leading to the development of various fields of study. Jojiso employed 16 administrative staff, including a general manager (dojejo) two assistant managers (jejo) and administrators. Artisans were led by a master craftsman who reported directly to administration. All necessary papermaking materials were supplied by the local government office (who even used recycled paper for papermaking).

The establishment of official institutions like Jojiso marked a major shift from the handcrafts system that had endured. In its place, artisans worked under the auspices of a local administrative system or central government. Consequently, this encouraged Korean papermaking skills to develop and improve more quickly. In particular, rapid academic development and publication during Sejong's reign spurred the production of paper at central and regional hubs. The most notable changes during this era were improved productivity, the introduction of alternative materials to compensate for di-

minishing volumes of paper mulberry, and the development of mixed-paper stock.

In addition, a drive to import and adopt advanced papermaking skills from China, in the both the twelfth year of Taejong (1412) and the sixth year of Seongjong (1475), represents a shift in Korean papermaking, once the state realized how important it was to be able to meet the increasing demand for paper. Jojiso played the role of a production facility that both satisfied this growing demand and handled post-production issues. The establishment of Jojiso contributed not only to papermaking, but also to printing techniques. That said, significant problems arose over time involving corruption, poor management and a low supply of workers. The lack of integrity and transparency at Jojiso reflected a culture of sloppy management that filtered down through the workforce. This resulted in paper of inferior quality.

Papermaking methods

From the outset, the Joseon dynasty strove to produce quality paper. In particular, measures to enhance papermaking methods and improve materials were prioritized. The decision-makers realized it was imperative to find an alternative to paper mulberry and improve papermaking methods.

Joseonwangjo sillok (朝鮮王朝實錄, *The Annals of the Joseon Dynasty*) reveals how early kings attempted to learn and adopt the advanced materials and papermaking methods that were available in China and Japan. An excerpt from the twelfth year of Taejong's reign makes the monarch's intentions clear:

"A person called Shin Deuk-jae (申得財) from Liaodong peninsula provided Chinese paper (hwaji) to the king, and he was rewarded with rice and cotton. Korean artisans were ordered to study his methods."

A collection of seosan (書算),
a type of traditional bookmark.

During Sejong's reign, Japanese paper mulberry (anpi) was imported to boost the nationwide supply of high-quality paper. According to the book *Seongjong sillok* (成宗實錄, *The Annals of Seongjong*), *Park Bi-hoi* (朴非會, a paper-making artisan) was dispatched to Beijing as part of a delegation to master Chinese papermaking methods. This led to the cultivation of paper mulberry, as recorded in *Gyeongguk daejeon* (經國大典, *Laws of the Joseon Dynasty*), revised and published during the sixteenth year of Seongjong. In a section of the same book, it mentions that artisans could be imprisoned for producing low-quality paper or paper of the wrong size. This drive for excellence extended to the collection of raw materials, including bamboo, mulberry bark, and hibiscus (the latter introduced by Park Bi-hoi from China). Various attempts were made to develop new types of paper unique to the Joseon dynasty. Nevertheless, the quality of materials and paper suffered over time. During

the third and fourth year of Sejo's reign (1457-1458), it was noted that:

"Writing paper was collected from each region and used for publishing Buddhist scripture at Haein Temple (海印寺). For writing paper, sunwaeji (純倭紙), gyowaeji (交倭紙) were mostly used, whereas songyeomji (松染紙) was used for the cover."

This record indicates fewer types of paper were used per item compared with scriptures produced during Sejong's reign. In reality, paper made during Seongjong's reign at Jojiso was not as refined as previous types. And, other than mulberry, only two types of paper-gojeongji (藁精紙) and yumokji (柳木紙)-were available. It may not have been quite so refined, but the paper produced for the king was undoubtedly well-made guemjeonji (金箋紙), a paper decorated with gold.

Thanks to the introduction of advanced Chinese papermaking methods, thinner, increasingly even paper could be produced from the mid-seventh century AD. This became an important event to distinguish early and late Joseon periods. Korean artisans were familiar with both Japanese and Chinese papermaking methods, and all used surokbeop (手漉法) instead of yububeop (流浮法, the Korean method). The only differences between the two

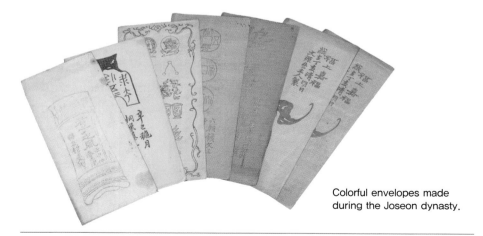

Colorful envelopes made during the Joseon dynasty.

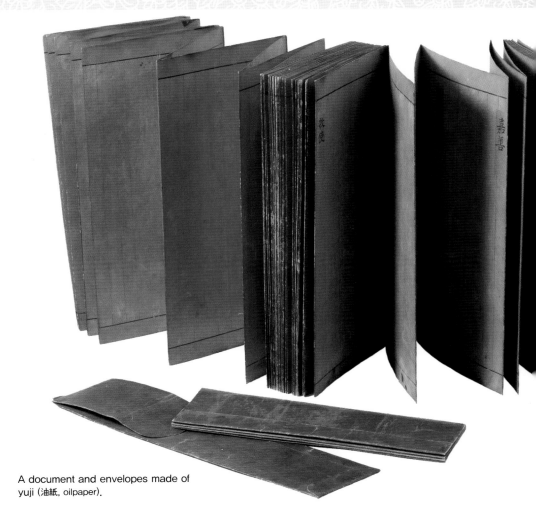

A document and envelopes made of yuji (油紙, oilpaper).

were the materials used and slight variations in production techniques. The key point worth making is that Korean artisans adopted foreign papermaking methods that they then combined with existing traditional Korean methods. In the book *Sanrimgyeongje* (山林經濟, *Agricultural Encyclopedia*) by Hong Man-seon (洪萬選), materials and production methods of the time are described in detail:

"The black bark is called 'jeo', which you can peel. The white bark beneath is called 'gok'. Plant the seeds in mountain valleys or in dry land during Feb-

Unmoji (雲母紙):
Unmo saekji is made by mixing powder of unmo with paper dyed in primary colors such as red, blue, yellow or black, or in secondary colors such as green.

ruary (lunar calendar). Cover the seeds with yams to keep them warm, and after three years, they will be ready to harvest. Cut them in the autumn when the leaves and stems turn yellow. Boil them before peeling off the bark. Add tree ash, barley ash, hay ash, and sea shell ash while boiling the bark. The bark bleaches after being boiled in this natural alkali, and should be rinsed in a fast-flowing stream for several days, before being beaten thoroughly. Afterward, fill a vat with water, put the beaten bark in the water, add dispersant such as mucus-like liquid from the root of elm trees or hibiscus, and mix it thoroughly. Using the mould, scoop out the paper and compress it with a board to squeeze out the water. Spread out the paper and dry it on rocks, on boards, in the field, or on the floor, using a fire's logs to quicken the drying process."

Jipumbyeonjuengseol (紙品辨證說, written by Lee Gyu-gyeong, a scholar belonging

to the Realist School of Confucianism in the late-eighteenth century) refers to the use of dispersant. It describes hwalcheoksu (滑滌水), which is thought to be either paper mulberry or elm tree sap. Today, the best natural dispersant is made from hibiscus root (a member of the mallow family). Hibiscus root replaced the elm tree as the most popular source of dispersant among artisans during the mid-nineteenth century. Seo Geon-nam (西健男), author of *Hwajijejoron* (火紙製造論, *Japanese Papermaking*), describes the origins of hibiscus usage in Japan, and claims that it was introduced to Japan from China via Korea.

During the Joseon period, paper was produced in many colors, using natural dyes. Paper could be dyed during or after hanji production. The dyeing process and techniques are outlined in *Imwongyeongjeji* (林園經濟志, *Agricultural Policy during the Joseon Dynasty*), *Gyuhapchongseo* (閨閣叢書, *The Housewife's Guidebook*) and *Sanrimgyeongje*.

Types of joseonji

The Joseon dynasty characterized and named joseonji types according to their material, thickness, width, color, glossiness and use. Many types had more than one name. Different types of joseonji can be classified according to criteria provided in *Sejong sillok jiriji* (世宗實錄地理志, *National Geographical Information Collected during Sejong's Reign*). The first criterion assessed for classification purposes was material. For example, jeowaji (楮渦紙) was made from

paper mulberry, gojeongji (藁精紙) from oat straw or barley straw, sangji (桑紙) was from white mulberry (*bongnamu* in Korean), baektaeji (白苔紙) from a mixture of paper mulberry and moss, songpiji (松皮紙) was made from pine-tree bark, yuyeopji (柳葉紙) and yumokji (柳木紙) were made from willow leaves, uiji (薏苡紙) from Chinese pearl barley, magolji (麻骨紙) from yam bark, baekmyeonji (白綿紙) from various cottons, and nohwaji (蘆花紙) was made from reed.

A second criterion assessed was color: seolhwaji (雪花紙) and baekroji (白露紙) may both have been made from paper mulberry but each had to be a specific color to be officially classified. Seolhwaji had to be snow-white; beakroji heron-white. On the other hand, jukcheongji (竹青紙) was as white and as thin as bamboo's inner fiber, in addition to being durable and strong.

Another classification was based on thickness, texture, glossiness and quality. Some types used for day-to-day purposes had a tough, glossy surface such as jangji (壯紙), ganji (簡紙), juji (周紙), sangji (上紙), jungji (中紙), yudunji (油芚紙), sangpum (上品), and jungpumdoryeonji (中品搗鍊紙). Yudunji is oilpaper. Sangpum, jungpum, and hapum are made by placing wet sheets of paper between dry sheets before beating. This produces a glossy, smooth sheen that benefits writers and calligraphers because their brushstrokes can glide much more easily.

A fourth criterion was usage: pyojeonji (表箋紙), jamunji (咨文紙), banbongji (半封紙), seogyeoji (書契紙), chukmunji (祝文紙), bongbonji (奉本紙), sangpyoji (上表紙), gapuiji (甲衣紙), anji (眼紙), sehwaji (歲畵紙), hwayakmyeonji (火藥棉紙), changhoji (窓戶紙), pyeonjaji (扁子紙), siji (試紙), myeongji (明紙), nogongji (老功紙), jangpanji (壯版紙), hwabonji (畵本紙), gyeomokji (啓目紙), deungdobaekji (燈塗白紙), baekji (白紙), changji (窓紙), gyeonyangji (見樣紙), huji (厚紙), jangji (壯紙), ondolji (溫突紙) , gongmulji (供物紙), and daesanji (大山紙). Jamunji was

used by students for practicing writing. Bongbonji was specifically used for documents to be sent to the king, whereas sehwaji was used for painting pictures to celebrate New Year. Changhoji, also known as gyeonyangji (見樣紙), byeolwanji (別浣紙), or samcheopji (三貼紙) was primarily used for making official documentation. Pyeonjaji (a thin, smooth type) was used for making fans or kites; gyeomokji for written correspondence with the king; baekji for wrapping, wallpaper, sliding doors and books. Books were produced using changji, as were windows, types of wallpaper, and sliding doors; gyeonyangji was for windows, wallpaper, books, wrapping and publishing; huji for flooring and windows. Jangji was used for making books, windows and flooring; ondolji was used for covering floors at homes that had traditional Korean under-floor heating (ondol). Gongmulji was for windows, wrapping, family-tree books and publishing; daesanji was used for wallpaper, sliding doors and books.

Paper was often classified according to the area in which it was produced: the book *Sinjeung donguk yeoji-seungram* (新增東國

Saekji (色紙).

輿地勝覽, *An Anthropogeographical Record of the Jeseon Dynasty*) lists major paper production areas as Yeongcheon, Milyang, Cheongdo in Gyeongsang Provinces, as well as Jeonju in Jeolla Provinces. There are also records of tribute papers (a form of provincial taxation) being imposed on Chungcheong Provinces, Hwanghae Province, Gyeonggi Province, Gangwon Province, Gyeongsang Provinces and Jeolla Provinces. Gyeongsang Provinces, with its many fields, supplied mojeolji (麩節紙) made from barley. Jeolla Provinces, with its vast paddy fields, provided gojeongji (藁精紙). Chungcheong Province provided magolji (麻骨紙), for which it is famous, made from hemp. The tenth volume of the book *Yongjaechonghwa* (慵齋叢話, Essays by Seonghyeon) mentions that Gyeongsang Provinces offered pyoji, doryeonji, anji, baekjuji, sangjuji, jangji; Jeolla Provinces provided pyojeonji, jamunji, bubondanjaji, jubonji, pibongji, seogyeoji, chukmunji, pyoji, baekjuji, hwayakji, sangjuji, jangji and yudunji. According to *Sejong sillok jiriji*, paper from Jeolla Provinces' Jeonju and Namwon was considered the best tribute paper, which included gapuiji, doryeonji, baekjuji, bubondanjaji, sangjuji, sangpyoji, sehwaji, bubonji, yudunji, jamunji, bubunji, jungpokji, pyojeonji, pyoji and hwayakji. Chungcheong Provinces offered various types of paper. Hwanghae Province provided yudunji; Gangwon Province gave hyuji.

The book *Gyeongdojapji* (京都雜志, *A Record of Seasonal Customs in Seoul*) lists the best types of stationery. Hwangseorangmipil (黃鼠狼尾筆) was the best brush, and seolhwajukcheongji (雪花竹青紙) the best paper. Haejumaeyeonmuk (海州烏煙墨) was regarded as the best ink, and onpuseogyeon (蘊抱烏石硯) was the best ink-stone. Scholars and writers favored seolhwajukcheongji paper owing to its whiteness and refined texture.

The highest quality paper used by ordinary people was reserved for weddings. Once the bride's and groom's families had agreed to the wedding, the

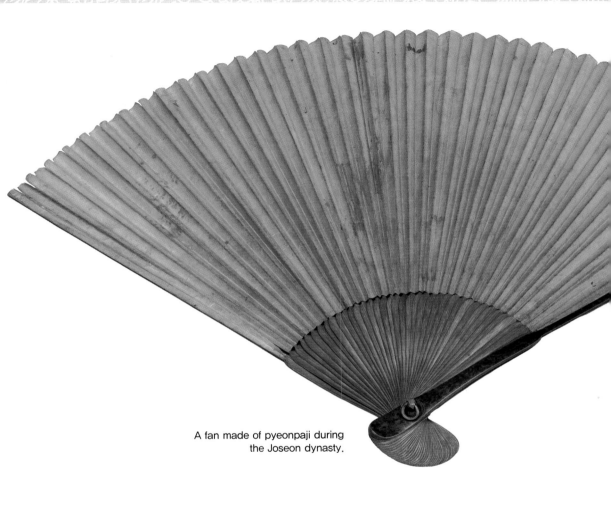

A fan made of pyeonpaji during
the Joseon dynasty.

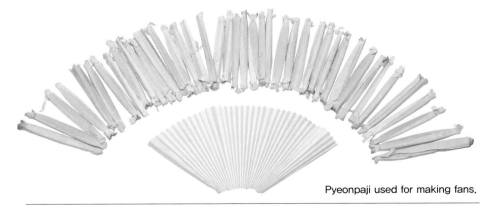

Pyeonpaji used for making fans.

Sajudanja (四柱單子) and honseoji (婚書紙).

groom's would send a letter to the bride's, in which marriage was formally requested (cheonggan). The bride's family would then respond with an acceptance letter (heohonjang). If the groom planned to present the bride with wedding gifts, it was customary to list all of these in the letter, which constituted a promissory note. Accordingly, the best paper was used for this purpose.

Paper used to express sincere condolences (jomunji, 弔問紙) clearly needed to be of good quality. For correspondence, gamji (紺紙) was mostly used, onto which vertical lines were drawn every 2cm-3cm, before wood-printed features depicting nature were added. Mountain, tree and orchid prints proved popular. Jangji (壯紙) was another common paper used for paintings that were hung on doors and walls during the Joseon dynasty. Paper could be

functional as well as decorative: it was not only used for painting and calligraphy, but also for covering a home's windows, walls, and floors. Changhoji was used for covering doors, and was graded based on its thickness (the thinner the better). A thicker type, ondolji, was preferred for floor coverings because its glossy texture reduced the spread of damp, and it could be cleaned easily. Owing to the overall strength of most types of hanji, discarded paper was often salvaged to make small boxes, cigarette packs, suspenders, closets and shoes. According to the book *Byeonuiji*, even clothes were later crafted from recycled paper.

Chracteristics of joseonji

Most types of paper from the early Joseon period were made from a variety of plants. Books made during Sejong's reign used the most types. Fewer plants were used after he was succeeded. Early on in the dynasty, paper production was located near areas where the raw materials were harvested. Therefore, artisans used only what was readily available. Different grades of paper (in terms of quality) were used depending on the publisher and the sector for which it was produced. The state usually acquired the best paper made from the best materials available. The private sector was largely supplied by producers who used the most accessible resources; nevertheless, in the early Joseon period, hibiscus roots were used by most producers in both public and private sectors.

Korean papermaking preserved its traditional methods throughout history, from baekchuji in the Silla dynasty and manji in the Goryeo period, right through to gyeonji and gyeongmyeonji in the Joseon period. Retaining the techniques meant paper quality throughout the periods was fairly consistent, too. In other words, up until the early Joseon dynasty, quality hanji was

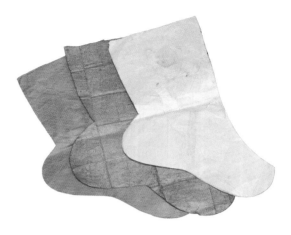

Patterned hanji used for making Korean socks.

robust, thick and glossy. The preference for thicker paper seems to have originated from the fact that most types of Korean paper were made from paper mulberry. The fibrous qualities of the plant dictated the paper's texture and to an extent influenced the evolution of gohaebeop (the traditional Korean papermaking method). Moreover, these thicker types of paper were preferred in China, especially for official documentation.

Another interesting characteristic of early-Joseon paper was that its surface had an irregular grain. This resulted from Joseon artisans beating and then forming hanji in a mould, instead of grinding the paper. This gave it the kind of durability lacking in thinly-ground Chinese stocks. Korean and Japanese artisans tolerated a grain because they understood the paper produced would last longer.

Records of paper produced in the early-Joseon period

Paper produced in the early-Joseon period received as much acclaim as Goryeo's paper. The early period also saw the largest number of hanji books ever produced. A wide variety of paper was produced at this point in history, too. *Jibongyuseol* (芝峰類說, *Comprehensive Encyclopedia*), written by Lee Sugwang, provides evidence that many types of joseonji were produced. The quality of Joseon paper was common knowledge throughout China, and books such as *Myeongjong sillok* (明宗實録, *The Annals of Myeongjong*) and *Yeol-*

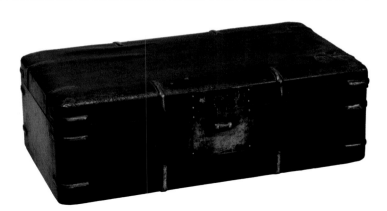

A filing trunk made out of hanji.

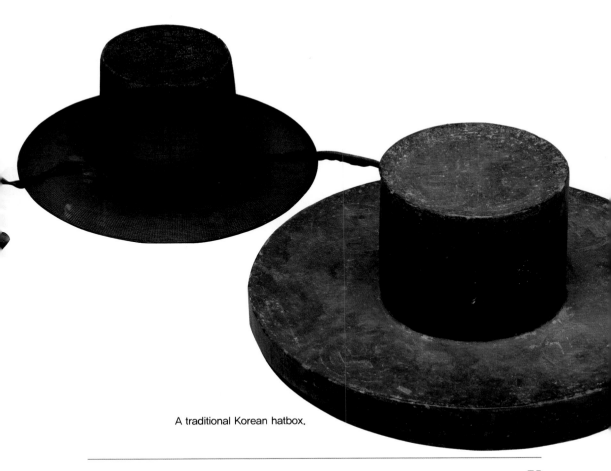

A traditional Korean hatbox.

hailgi highlight the reputation of and praise for joseonji. Chinese records show both joseonji and goryeoji were referred to as gyeonji or myeongyeonji, since they saw no need to make distinctions.

The superiority of Korean paper stems from the unique papermaking methods. These had advantages over Chinese techniques. The Chinese ground bark, cloth, bamboo and grass. The fibers were cut short, and the resulting paper was soft but easily torn. Korean paper was made by repeatedly beating intrinsically strong, long-fibred mulberry. The methods of scooping and fulling were advantageous as well, lending Korean paper a smoothness and brightness, made possible by paper mulberry's ideally long fibers. Hibiscus root dispersant (hibiscus liquid) was added for even more durability and sheen. For these reasons, the Chinese mistakenly thought that Korean paper

Decorative wallpaper.

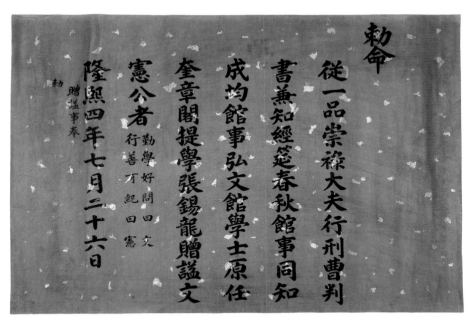

Chikmyeong (勅命), a document detailing the king's directives.

was made from silk. It was only years later that paper mulberry was identified in *Iltongji* (一統志, a book written during the Ming dynasty) as the main ingredient. Simdeokbu (沈德符, from the Ming dynasty) claimed in the book *Bibueoryak* (飛鳬語略) that gongjeon paper (貢牋, also known as gyeongmyeonjeon) from Goryeo was the best quality paper. In addition, Donggichang (1555-1636) favored this type of Goryeo paper for his calligraphy. Part of the painting *Gwansanseoljedogwon* (關山雪霽圖卷, currently on display at National Palace Museum in Taiwan) is painted on Goryeo gyeongmyeonjeon. Other paintings from the Ming and Qing dynasties also used various types of paper from Goryeo, and there are samples of royal correspondence sent from the Joseon dynasty to the Ming and Qing emperors. These samples are thick, comprising between two and four layers. Hwalryeomji (闊簾紙) is the name given to the paper derived from large, regular silk-thread stitching.

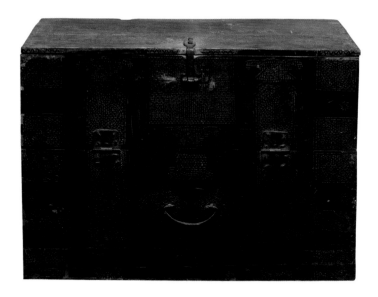

A patterned paper plate used for decorating cabinets.

The late Joseon period

Korean papermaking shrank in the latter years of the Joseon dynasty, notably after the Japanese invasion of Korea (1592-1598). Earlier in the dynasty, paper was highly praised for its quality and longevity dating back to goryeoji's heyday. The government took over papermaking after the reign of Sejo, which led to an increase in production following various mandates. In spite of this, several factors caused the downfall of Korean papermaking. The reasons include an explosion in demand, intense pressure exerted by the Ming and Qing dynasties for tributes, plus several wars. Dwindling paper mulberry stocks forced many artisans to mix in substandard materials such as hay, barley and reed, which reduced quality. A series of wars and extended conflict drained the country's coffers, while the government exploited the artisans by failing to compensate or train them properly. This accelerated the downward spiral. In addition, underlying sociocultural factors contributed to the worsening situation, specifically the high concentration of papermakers based in just three areas (Chungcheong, Jeolla and Gyeongsang Provinces) coupled with the limitations of state-run manufacturing. Cultural facilities were destroyed and the supply of materials from the Ming dynasty was cut off. The artisans scattered as Jojiso crumbled.

The demand for paper tributes became even greater after the Manchu invasion (1636-1637). Various paper tributes (mainly pyojeonji and jamunji)-essential for subservience diplomacy at the time-could not be made fast enough to meet increasing demand. One record describes how the Joseon dynasty was once asked to provide 66,016 gweon (a traditional measurement of paper) of baekmyeonji and 29,984 gweon of hubaekji when the emperor of the Qing dynasty passed away. There is also a record that artisans were forced to use paper mulberry root because of a shortage of materials. This duty on paper

tribute production mostly fell to the temples and peasants in Gyeonsang, Jeolla and Chungcheong Provinces. They were exploited again as local authorities and wealthy local landowners asked the temples and peasantry to produce their paper.

In its bid to bring the situation under control, the government decided to take over the production capacity of the temples, because temples were suitably equipped for the production of Buddhist scripture. They had a rich supply of paper mulberry, and they were located near clean water, which was essential to produce quality paper. Korean Buddhist temples became the surrogate Jojiso after the Japanese invasion. The extent of exploitation is made clear when examining records of the twenty-sixth year of Sukjong's reign (1700), when half the nation's paper was produced by the country's temples. Even local government offices and military officials de-

An envelope.

manded paper from temples on the cheap, or sometimes for nothing. Some monks deserted after cracking under long periods of servitude or poverty. Eventually, even prominent temples such as Tongdo Temple (通度寺) in Yangsan and temples in Mount Myohyang were abandoned. Some temples requested the government acquire them; others sought out favors from royal family members to avoid exploitation from the local government offices. Either way, they still had to pay paper tributes to the region's powerful families.

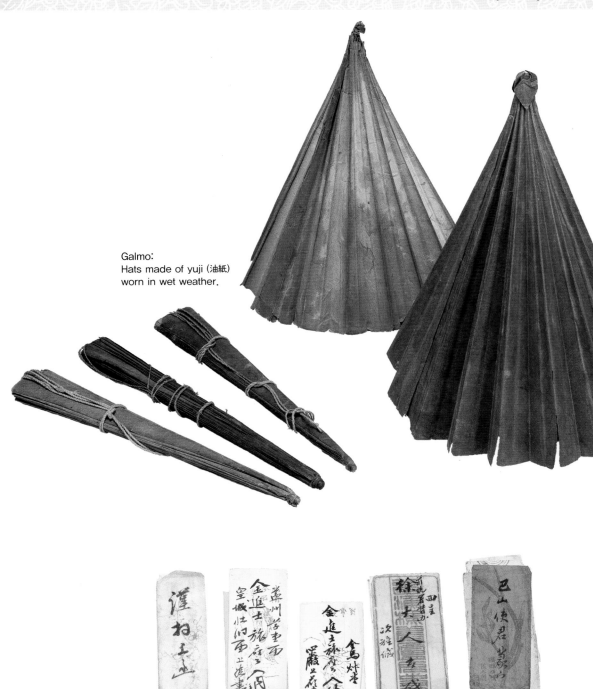

Galmo:
Hats made of yuji (油紙)
worn in wet weather.

Envelopes.

Records of paper in the late Joseon period

Just as ceramics styles changed over time from cheongja (blue) to buncheong (grayish-blue) to baekja (white), so did the types of paper being used. In particular, paper production and other handcrafts diminished by the end of the Joseon dynasty.

On returning to Korea after an extensive tour of China, Park Je-ga (author of *Bukhakui*, 北學議) made a detailed comparison of Chinese and Korean paper, in which he argued that hanji was stronger and more robust, but less suitable for painting and calligraphy. This kind of problem was also pointed out in the book *Seolsuwesa* (雪岫外事) by Lee Hui-gyeong, and in *Yeolhailgi*

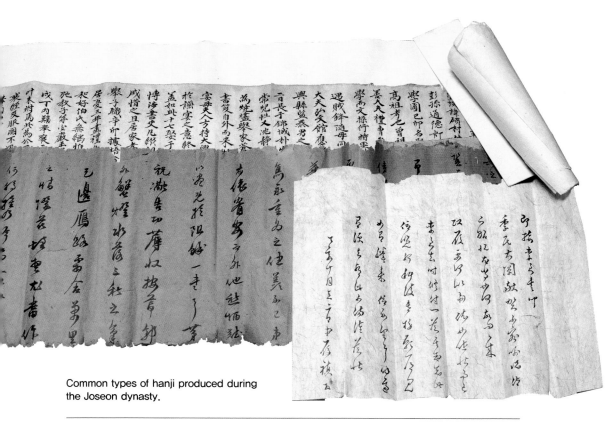

Common types of hanji produced during the Joseon dynasty.

by Park Ji-won. In addition, Jeong Yak-yong talked about the lack of standards and printing-related problems. Lee Yu-won took issue with the quality of the materials available. The Chinese assessed that joseonji was definitely strong and durable, but certainly not delicate enough to be used for painting and calligraphy. The book

A map of eight Korean provinces.

Geumhwagyeongdokgi (金華耕讀記, *Guidelines for Agriculture and Home Economics*) emphasizes how paper in the late-Joseon period was substandard.

People who expressed their reservations about hanji in writing were mostly scholars belonging to Bukhakpa who were advocates of advanced Qing culture. However, when these scholars made their assessments, the country and its handcraft industry were at their lowest respective points following a succession of devastating wars. Therefore, although there is an element of truth to these criticisms, it would be inaccurate and unfair to judge the entire period merely by latter-day Joseon standards.

The modern era

During the power struggle among international powers at the end of the Joseon dynasty, Japan used its geographical advantage to grab Korea first. Records from that time show that Korean paper was considered substandard in quality, in spite of its durability and strength. Facilities were deemed outdated, inefficient and inadequate.

In the nineteenth year of Gojong's reign (1882), Jojiseo, which was in charge of paper production, was removed and all the paperwork relating to paper production was brought under the control of Gongjo (a larger administrative branch that overlooked a wider area of industries). Improved methods and production practices were encouraged there. Growth of the paper mulberry was also encouraged to reduce and stabilize the cost of materials, while cooperatives were established to maintain production organization, and to research plant varieties to improve materials.

Yangji (western paper) was introduced to Korea in the twenty-first year of Gojong's reign in 1884. At the end of the Joseon period, Kim Ok-gyun went to Japan as a member of susinsa (the official delegation) where he bought a facility for making western paper from a Japanese national, Imdeokjwamun (林德左門). Part of it was moved to Hanseong (present-day Seoul).

The main R&D center of the Joseon governor-general, founded in 1912, opened a papermaking department in 1915 to analyze and research materials and various types of paper. They offered practical technical training and had on their staff a number of qualified hanji artisans nurtured through their various training programs. What is notable is that they imported

A hanji factory and its workers during the late Joseon dynasty.

and distributed hibiscus seeds to standardize the dispersant, Japanese-style screen, and papermaking method. In addition, budgets were set aside each year after 1914 to subsidize and encourage the purchase of modern tools such as steel plates and cauldrons. Attempts were made to produce pricey hwaji ostensibly to add value. As a result of these efforts, the production of mulberry bark increased (1915-1921), as did mulberry-planting programs. In an effort to reduce costs, the mix of wood pulp was tried for the first time in the history of hanji. In the mid-1930s, hanji production picked up for the first time under Japanese colonialism, with production centered in Northern Jeolla Province and Gyeongsang Provinces.

Papermaking methods
Papermaking methods underwent significant changes during this time.

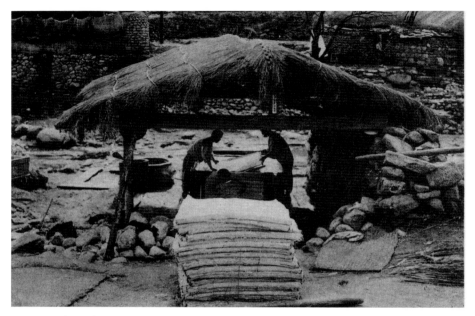

Jangpanji (壯版紙) production near a well in the late 1920s.

To boil and bleach materials, chemicals such as soda ash, caustic soda, and bleaching powder were used. A beater was used instead of a large mallet, and a steel plate was used for drying. Combined, these changes significantly improved productivity and quality. Common varieties of mulberry were commercially grown such as white mulberry and wild paper mulberry. The Korean names of some of them include gujinamu, ganghwasandaknamu, hwataesandaknamu and bakjuinamu. Rice straw was also used. A mucus-like liquid made from elm trees replaced hibiscus as the dispersant. Sap was extracted from elms through planing and tapping techniques.

The production process

The production process that developed and become standardized is still

used today. The papermaking process is as follows:

Peeling → removing dark bark → removing dirt → immersing in water → boiling → washing → bleaching → beating → mixing → stirring → sheet formation → pressing → drying → completion

The method of producing raw materials adopted a collaborative system. Artisans used to make raw materials at a shared workstation, before working on sheet formation and finishing at their own farms. Then later a small number of factories emerged dedicated to making hanji (in contrast to farmer-artisans who made paper on their farms part-time to supplement their incomes), which went on to form the basis of hanji production in the years to come. A system of oversight to examine the quality of hanji was also established around this time.

Types of paper

In 1909, there were about 40 types of hanji. All were made from paper mulberry fiber, apart from gojeonji. The best known are baekji (白紙), jangji (壯紙),

gakji (角紙), hwanji (還紙), ipmoji (笠帽紙), and hwangji (黃紙).

Baekji was a generic term referring to thin paper, and included types such as changhoji (窓戶紙), sagoji (四庫紙), yusamji (油衫紙), taemibunji (苔美紛紙), san-naeji (山內紙), wansanji (完山紙), gapyeongji (加平紙), and gyeonyangji (見樣紙). These were mainly produced in Jeolla Provinces, Gyeongsang Provinces, and Gyeonggi Province. Jangi was similar to baekji, albeit slightly thicker. It included types such as taejangji (苔壯紙), yeongchangji (映窓紙), daejangji (大壯紙), nong-seonji (籠扇紙), ipmoji (笠帽紙), seohuji (書厚紙), uijangji (外匠紙), hyejungjangji, and sijeonji (詩箋紙). Gakji was used to refer to thick and more durable types of paper, mostly made using more than two layers of paper. Types included sobyeolji, daegakji (大角紙), and jamunji (咨文紙), which were mostly made in or around Seoul. Hwanji is a contraction of "hwanhonji (還混紙)", and it refers to types of recycled paper. These types of paper were used as the first layer to put on walls or ondol-traditional Korean floors. Ipmoji was used for Korean traditional hat made mainly of reed. Hwangji was rare, and it was made us-

Workers peeling bark from mulberry.

ing strong oat stem in Hamgyeong Province. It had a yellow tint, and the surface was stiffer compared with other types of paper, but it was resilient to insects. Paper was commonly dyed in Amur cork tree sap to prevent damage caused by insects. It also produced a yellow hue. Other colors available included jade green, pink, green, blue, and navy blue; other types included acheongji (鴉靑紙), hongpaeji (紅牌紙) and bundangji (粉唐紙).

Hanji sizes

More than half of hanji available at the time was large, and much was over a meter long. The longest was yeongchangji (映窓紙, 1.64m long) and the widest was daegakji (大角紙, up to 1.21m wide). Huji, comprising nine types of paper, referred to paper whose basis weight exceeded 100g/m². Among the nine, the heaviest was jamunji, which weighed 491g/m². There were eight types of paper whose basis weight was less than 36g/m². The thinnest type was

Paper drying on wooden boards.

sagoji (18.2g/m²). Paper from Jeolla Provinces accounted for more than half of the types. The four types of paper from Seoul were large and over a meter long. The most expensive of all was taejangji (苔壯紙) from Jeolla Provinces owing to its quality, even though it was small. However, no samples remain. Other types were regarded as superior and awarded a special status (e.g. hae-jungjangji, sannaeji, wansanji and gapyeongji). The consensus is that there were unwritten conventions regarding standards of quality, and purchases were based on confidence and trust.

Recognition and appreciation of hanji

Machines and chemicals replaced natural materials and labor-intensive processes with the advent of hanji factories. Traditional hanji had originally been produced by hand, but had since become unproductive and expensive. Conversely, yangji exploited machine-driven processes and their inherent cost efficiencies. Therefore, yangji gained popularity because of its price and quality, becoming widely used for painting and calligraphy. Hanji was not only more expensive, but it was also inferior in quality because of the shortage of paper mulberry in Korea. Yangji steadily spread until it had largely replaced hanji. Timescales shortened and costs fell because of the introduction of machines and industrial additives, but many of hanji's original qualities were lost.

Over in China, hanji had become an everyday essential thanks to goryeo-ji's popularity. Even at the end of the nineteenth century, 300,000geun (a traditional measurement of weight; 1geun = 600g) of hanji was exported to China each year. But as the twentieth century began, cheaper copies of hanji appeared that sent shockwaves through the more expensive hanji market.

The Japanese introduced paper that suited their lifestyles and tastes after annexing Korea. Alongside imports of Japanese paper that suited Japanese painting styles, efforts were made to tailor hanji to meet the tastes of Japanese patrons. The most representative of these efforts was hwaseonji, which is still widely used in Korea. Hwaseonji was made by copying Chinese seonji, developed by the Japanese, and produced in Korea. Eventually, the Korean papermaking culture gradually dwindled, leaving only a few types of hanji remaining, including changhoji, jangpanji, jangji, and taeji.

Saekji (色紙) used for correspondence.

司宣氣體伏若何伏慕區區不任下

伏不審仲秋

誠小人無撥赴任眠食粗保私幸

何遑除萬不備伏惟

下鑑上書

壬寅八月十三日公州

The present day

The fifty years following Korea's liberation from Japan (1945) saw the hanji industry in Korea wane then disappear. This was brought about by a number of political and economic factors, and by the subsequent social unrest that occurred after independence. It was fuelled by the Korean War and a coup and followed by policies that gave priority to industry over agriculture. Regional cooperatives collapsed as a result of government centralization during the military regime. These were the last nails to be hammered into the hanji industry's coffin.

One adverse effect of the government's ongoing industrialization policy was that agricultural communities could only produce hanji during the off-season as a part-time job to supplement farmers' incomes. Changes in traditional architecture and housing also dramatically reduced demand for the remaining types of hanji, changhoji and jangpanji, which had been used for windows and floors in traditional housing. Nowadays attracting, training and securing a workforce of paper artisans is difficult since papermaking is such an arduous job. Hanji is now mostly a cottage industry, although management is made more difficult by the fact that it is deemed an unproductive, expensive and environmentally unfriendly industry. Paper mulberry remains the main raw material, with which recycled paper may be mixed. For now, even paper mulberry (the key raw material) is imported because mulberry orchards are now much scarcer.

Most producers are centered in Northern Jeolla Province and Gyeongsang Provinces. The best-known types include sunji, hwaseonji, changhoji,

chaekji, piji, unyongji, baejeobji, saekji, jangpanji, chobaeji, byeokji, soji, do-beonji, and panhwaji. The paper currently produced is indiscernible in terms of type or origin of production. However, if you have to point out regional differences, Gyeonggi Province and Gangwon Province mainly produce sunji, using Korean paper mulberry; in Northern Chungcheong Province and Northern Gyeongsang Province, more types of paper are produced. In Southern Gyeongsang Province, with Uiryeong as a center, changhoji (made using a single mould) is the main product. Jeonju (in Northern Jeolla Province) has traditionally been the main supplier of hwaseonji. Factories in operation mostly produce changhoji and jangpanji, although other products include colored hanji, soji, sunji, hwaseonji, pojangji and ingyeonji. These types of paper are mostly cheap products, not high-quality or high value-added

A machine used in western papermaking.

ones. The single-mould method, which was once a standard technique in traditional Korean papermaking, is now rare, having been superseded by the double-mould. Double moulds are most commonly used in Northern Jeolla Province, but are also common in Gyeongsang Provinces. It is notable that the single-mould method is particularly popular in Uiryeong (Southern Gyeongsang Province), where changhoji and jangpanji are produced.

Today, a lack of proper recognition or appreciation by consumers of hanji products, exploitation by middlemen, and faltering negotiations between producers and sellers over price all contribute to the decline of small hanji producers. Due to distribution-channel problems, prices of the products cannot be guaranteed. Even where good quality hanji is made, the distribution channel will always raise questions and have nagging doubts. The current market situation for handmade or machine-made hanji is dire: it is being sold without standards or labeling that would enhance and promote decent production methods and product quality. The public is largely unaware of the problems, and makes purchases without realizing differences in quality. This has led to a decline in hanji making, which nowadays focuses on producing more paper more quickly as cheaply as possible. High-quality hanji is a rarity these days. Cheaper imported paper mulberry and pulp are now being used instead of far pricier Korean paper mulberry. To avoid labor-intensive methods, toxic chemicals such as caustic soda and sub-chloride bleach are commonly used. The single-mould method has also been replaced by the double mould.

III

Papermaking

Making hanji
Western papermaking
A comparison of hanji and western paper
Comparing Korean, Chinese and Japanese paper

Making hanji

The main materials used in hanji

Paper mulberry (*Broussonetia papyrifera*) bast fiber is the main raw material used for making hanji. It belongs to the *Moraceae* family of mulberries, two varieties of which are indigenous to Korea. These are known in Korea as daknamu and gujinamu (*namu* translates as "tree"). Little distinction has been made between the two and crossbreeding is commonplace.

The hardy Korean paper mulberry seems undaunted by the peninsula's climatic extremes (sizzling summers and bitter winters). In fact, the species flourishes in Korea thanks to the country's mineral-rich sandy valleys. As a result, Korean growers normally reap higher yields than farmers based in Thailand and subtropical China. Wild paper mulberry (sandaknamu) and oriental paper bush (samjidaknamu) are two additional species native to Japan that have been imported and are used for papermaking in Korea.

Different papermaking materials have gained favor at different points in history. Hemp and paper mulberry were both popular early on; however, paper mulberry became the primary source from the mid-seventh century to the end of the Goryeo dynasty. During the Joseon dynasty the demand for paper skyrocketed with the publishing boom. Therefore, other materials were used in order to satisfy demand for paper, including oriental paperbush, wild paper mulberry, hemp, white mulberry, rice straw and reed. The adoption of alternative materials also helped to reduce production costs, and many more people were able to use paper. During the reign of Taejong, the first national jejiso was established to regulate the production of paper.

This underlines how important papermaking was considered at the time. Its role diminished after the reign of King Yeonsan Gun. It deteriorated much further as a result of *Imjinwaeran*, the Japanese invasion of Korea. Afterward, only one or two papermaking materials remained available. In the late-Joseon dynasty, traditional hanji-making began to disappear, to be replaced by hwaseonji and yangji. Today papermakers rely on Chinese and Thai paper mulberry, Manila hemp, used paper and cotton instead of traditional Korean paper mulberry (mainly because of cost and supply limitations). Nonetheless, Koreans have traditionally used a wide range of materials for making hanji, illustrated by the paper used in early Joseon books and in surviving hanji samples. Some academics have overlooked the fact that paper mulberry was not the only material available in Korea for making hanji.

Paper mulberry (daknamu / chamdaknamu)

Paper mulberry, a deciduous shrub belonging to the Moraceae family of mulberries, is indigenous throughout Korea. It grows to a height of 3m. Its small branches are brown with a purplish tint. As a sapling, its bark is covered in a protective layer of very fine hair, which gradually disappears as the plant matures. Its oval leaves are 5cm-20cm long and have serrated margins. It is particularly abundant in Gyeongsang Provinces and Jeolla Provinces, and the beaches of Southern Chungcheong Province. Gangwon Province and Northern Chungcheong Province are known to produce the best quality paper mulberry bark. Paper mulberry generally grows in soils where gneiss or granite deposits satisfy all its nutritional requirements. Paper mulberry is often planted on ridges and roadsides where other plants struggle to survive. Successful growers space plants evenly and regularly in order to prevent soil erosion, especially where gradients are steep. It is harvested an-

Paper mulberry.

nually in late autumn just after the crop has lost its leaves.

Paper mulberry (gujinamu)

Gujinamu, a larger variety of paper mulberry, is a deciduous tree that grows 5m-10m in height and up to 60cm in diameter. It is indigenous to many parts of Korea, but is most common on Ulleungdo. Similar varieties are native to China, Japan, Taiwan, India and Malaysia. The Korean name derives from its serrated margins (*guji* translates as "weave"). Its fibers are long and strong, which made it the material of choice for flooring in many regions.

Wild paper mulberry (sandaknamu)

Wild paper mulberry is a deciduous shrub that belongs to the Daphne family. It grows to 1.5m in height. It is most abundant in Japan but is also common in Ganghwado, Jindo, Namhaedo and Jinhae in Korea. It flourishes in deep valleys or in the shade of larger trees, preferring wet or secluded environments. The Sandaknamu crotch normally sprouts many branches and sprays. These sprays are bare and dark brown. Leaves are small and pleasant to touch, and small brown flowers blossom at the height of summer in late July. This species prefers shaded areas even after being transplanted, which makes it a firm favorite with gardeners. Its seeds can be collected in October, buried in the ground in January, and planted in the spring. The dense root systems are lighter brown than the dark brown bark. It is favored as a source material to make fine quality products, such as official documents, maps and dictionaries because of its durability and strength.

Oriental paper bush (samjidaknamu)

Oriental paper bush is a deciduous broadleaf shrub that originated in China

Oriental paper bush.

and reaches 2m in height. It is grown throughout the southern climes of Jeju Province, Southern Jeolla Province and Southern Gyeongsang Province in Korea because it struggles to survive the bitter winters commonly encountered in central regions of Korea. It mostly grows on the outskirts of oak forests or in deep and fertile soils. It grows best in moist, shaded areas, and does not survive long in dry conditions. It is a fast-growing plant, developing a three-branched bough. The hairy bark has a distinctive grayish-green hue. Leaves grow 8cm-15cm long by 2cm-4cm wide; backs of leaves are white and stalks are 5mm-8mm long. Its dangling brownish flowers bloom in March and small oval nuts ripen in July. The shrub's fibers are used for making top-quality paper, bills, stocks, maps, dictionaries and stencil paper. The species grows best in southern climes, and many gardeners plant it because of the wonderful flowers it produces. Seeds are collected in July, dried in the autumn, stored during the winter, and planted the following spring.

Wild mulberry (sanbongnamu)

Wild mulberry is indigenous to Japan, China, Taiwan, and the Himalayas. In Korea it is found around Mount Jiri. Its leaves are used for feeding silkworms, and the bark is the main ingredient for making yellow dye and hanji. The Chinese started using this and hemp during the Wei and Jin dynasties between the third and fifth centuries AD. Wild mulberry and hemp were considered key papermaking materials in settlements dotting the Silk Road. Paper made from wild mulberry is comparable in quality to that made from paper mulberry. It was therefore chosen when making paper for printing and painting during the Tang and Song dynasties.

For papermaking purposes, any species of mulberry can be treated in one of two ways: it should be either steamed and stripped of its bark or simply stripped of its bark. If steaming and stripping is the method of choice, trees should be harvested in February and March. Without steaming, the trees should be harvested later in the spring. Mulberry collected in the spring is most suitable for making paper. Most mulberry species have thinner, longer, and narrower bark fibers than the paper mulberry. They also yield less and are more difficult to bleach. These factors have made mulberry less popular among growers, which has had an adverse effect on supply.

Hemp

Bast fibers from hemp and ramie have been used since ancient times as papermaking materials. In China, Tang dynasty hemp was one of the main materials for papermaking. In Japan, it was used until the Heian period, only to be adopted again recently. In Korea, hemp fiber (apka) is imported from the Philippines to make hanji.

Secondary materials

Although plant liquids alone were originally used to help distribute materials evenly during the hanji-making process, industrial additives are now used. However, producers are increasingly turning to hibiscus liquid as a decent alternative as they realize its benefits when used as a formation liquid in the papermaking process. Koreans call the hibiscus root *dakpul*, which roughly translates as "paper mulberry glue." The name derives from its use as an organic dispersant when making paper with the dak-paper mulberry.

Hibiscus manihot (also known as hibiscus) is an herbaceous annual belonging to the mallow family *Malvaceae*. There are three species indigenous to Korea, which are harvested between October and November before the first frosts. It grows to a height of 1m-1.5m and has between five and nine

Hibiscus in flower.

Hibiscus.

alternate leaves (ovate or lanceolate; serrated or lobed). The large, trumpet-shaped flowers bloom from August to September. Colors are white, pink or brown. The root is renowned for its succulence and cultivated for papermaking dispersant. Hibiscus prefers sandy soil because it provides suitable drainage. The plant thrives in rich soil, in which case it requires pollarding or pruning. Alternatively, picking the leaves, flowers and buds in July and August can inhibit growth. As a dispersant, hibiscus liquid prevents the long fibers of paper mulberry from becoming entangled. This makes it a very important plant in the eyes of paper producers, second only to the paper mulberry.

Major functions of hibiscus liquid

•Facilitates the paper-formation process

Paper mulberry's long fibers tend to form a rough surface. Without using hibiscus liquid, the fibers would become entangled, which would produce a spotted and uneven surface. Adding it distributes the fibers evenly and provides the mould optimal drainage. This enables papermakers to produce thin, durable and fine-quality paper using long fibers. Another benefit is that hibiscus liquid gradually loses viscosity during the process, which helps filter out more impurities to produce better paper.

•Promotes consistent thickness

The rate of drainage through the mould determines the paper's thickness, which is influenced by the volume of hibiscus liquid applied to the mould. Papermakers can monitor this rate, gauge the amount of liquid required, add more when necessary, and therefore produce paper of the desired thickness.

Hibiscus liquid being extracted.

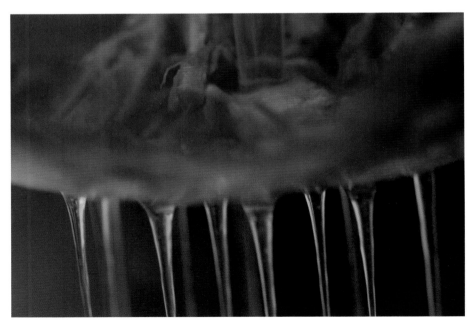

Extracted hibiscus root liquid.

• Stiffens and strengthens the paper

Hibiscus liquid stiffens paper and increases its strength. Using less softens the paper; using more helps the mould to drain. The stiffness and strength of paper can be increased when the mould is shaken carefully.

• Helps paper separate

Hibiscus liquid makes it much easier for producers to separate layers.

• Prevents fibers from sinking

When the paper stock is placed in a vat and stirred, it tends to disperse, condense, and then sink to the bottom. This is the main obstacle in the production of quality paper. Adding a small quantity of hibiscus liquid rectifies the problem. The liquid loses its viscosity when the temperature rises, which is irreversible. Hot summer nights cause some of the biggest headaches for producers because the ceaseless heat can render a batch useless by morning. To compensate, papermakers use twice as much hibiscus liquid in midsummer as they do in midwinter. Experienced producers ensure that their batches are stored in a cool, well-ventilated room. Given that the liquid loses its viscosity after being diluted with water, it should be used as quickly as possible. Stirring also reduces viscosity, but to a lesser extent than other factors, such as the type or condition of hibiscus liquid.

Storage

In the past, the roots of hibiscus were harvested, tied with straw, dried under eaves, and used whenever necessary. Modern preservation methods differ considerably. Hibiscus is sold in 30kg-38kg bundles, and concrete warehouses are designed and constructed specifically for the purpose of storing

them. Sometimes bundles are frozen; alternatively, they are chemically preserved. The chemicals used for the preservation of hibiscus roots are as follows:

Name	Concentration	Amount (per liter of water)	Amount (per kilo of roots)
Copper sulfate (CuSO₄ · 5H₂O)	0.27%	2.7g	18ℓ
Cresol solution	33 times	30cc	18ℓ
Chloro-cresol	200 times	5cc	18ℓ
formalin	50 times	20cc	18ℓ
PCP-Na	0.4%	4g	18ℓ

The following precautions should be taken when using hibiscus liquid:

1. It should be stored at a cool, constant temperature. This makes underground storage a suitable and popular option.

2. The roots should always be sufficiently submerged in the storage liquid. A preferred storage liquid is formalin.

3. Storage liquid should be prepared in advance, diluted and stirred properly before adding the hibiscus roots.

4. Hibiscus roots should not be handled with metal tools during any part of the process.

To extract liquid from the stored hibiscus roots, the first step in the process is to beat the roots on a stone or wooden plate. Then place the roots in a jar or a pot, soak the roots with water, and then repeatedly knead and wash the roots with a wooden tool (similar to the kind used for washing clothes by hand). Excess liquid is collected in a cotton cloth and put in a separate pot. A decent filter cloth is necessary because cheaper, rougher cloths will invari-

ably let through more impurities and therefore compromise quality.

Hanji production tools

Sheet former (vat)

Traditional vats used in papermaking were made out of pine lumber. These were assembled using tight-fitting interlocking joints and grooves and wooden nails (instead of iron ones). This specialized carpentry prevented vats from leaking even after cracking. Vat sizes vary depending on the size of paper to be made. Traditional vats measured 5ja × 8ja (1.5m × 2.4m); single moulds typically measured 3ja2chi × 2ja2chi (Ja and chi are traditional measurements of length. 1ja = 30.3cm; 1chi = 3cm).

Single-mould and jangpanji vats differ slightly. Double-mould vats vary based on the size of paper used. Nowadays, wooden vats have been replaced with concrete, stainless steel and PVC types. Sizes also vary, depending on the type of paper being produced and the size required. Professionals always incorporate margins too. Typical sizes are 1.5m-2m long × 2m-3m wide × 0.7m-0.9m thick. When using a single mould, a support is place in front of the vat so that the operator can work standing up. Two pieces of lumber are placed either side of the container; one of these is adjusted by the operator so that it works as a drainage and sheet-separation device.

Beating stone

This is a plate on which raw paper mulberry bark is placed and repeatedly beaten. Stones found near streams or outdoors can be used, while the Japanese prefer to use wooden plates only.

A beating stone and beating rod beside a stream.

Beating rod

This is a type of mallet used for beating paper mulberry bark. It is made out of meokgamnamu (pine) owing to its lightness.

Debarking knife

This knife is used for peeling paper mulberry bark. Each region in Korea has different materials for making debarking knives, as well as a unique technique. For example, only one side of the knife is used in Jeonju, while both sides are used in Uiryeong.

Wrapper

This is a type of wrapper on to which boiled paper mulberry bark is placed before being washed. A soft hemp cloth was traditionally favored; nowadays

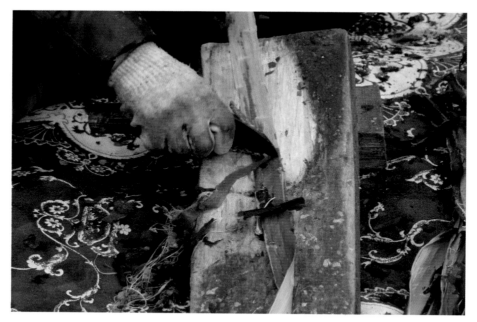

A peeling knife is used for scraping off mulberry bark.

mosquito nets or fishing nets suffice.

Mixing rod

This rod is used for stirring mulberry bark to ensure a consistent mix. It is also the tool used for mixing in hibiscus liquid.

Spacer

Reeds, sedge, cotton or straw were traditionally placed between paper layers to make paper separation easier afterward. Nowadays producers use plastic-net spacers instead.

Seperating stick

This is the main tool used for separating sheets of paper. It was traditionally

made out of young bamboo sticks or paper mulberry. Today plastic sticks (PVC) are often used.

Mixing stick

This is the stick used for mixing hibiscus liquid and mulberry material in a papermaking vat. Two operators stand at opposite corners of the vat stirring the paper stock while facing each other. This activity is known as *palgaechinda*, literally "going wild".

Stacking plate

This plate is used for placing sheets of paper in piles after they have been taken out of the mould. The plate is ideally larger than the sheets being produced in order to help drainage. Moist Sheets need to be moved and pressed elsewhere, so the plate rests on wheels for portability. Typical traditional sizes: daebal (0.8m × 1.4m); gukjeonjibal (1m × 1.8m) wooden plates.

Drying chamber

Jibang is the Korean name given to the drying chamber. The floors and walls were usually covered with paper. Typical dimensions were one "kan" (6ja × 6ja/1.8m × 1.8m). The paper dried in a jibang is called ondolji.

Filtering sack

This is the cotton sack used for filtering hibiscus or elm tree liquids.

Digester

This huge pot is used for boiling and bleaching paper mulberry bark using caustic soda. Dimensions vary depending on the amount of paper mul-

berry being bleached, although a typical example would have the following dimensions: 1.63m long × 0.63m wide × and 0.59m tall. The pot is positioned below ground level to minimize heat loss. Half of the pot is used at one time. Many factories use 100geun (60kg) pots.

Beater

A beater is used for crushing paper mulberry bark after it has been bleached and washed. There are two types: the first is a knife beater with a rotating blade. The other is called a maru beater (Holland beater) with a rotating sawtooth blade. Motorized beaters are now used. Knife beaters could easily cut

A digester.

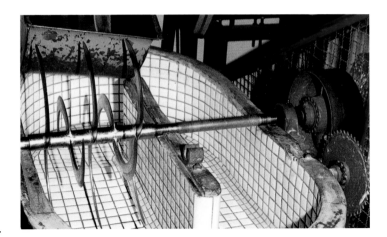

A knife beater.

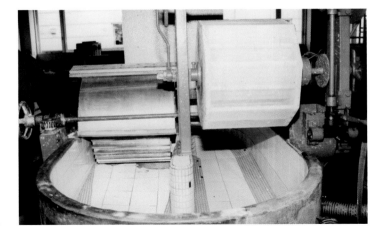

A Holland beater.

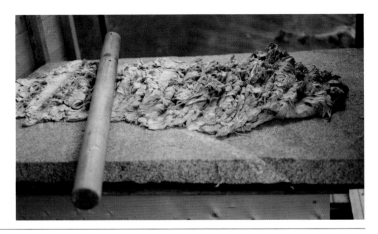

A rod used for
beating bark.

or damage fibers, so a mallet beater was introduced that could be rotated through 360°.

Compressor

Paper formed and removed from a papermaking vat contains a lot of moisture. It dries slowly and tears easily. The compressor squeezes excess moisture out of the paper. In the past, heavy objects such as stones or lumber were used in order to facilitate the process. These days a hydraulic compressor or lever is used. Proper compression also makes paper separation much easier.

Dryer

After the majority of the moisture is squeezed out of the paper using the

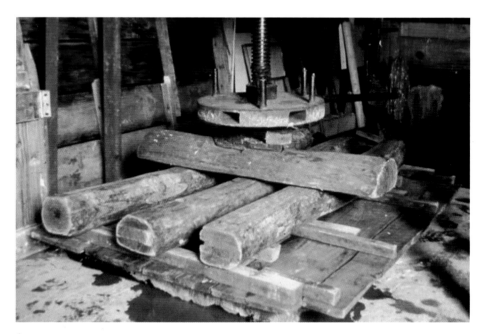

A compressor.

compressor, a dryer completes the process. Paper was traditionally dried using sunlight, wooden plates or by placing it in a jibang (a drying room). Nowadays, steam-iron plates are used. Special care needs to be taken to ensure that the paper doesn't dry too quickly. If this happens, the paper will either become too stiff or create rust stains through oxidization. For this reason, plates are made of stainless steel.

Vat

This is a type of vat into which macerated paper mulberry fiber is poured and mixed thoroughly.

Bucket

This bucket is used for collecting the macerated paper stock after it has been

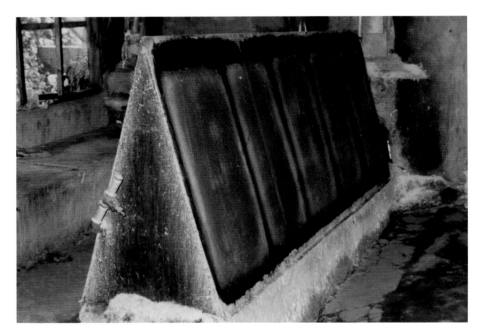

An iron dryer.

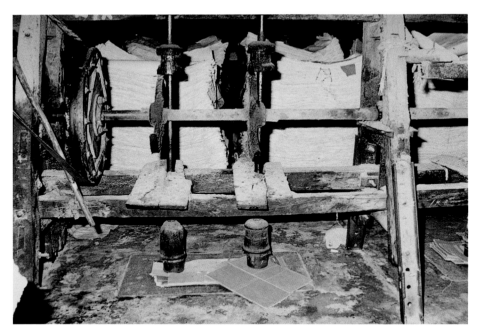

A traditional calendar used for making jangpanji (壯版紙).

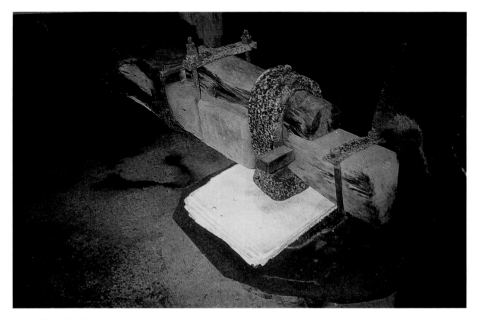

A traditional calendar.

beaten. It is made of stainless steel and features drainage holes.

Calender

This hammer was traditionally used for treating the surface of paper. Wooden roller-style calenders and treadmill-style calendars were used for making paper more compact. Modern machine hammers are used for making jangpanji nowadays.

Mould

There are three types: a single mould, a jangpanji mould, and double mould. Producers use specific types according to the paper production method, mould shape and frame shape, and mould-design characteristics.

• Oibal (the single mould)

The oibal is reserved for paper of a certain sizes: changhoji (3ja2chi × 2ja) and chaegji (2ja2chi × 1ja5chi) are examples. Single-mould sizes can be adjusted to suit specific jobs. Sububeop (手浮法) is used for forming paper with a single mould, and its characteristics are determined by the movement of water.

• Jangpanjibal (the jangpanji mould)

The jangpanji mould has a thicker, stronger frame than other types. It also has a distinctive shape. Unlike most other paper types, jangpanji requires a team of two people to produce it. The mould measures 3ja8chi × 4ja2chi, and the frame is made by stripping lengths of bamboo from the center and tying them along the length toward the far ends. Jangpanji moulds are no longer used for paper production.

• Ssangbal (the double mould)

Double moulds come in a wide variety of sizes. Some exceed 100ho. Paper is produced in an entirely different way to that produced using the single mould: the double-mould frame enables producers to make single sheets of paper of various thicknesses. Furthermore, this type of mould is easier to control, which makes it more economical. However, paper made with a double mould is weaker than that made with a single mould. The consensus is that the double mould was first introduced to Korea in Jeonju during the Japanese occupation. Nowadays, it is commonly used in traditional Japanese papermaking, which is understandable given that the method originated there. In Korea, most moulds and their frames are still manufactured in Jeonju and distributed nationwide, although harvesting, preparing, and threading of bamboo sticks is carried out elsewhere beforehand.

A mould frame.

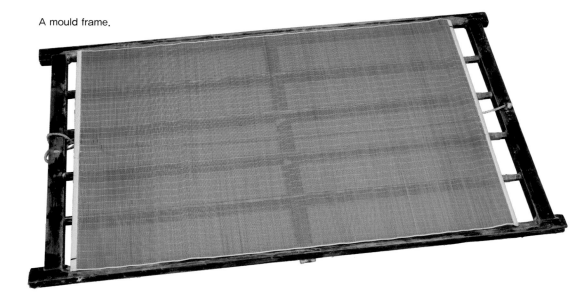

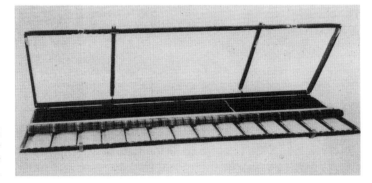

A single mould
and mould frame
used during the
Joseon dynasty.

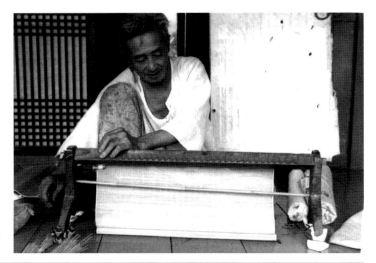

An artisan making
a single mould.

Single-mould production methods

The single mould is made out of bamboo. It takes about a week to construct a mould designed to produce changhoji (a fine paper for calligraphers, measuring 3ja2chi × 2ja). Sticks of bamboo are selected, harvested and split into the thinnest workable lengths. This process is especially challenging given that each part of this arduous, tedious work is done manually. The sticks are soaked in water, have their tips rounded by hand, and are then woven tighty together with cotton thread that has been dyed in a nonporous persimmon solution. Very few producers make single moulds in this way nowadays. Those who do are based in Sangchaek, Habcheon in Southern Gyeongsang Province.

Tools for making moulds

Mould sticks, knife, saw, etc.

Bamboo mould sticks (bamboo split into the thinnest workable lengths) vary in width and roundness: the more delicate the paper needed, the rounder and thinner the bamboo sticks should be. They are treated with a protective coating.

Thread for tying mould sticks (choksa)

The thread for tying mould sticks was traditionally dyed in a persimmon solution. This prevented it from rotting after coming into contact with water. Nowadays nylon thread is used.

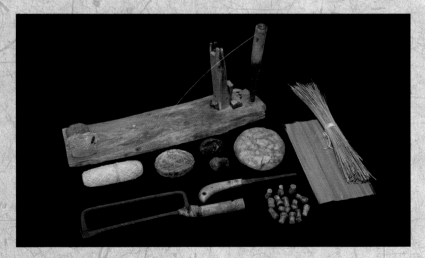

Tools used for making moulds.

Manufacturing moulds

Moulds are made from August to the following April (according to the lunar calendar). The mould sticks are placed on a wheeled mould frame and threaded together. They are then snipped to the required length. A unique set of tools and know-how is essential to ensure sticks have a consistent length, diameter and shape. The Korean terms "making a mould" and "tying a mould" are interchangeable in some parts of Korea. The thread used for tying sticks is called *choksa*. It can be dyed and treated in a persimmon solution, or can be treated in some other way. Today nylon has replaced cotton as the main material for threading.

The mould sticks for a jangpanji mould are thicker and packed together less densely. It is estimated that you would need to work 12 hours a day for 30 days to make a jangpanji mould measuring 4ja8chi × 9ja4chi. Each thread is a distance of 5 pun-6 pun apart from the next (Pun is a traditional measurement of length. 1 pun = 0.3cm). Paper made with traditional moulds has a slight dent where the mould's thread and bamboo sticks or mesh came into contact with it. This lends the final product authenticity. Some modern machines reproduce these indentations, stamping traditional patterns on the paper.

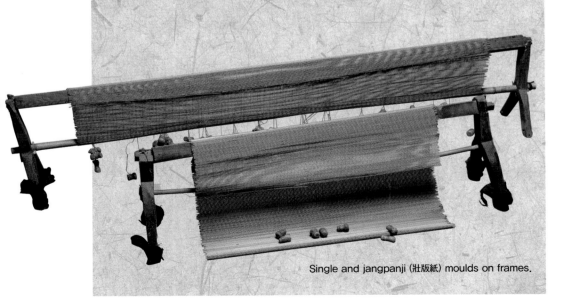

Single and jangpanji (壯版紙) moulds on frames.

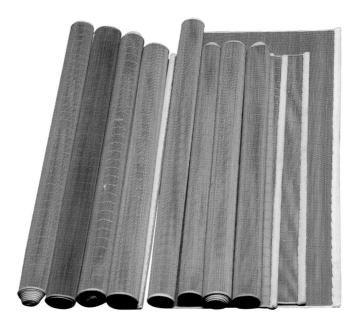

Single moulds of various sizes.

Draining rod

This round drainage frame is used for draining paper that has just formed and been removed from the mould.

Brush

This tool is used for placing paper on the dryer. Synthetic materials have replaced the soft branches, sorghum stocks, or horsehair originally used.

Types of hanji

There are many types of hanji, but they can be broadly classified into either saengji or sukji. Saengji refers to hanji that has been dried but not treated; sukji refers to treated saengji. Because it has not been treated, saengji is

quite tough and has a rough surface. Its uneven and irregular fibers cannot absorb moisture or ink evenly. Sukji, on the other hand, is made by beating or "treading" the saengji. The paper is soaked, dyed, or bleached before hammering, depending on specific requirements and paper usage. Bleaching paper by sunlight is an effective method to protect paper from deteriorating or discoloring. The bleached paper fades from its original yellow to white and becomes sleeker and more even. This process involves repeatedly dampening paper, hammering it, and drying it in the sun.

During the Joseon dynasty, hanji was classified according to raw material, color, size, length, thickness, appearance and usage. These days hanji is categorized as follows:

Hanji is first categorized in terms of its usage. Changhoji, chobaeji, dobaeji, hwaseonji, jangji, sunji, pyoguji (baejeopji), jangpanji, pojangji, unyongji, yocheolji, panjiyongji, chaegji, munyangji, and saekji are examples. Changhoji was used for covering windows, chobaeji for making lining paper, and hwaseonji for painting and calligraphy. Jangji refers to paper produced in Jeolla Provinces. This type was thick, large and used mainly for painting. Sunji is particularly thin and is made from 100% paper mulberry. Pyoguji (baejeopji) was developed and introduced recently, a second-rate paper that lacks quality because it is made from blended pulps instead of from 100% paper mulberry. Jangpanji is used for flooring. It is machine-made from 90% imported materials. Yocheolji first appeared in the late 1970s. Its name translates as "concave and convex".

The second categorization is based on size. Changhoji, chobaeji, hwaseonji, sunji and jangji are examples. Changhoji can be subcategorized into daebalji (2ja2chi × 3ja3chi) or jungbalji (1ja9chi × 3ja2chi); chobaeji can be subcategorized into daechobaeji (1ja9chi × 3ja2chi), jungchobaeji (1ja7chi × 2ja7chi),

and sochobaeji (1.5ja × 2.5ja). However, sochobaeji is rarely used nowadays. Hwaseonji and sunji come in various sizes, even though daehwaseonji (gukjeonji) (1.8m × 1m), standard hwaseonji (1.3m × 0.7m) and sohwaseonji (1.2m × 0.65m) are more common. The sizes previously mentioned refer to the sizes of mould frames, which correlate to respective hwaseonji sizes. Jangji can be divided into 100 hoji (1.3m × 1.6m), 120 hoji (1.4m × 1.7m), 150 hoji and 200 hoji. Each type is classified by size, but most are used for painting (Ho/hoji is a unit for indicating the size of a painting.).

Third, hanji can be classified depending on the additives used in the production process. Taeji, saekji, unyongji, piji and dakji are examples. Taeji is paper with moss mixed in. It is used for decorating traditional folding screens or house interiors. Saekji is dyed hanji. Unyongji is colored paper made from mulberry. Piji and dakji are types of plain paper mixed with mulberry bark.

A fourth category is based on the paper's thickness. Hotji, ihapji, samhapji, and yukhapji are examples. *Momme*, a Japanese weight measurement, is sometimes used when classifying paper (1 momme = 6don/3.75kg).

Making traditional hanji

Hanji used to be called *baekji* (百紙), which literally translates as "one hundred paper". In previous centuries it was thought that a hundred people were involved in the entire production process (harvesting, steaming, boiling, drying, peeling, mixing and forming). Hanji production is a nine-step process: Preparing raw materials → boiling → washing → bleaching → beating (gohae) → forming sheets → draining → beating/hammering (dochim) → pressing

Preparing the Main Materials

Preparing the main materials follows four steps: Harvesting → boiling (dak-muji) → peeling bark (heukpi/baekpi) → soaking

• Harvesting

The main material used for producing hanji is paper mulberry. A year-old paper mulberry tree is harvested from November to February. This is when paper mulberry contains the richest fibers and the right amount of moisture (50%). *Maenaji* (literally "young paper mulberry") is used because its fibers are thin and soft. This makes it easier for producers to form sheets. Older paper mulberry harvested later than February usually contains tougher fibers and produces a lot of lint. This makes it difficult to peel and boil. Paper mulberry should be cut cleanly at an angle at the base with a sickle. Failing to cut back low enough can either stunt the following year's growth or encourage rot to set in. The most important factor that determines the quality of paper mulberry is the condition of bark. Stormy weather throughout the year may cause branch damage, so it too influences the quality of paper mulberry. The cut branches are harvested in 16kg-17kg bundles (25geun-30geun) and tied together using arrowroot vine.

Common mulberry varieties in Korea include *chamdaknamu* and *gujinamu*. The bark of chamdaknamu is called *jeopi*; gujinamu's is known as *gupi*. The fibers from jeopi dissolve well, producing an even paper surface. Gupi, on the other hand, is lumpy and produces lower yields. When gupi is spread on a large stone plate, sun-dried and hammered manually (rather than using a mechanical beater), its surface becomes glossy, which makes it the perfect paper for flooring. In some areas, paper mulberry harvested in mountains is called *metdak*; produce from fields is *chamdak*. Paper mulberry produced in

Harvesting paper mulberry.

Paper mulberry yields

Types of paper mulberry	Yields	Types of paper mulberry	Yields
Hardwood	100%–5,500g	Paper stock	4.5%–250g
Heukpi	15%–825g	Finished product	4%–220g
Baekpi	6%–330g		

Gapyeong, Jecheon, Cheongsong, Yecheon, Wansan, Sunchang, Namwon, Hamyang, Hapcheon, Uiryeong, Goisan and Wonji is famous for its quality.

• Steaming (dagmuji, dangmuji)

This is a process of steaming harvested paper mulberry so that the outer bark can be peeled easily. Traditionally, producers would steam it during the quietest time of the agricultural year in fields containing fast-flowing streams. After two interconnected gourd-shaped pits (one large, one small) had been dug, the smaller pit was filled with firewood. Then stones were placed on top of the firewood. The larger pit was filled with as much mulberry stock as firewood placed in the other pit (about 30 piles). The mulberry was then covered with branches and a layer of soil. (Nowadays plastic sheets are used instead of soil.) The producers would then light the firewood, until

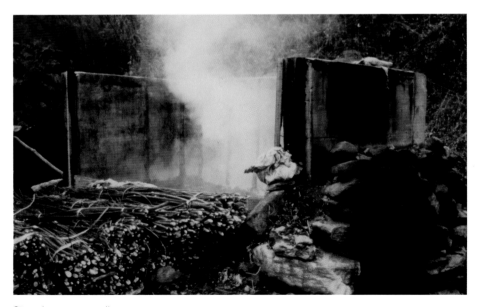

Steaming paper mulberry.

it had heated the stones sufficiently. Then, water was poured on to the stones to produce steam. The paper mulberry would steam once the steam passed through the conduit and filled the larger pit. The steaming method described varies depending on factors, such as the variety of mulberry tree. Broadly speaking, the fire is lit at 8am, water is poured on the stones at 1pm, and steaming continues until 6pm.

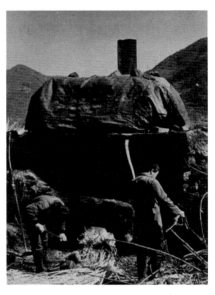

Steaming near Jeonju in the 1970s.

Present-day papermakers in Jeonju and parts of Gyeongsang Provinces use huge rectangular steam pots. These are much more convenient than the pits used traditionally. Water is poured into the bottom of the pot. Then a stack of paper mulberry is placed above. The water is heated by a wood fire that creates the necessary steam. The initial cloud of steam gives off a pungent smell, which later becomes much more fragrant once the paper mulberry is completely steamed. Steaming is completed once the producer is happy that the paper mulberry is soft enough. A poker is used for testing its consistency.

Nowadays most steaming is carried out using a steel or cement vat. Diesel generators or boilers supply the heat. After steaming is completed, producers pour cold water in the vat and leave it for a day. Alternatively, the paper mulberry can be continually steamed until the outer bark contracts. This allows the bark to be peeled easily. Steaming can be carried out three to four times a day using modern equipment; each cycle takes about five hours.

• Peeling, drying and bleaching

Steaming makes it easier to peel bark. Sufficiently steamed mulberry bark is peeled from the bottom. Branches are gripped (by right-handed people) in the left hand. The outer bark is then stripped from the wood, starting from the root end of the stem. Then the process is repeated until the rest is peeled. After being sun-dried, this bark is called *heukpi*. Heukpi is also known as *pidak* or *jopi*. Heukpi soaked in an ice-cold stream for 10 hours before being peeled is called *cheongpi*. This is called *baekdak (baekpi)* once it is peeled. Baekdak is also sun-dried for a set period of time for the purpose of bleaching. Sometimes producers lay it outside on snowy days before bleaching it in the sunshine. The optimum length for baekpi is 0.9m (after roots and tips have been removed). Some authorities claim *han* means "cold", and that it is derived from the Chinese "寒", to define the process of bark soaked in icy water during wintertime.

Once peeling is completed, the peeled beakpi should be dried. This is done during winter in order to protect the baekpi's quality. At the time of writing, Korean pidak costs about ₩1,500/geun. Baekdak costs ₩7,000-₩10,000/geun. Three geuns of heukpi costs as much as one geun of beakdak. Add labor costs per geun

A worker peelings paper mulberry bark near Mt. Sokri.

131

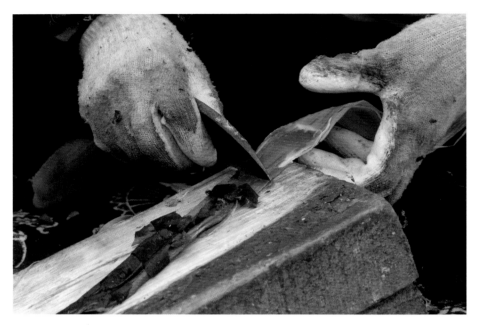

Chopping boards used in Gyeongsang and Chungcheong provinces for peeling bark.

(₩1,500 × 3) + (₩1,500 × 3) = ₩9,000. The produce's weight-to-volume ratio can vary enormously. If dried well, it will weigh significantly less. Understandably, buyers are wary during the rainy season. Plenty prefer to deal directly with trusted local suppliers.

Generally, chamdaknamu was favored for books and painting paper. *Meogujaengi* (a type of budak paper with long fibers) was used for jangji, munjongi, ondolji and umbrellas.

• Soaking

Well-dried baekpi is leached in a cold, clean stream for up to two days. This softens it sufficiently, and enhances the boiling process later. It also helps to remove non-fibrous materials from the baekpi. Soaking it in a running stream also helps expel dust. Attempting to do the same in still water would

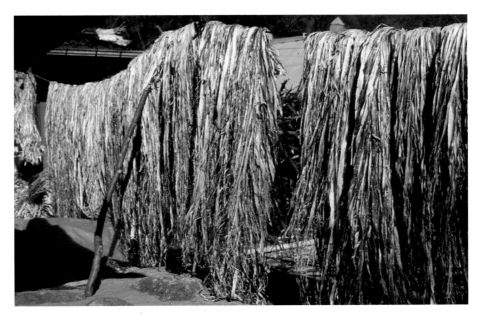

Sun-drying and bleaching bark.

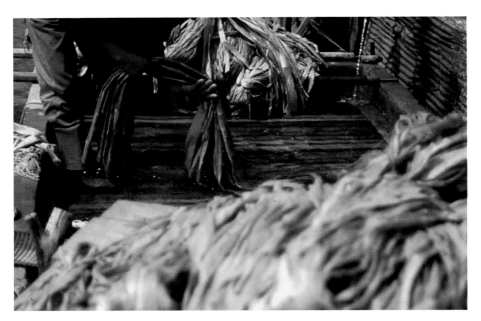

Soaking bark.

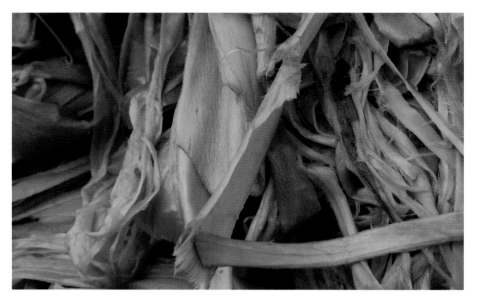

Baekdak (bleached mulberry bark).

have unwelcome results, since the water becomes dirty within a few hours, defeating the object of the process. After all, as previously mentioned, the whole point of soaking is to remove all non-fibrous elements. If not, the boiling and bleaching processes will be impaired. Furthermore, soaking baekpi reduces the boiling time by preventing mulberry fibers from clotting.

• Boiling

Once baekpi has been soaked properly, it needs to be cut into 30cm-40-cm lengths and placed in a vat. Caustic soda should be added before being boiled for four to five hours. The caustic soda filters into a big pot once 70°C-80°C degree water is poured on to the ashes of hay, buckwheat stalks and beanstalks. Caustic soda that resembles slippery soap water is considered ideal. This translates as having a pH value of 10-12, even though it can reach pH13 as a concentrate. The amount of caustic soda necessary to boil

Ashes made from buckwheat stalks.　　Mulberry bark mixed with caustic soda.

100geun of baekpi depends on the type of ash and respective amounts used. If hay is used, about 1,500 pyeong of space is needed. This produces 220kg of ash (equivalent to about four 60kg burlap bags of rice). Buckwheat stalk has a higher alkaline value than hay, which means it boils more quickly. Roughly 2.5 burlap bags of buckwheat ash are required for every 100geun of paper mulberry. After the paper mulberry has been boiled in the caustic soda, operators should be able to tease and tear it easily by hand.

Industrial chemical additives are now used instead of caustic soda obtained from ash, primarily because they make production cheaper, quicker and easier. The chemicals used include soda ash (sodium carbonate), caustic soda (sodium hydroxide), or soda sulfate. Soda ash is used for making quality paper used by painters and calligraphers. While soda ash damages fibers less than other additives, it also removes fewer impurities. As an aqueous alkalescent solution with a low OH-ion value, it is often mixed with quick-

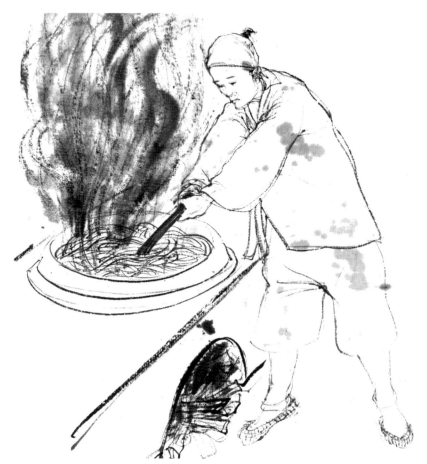

The boiling process.

Types of ash and respective boiling times

Types of ash	Ash (kg)	Lye water (kg)	Paper mulberry (kg)	Boiling time (hr)
Haystack ash	20	70	3	9–10
Buckwheat stalk ash	10	60	3	7–8
Cotton stalk ash	8	60	3	5–6
Beanstalk ash	8	60	3	5–6
Chili stalk ash	8	60	3	5–6

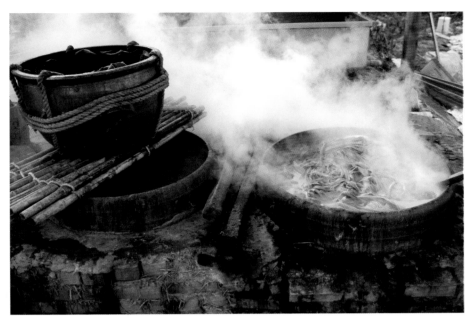

Boiling mulberry bark with caustic soda.

lime that is made by firing, baking or boiling limestone (rich in calcium oxide). However, caution is required in the storage of quicklime, and longtime storage should be avoided, because quicklime reacts with carbon dioxide in the air and reacts with water to become slack lime.

For every 60kg of paper mulberry used in production, about 7kg-8kg of soda ash is required (12%-15%). Caustic soda is readily available, although it does have its drawbacks: it absorbs moisture too easily and is highly corrosive. This means health hazards for operators, who should therefore wear protective clothing and avoid any direct physical contact. 6kg-7kg of caustic soda (10%-12%) is used per 60kg of paper mulberry. Soda sulfate (*mangcho* in Korean) has two types: the first type doesn't contain water. The other crystallized type contains ten water molecules. Soda sulfate occurs naturally, but is mainly obtained as a by-product of rayon or dichromic soda factories. If the

A worker teases fiber to check it has been boiled properly. It should tear easily.

Assessing pH values for caustic soda.

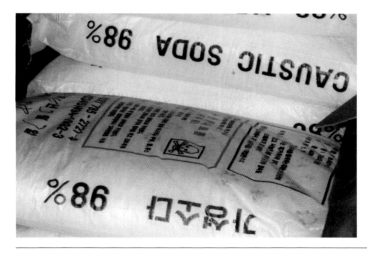

Bags of caustic soda.

soda sulfate becomes hydrolyzed, caustic soda is produced. This is the agent that acts on non-fibers in paper mulberry. Alkaline solutions (caustic soda) enable extraction of relatively pure cellulose by making materials' impurities soluble during the boiling process. Fibers are quite stable. High acid levels may weaken or burn them, but alkalis do not. Using stronger alkali-based additives than caustic soda (e.g. soda ash) to increase fiber purity will nevertheless reduce the paper's glossiness. Boiling paper mulberry with caustic soda does remove impurities and provide higher yields, but boiling any material damages its fibers to an extent. Again, the knock-on effect is that it gives paper a duller sheen, and also emits pollutants harmful to the environment. On the one hand, boiling materials in lye may produce a glossier final product. On the other hand, it removes far fewer impurities from the paper, weakens the fiber, and produces paper that will disintegrate sooner. Paper mulberry is only added to water or lye once the temperature exceeds 80°C. Soda ash or caustic soda is added after the water starts boiling. The pH value for lye should be 10-12, pH11-13 for slack lime, and pH13 for caustic soda. Paper mulberry is removed once it has boiled enough, and then checked by analyzing the softness and pliability of the fiber.

Washing, bleaching and dirt rejecting

• Washing and bleaching

After the boiling process is completed, the material should be left to stand for two to three hours. Afterward, it is rinsed in clean running water for half a day. If still underground water is used instead, the water should be changed two to three times during the 12-hour period to remove any traces of soda. The fiber should be evenly distributed for better overall exposure to water. In particular, when baekpi bark is soaked in running water in the sun,

The process
of sun-bleaching
and rinsing.

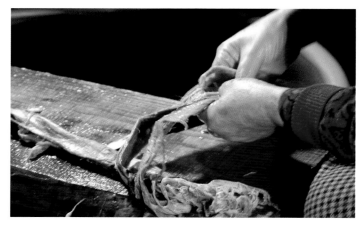

Dirt rejecting.

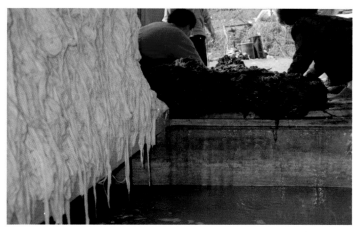

Bark (right) before it is
bleached using
hypochlorite (left).

Raw mulberry material after the caustic soda has been removed.

it is advisable to spread it out evenly and turn it regularly so that all of the bark receives an even amount of sunlight and water. Sun-bleaching should take about five days if it is sunny; a week if overcast. Bleaching occurs because ozone and peroxide are generated underwater in response to the presence of the sun's ultraviolet photochemical activity. The process is admittedly time-consuming, but it does not damage fibers. Washing and bleaching are carried out during wintertime when the water is cold. Papermakers avoid washing fiber in warmer water, since it damages paper mulberry fiber. It also contains algae and bog moss, which are abundant natural contaminants.

Currently, producers use industrial additives (bleaching powder, hypochlorite, and chlorite) for bleaching. These may make the bleaching process easier, but they create pollution and damage fiber. Bleaching powder is made by absorbing chlorine gas into slack lime. The powder is white, gives off strong fumes, and dissolves when reacting with moisture, even in a vacuum. Cau-

tion is therefore required when storing bleaching powder because it dissolves rapidly when exposed to heat, light or humidity. Bleaching liquid has become more popular in recent years to avoid the problems of volatility associated with bleaching powder-water reactions.

When cooking salt is electrolyzed, the negative pole reveals the presence of sodium. Sodium quickly absorbs moisture to create caustic soda and hydrogen. The positive pole indicates chlorine. This, when combined with caustic soda, produces the bleaching liquid (sodium hypochlorite; $NaClO \cdot 7H_2O$). Sodium hypochlorite is the most common bleaching agent used by hanji producers. The ratio of water to sodium hypochlorite is 15:1. Material is normally bleached for six to eight hours.

Chemical agents provide simple and effective bleaching. However, damage to fibers, costs involved in treating waste water, and subsequent washing to remove leftover chemicals in the fibers are drawbacks. Anti-chlorinating agents (sodium hyposulfite, sodium sulfite, sodium bisulfate) are used for removing the remaining chemicals. Iodine potassium starch liquid or iodine potassium starch paper is used for checking that paper stock no longer contains bleaching agents. These turn blue when bleach is present in the paper stock.

• Dirt rejecting

Impurities should be removed from the paper mulberry bark after washing and bleaching are finished, and before the beating process begins. Specks are caused by hail, frost, disease or buds. The bark is lifted out of the water, after which specks and blemishes are meticulously removed by hand. Experienced operators can manually clean 3geun-4geun per day. While chemical agents could be used to speed up the process, these are best avoided because they damage hanji fiber. It is particularly difficult to mechanically remove

Dirt rejecting.

impurities from paper mulberry bark owing to the characteristics of the fiber. Pickers either work near clear, fast-flowing streams or have water tanks at hand. Pickers working at the side of streams use deep baskets from which small quantities are removed and picked. Some materials (wild paper mulberry and oriental paperbush) occasionally undergo both manual and mechanical processes; hay or used paper is beaten first before impurities are removed.

Beating (gohae)

In this stage of papermaking, the artisan places baekpi on a flat stone and

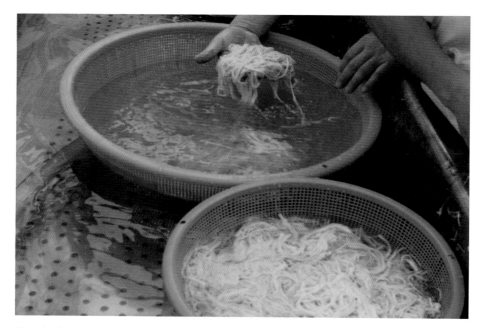

Dirt rejecting.

A fishing net used for dirt rejecting.

beats it for 40 minutes to an hour with a mallet to macerate the mulberry fiber. Beating times vary according to the species of mulberry tree used. Producers typically try to double the size of the baekpi. They also look for protruding fibers, and check if the baekpi disperses when dipped in water. If all three criteria are satisfied, the process is considered completed. The fiber should be beaten on a flat stone or wooden plate, beaten from left to right, and then vice versa. Water is regularly added to the baekpi during the beating process. Birch is the favored type of wood for plates because it is stronger and more durable than others.

A rod used for beating.

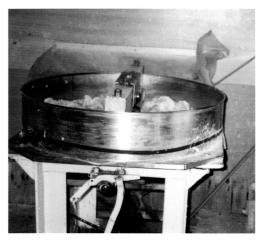

Machines used for beating.

Two types of motorized beaters have replaced the manual mallets of yesteryear, the T-shaped rotating mallet and the mortar mallet. With the former, baekpi is placed in the mortar and pounded by a fixed rotating T-shaped mallet. The operator flips, mixes and arranges the baekpi underneath the beater as required. The mortar-driven mallet moves from left to right (similar to the manual beating method). This beater is ideal for mulberry fiber since it pounds all areas of the fiber's surface two or three times.

In addition to using motorized mallets, operators can cut baekpi into thin strips before beating the baekpi into a pulp. The Hollander beater and knife beater are employed in this method. The Hollander beater is used in western papermaking and to manufacture machine-made hanji. 5kg-40kg of baekpi is beaten at a time. The knife beater, which uses a round, knife-shaped rotating wing to beat the bast fiber of paper mulberry or white mulberry, is ideal for beating long fibers because it significantly reduces the incidence of short fibers tangling with long fibers. Nevertheless, papermakers producing high quality paper still prefer traditional mallets because the tools work tangled

ends better than their mechanical equivalents. Because mulberry fiber is long and thin (similar to silk), it is much more likely to become tangled. Mulberry fiber quickly transforms into pulp so it should not be beaten for too long. Otherwise paper formation will be more difficult to achieve later in the process. The same method of beating is used for wild paper mulberry and oriental paperbush, although wild paper mulberry is beaten

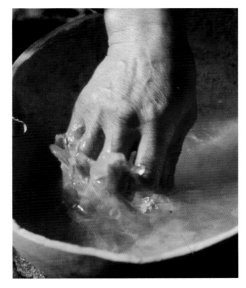

Fiber beaten into a pulp.

for longer because of its slightly tougher consistency. Chemical pulps have much shorter and stiffer fiber consistencies than mulberry fiber. This means the strength, glossiness and transparency of paper is reduced if any is mixed in with paper mulberry fiber. Nevertheless, pulp additive is now commonly used by papermakers because it is readily available and economical.

After beating, the next stage of the process is called *haeri*. This is where producers thoroughly mix the beaten fiber in water. Traditionally, the fiber was put in a net and submerged in a running stream. The fiber is stirred until it is mixed thoroughly. Traditionally a stick was used to mix in the fiber. Nowadays artisans use a screwdriver. Then specks are picked again. The amount of picking is dictated by the quality of paper required; the higher the quality, the more picking. Any residue caustic soda is also removed at this stage, and changes in the lignin chromophore takes place, which brightens the fibers. Afterward, the hibiscus liquid is added and mixed in before

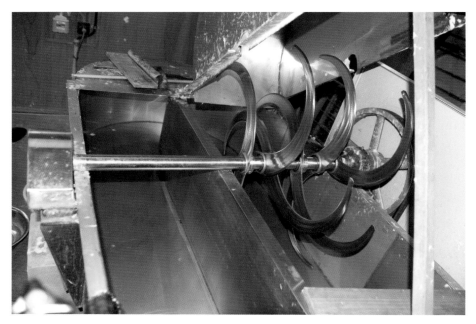

A knife beater.

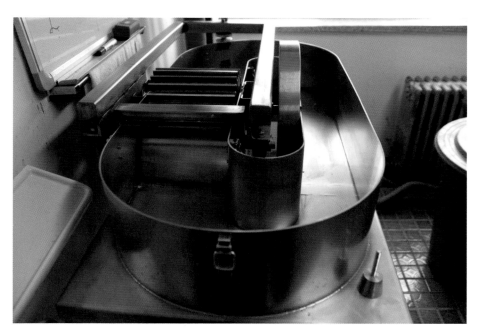

A Holland beater.

paper formation.

Sheet formation (choji)

The quality and type of hanji produced vary depending on the technique used for sheet formation. There are two methods used for forming paper. The heullim (single mould) method sheds water as the paper forms, whereas the gadum (double mould) method contains the water. Traditionally, single-mould sheet formation and jangpanji formation were used. These are variations of the heullim method. A double-mould formation, which is popular today, combines both gadum and heullim methods. The principles of hand sheet formation are summarized as follows:

Paper stock, hibiscus liquid, and other chemical additives (PAM/polyacrylamide and PEO/polyethylene oxide) are diluted in water. Then the artisan moves the mould through the mixture so that the liquid washes across the mould.

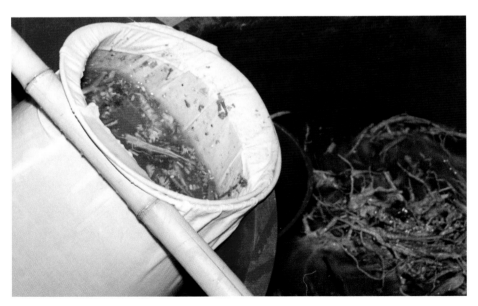

Filtering hibiscus liquid.

As the liquid falls away through gravity, layers of fiber residue remain. These layers are pressed and dried; the entangled fibers gain elasticity and hanji is produced. After paper mulberry, the second most important ingredient in the production of hanji is hibiscus liquid. This generates viscosity in the paper stock, which prevents mulberry's long fibers from sinking to the bottom of the container. It also controls the speed at which water runs across moulds and helps to produce better overall consistency in paper quality. Therefore, hibiscus liquid is absolutely essential. Furthermore, it makes it easier to separate stacked sheets of wet paper. In addition, the concentration of hibiscus liquid used determines the final thickness and density of the paper. If the solution is highly concentrated, water flow and drainage through the mould is slow, which makes sheet formation more difficult to achieve, but produces thinner and stronger paper as a result. If hibiscus liquid is not used, fiber dispersion does not occur, which produces uneven paper of inconsistent thickness. It will also cause water to drain off too quickly, resulting in further inconsistencies.

Hibiscus liquid goes off fast and dissipates when exposed to heat, which means problems during sticky Korean summers. Bimok juice (the bimok tree belongs to the camphor family) was traditionally mixed in to extend the working time of hibiscus liquid, which can be used or stored for about a day in summer and a week in winter. It dissolves in water and is nontraceable in mulberry fiber. This makes hanji more durable, and ink remains bold for longer. This is one of the reasons hanji survives for millennia. Hibiscus liquid's pH value is seven, which means that hanji made using traditional methods and hibiscus liquid is acid-free paper. Chemical additives similar to hibiscus liquid are PAM and PEO. PAM exhibits similar qualities when produced as a sticky liquid or a diluted polymer gel. Storage as a liquid is

possible, although it does not dissipate in the paper stock if it is not mixed properly. PEO is another high polymer with a molecular range of 200-400. This means it dilutes well. However, adding a lot of PEO powder at a time will create a lumpy mix, so it should be added gradually in small amounts to avoid this. This also helps to improve "internal-sizing treatment", which is notoriously difficult when making paper with hibiscus liquid.

Method of paper formation

Properly beaten mulberry bark is mixed in a vat with hibiscus liquid and water. The optimum ratio of water to mulberry is 8:2; the best hibiscus liquid to mulberry ratio is between 4:2 and 3:2. Only after proportionate amounts of water, hibiscus liquid and mulberry are mixed does the sheet formation process begin. Evenly mixed mulberry bark is carefully scooped up using a bamboo-framed screen. Each sheet of paper is formed as the mulberry fiber and water gradually collects, congeals and accumulates. Sheet formation uses a traditional or modern papermaking method, categorized by the types of mould, screen and frame used, how the fibers form in the process, and the technique adopted by the operator. Traditional methods include single-mould formation and jang-panji formation; modern methods include double-mould formation.

Beaten mulberry fiber.

151

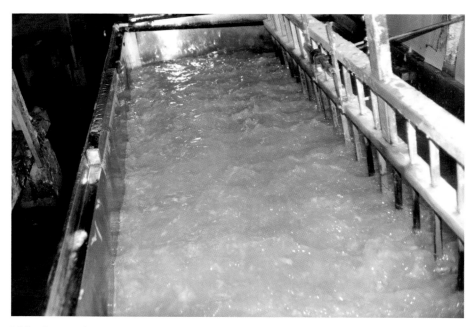

Mixing beaten fiber thoroughly in water.

Stirring fiber.

• Traditional sheet formation

Single-mould sheet formation

This is the oldest sheet formation method. First of all, beaten mulberry fiber is completely diluted in a vat through stirring so that it is mixed well with water and dispersant. Afterward, each sheet of paper is formed using a single mould. The phrase "single-mould formation" might have derived from the way the single-screened frame swings across the vat on a rope, and the way operators swing the screen alternately back and forth. (The mould is suspended via a rope, which is itself attached to a horizontal length of wood spanning the vat width-ways.) The single mould enables mulberry fiber to accumulate in crisscross layers, providing hanji its tensile strength. Because much more water sweeps over the mould's edges than through its screen, the fibrous solution has less time to stick to the mould. The direction of fibers is determined by the flow of water, and the surface of the paper reveals the direction that the fibers flowed in the mould.

As the mould swings through the vat, water flows over the front edge of the screen and flows over and off the back and sides. A thin film gradually thickens with each additional swing through the mixture; after three or four swings, the film should have gained sufficient thickness. If thicker paper

Single-mould sheet formation.

is required, a sideways motion is more effective. The artisan should combine two moist crisscrossed layers to make a sheet of paper. Single mould paper made using this type of layering is also called umyangji (meaning yin and yang), and it requires a great deal of skill and experience. Its dense crisscrossed fibers resemble (井)-a Chinese character pronounced "jeong" that translates as "a well"-and produce a strong and durable type of paper. The paper has a distinctively opaque quality that makes it a common feature in doors and windows. It has been used in traditional buildings, in homes and in restoration projects ever since the Goryeo dynasty.

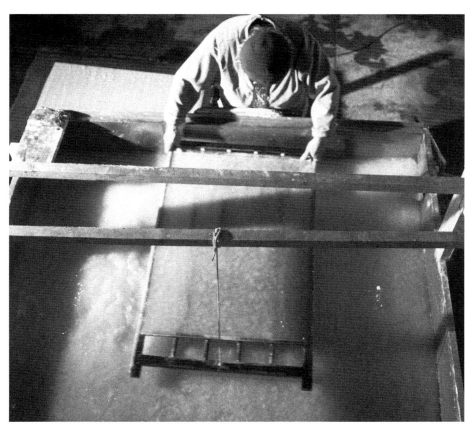

Single-mould sheet formation.

Jangpanji formation (larger types of paper)

This papermaking method, which can be categorized as both a variation of heullim and a single-mould method, was used to make larger sheets of paper during the Joseon dynasty in order to produce jangpanji, pangji, nongseonji, gwaji and historical books. Teams of three worked on each mould: two people operated the mould together, swinging it in arcs through the vat from four directions (forward, backward, sideways left, sideways right) repeatedly until a film had gained the desired thickness. The third member of the team was in charge of folding the just-formed wet sheets. These layers were combined to make a single sheet of hanji of a suitable thickness. All paper made using a single mould has a fiber formation in the shape of the letter jeong (井), which gives the paper an even surface and necessary strength. As the jangpanji mould is large, the shape of the mould and frame is square, which is a slightly different shape from the basic single mould. The mould has thick

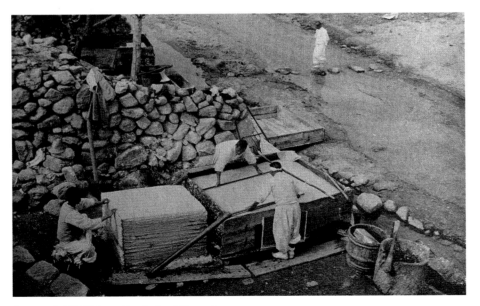

Jangpanji (壯版紙) formation in the 19th century.

bamboo sticks that are stripped from the middle. In addition, jangpanji uses many bamboo beams running under the frame to support it. Jangpanji paper can exceed 200ho, it absorbs ink consistently, and production techniques are very similar everywhere it is produced. Production has fallen gradually since the 1970s to the extent that very few artisans now make this type of paper. This traditional craft faces extinction.

•Combining traditional and modern methods

Double-mould formation

This method was introduced by the Japanese in the early 1900s and spread fast. Jeonju was the hub of production. In double-mould formation, the amount of water you use determines the thickness of paper. The frame's slim outer rim allows the water to collect before draining and depositing fiber. The Korean word *ssangbal* translates as "double mould". It owes its name to the original frame having two separate moulds in a large frame. The present-day version has one large square mould that is partitioned down the center so that two separate sheets can form. Given that the mould and the frame are large and heavy, they need to be supported by several horizontal lengths of strong wood fixed to the ceiling, connected by ropes. *Dengujosi* (典具貼紙) and other materials are placed in the vat to help improve the quality of paper, and to make the fibers crisscross properly. This method employs a *front-water* approach (driving the mould forward and then backward through the mould) or a *side-water* approach. Most work is carried out using the front-water approach. Double-mould paper made in this way reveals fibers that are formed at a right angle to the direction of the bamboo lengths. When using double moulds, the water contained in them is drained along with excess paper stock. The mould is again dipped in the vat and the process is repeated until

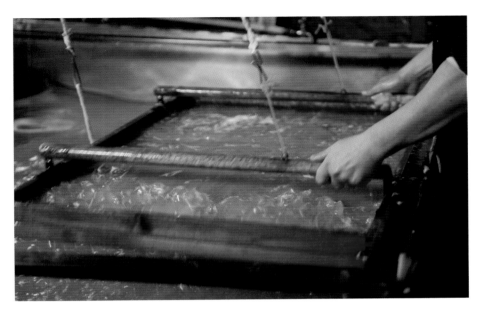

Double-mould sheet formation.

a thin translucent film collects. This typically used to take five or six swings through the vat mix; these days it takes only two or three. Interestingly, the imprints left by the bamboo lengths vary depending on whether or not an extra layer of fiber was placed under the mould. The single-sheet making method produces hwaseonji (thin, translucent paper suitable for painting). Double-mould papermaking combines gadum and heullim papermaking methods, which help artisans to produce paper with an even surface and a consistent thickness. It has the advantage of being able to produce four sheets of paper, while a single mould can only produce one. The downside is that the unique fiber formation of double-mould papermaking results in weaker paper through which ink spreads unevenly.

Pressing: stones on sheets

First, sheets of paper are placed on a table. Then thread or rushes (nylon now-

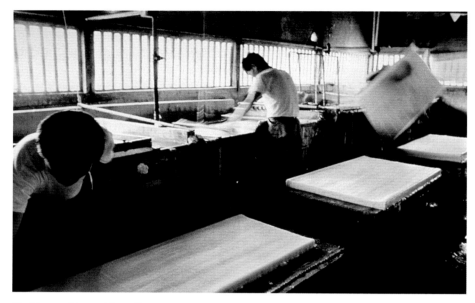

Double-mould sheet formation.

adays) are placed along the outside edges of each sheet to help separate them. These temporary spacers are called *baegae* in Korean. Thicker paper is produced after squeezing out the excess moisture from the paper, whereas paper consisting of two sheets is created by swinging the mould twice through the vat, and placing a spacer in between. A wooden hoop is rolled on top of overturned mould. The hoop (measuring 1.0m × 0.10m) allows the sheets to drain more efficiently, although it is used only on changhoji moulds rather than the delicate hwaseonji mould. A mould is placed on top of a board. Then flip the mould on which the moist sheet was made. Afterward, the hoop is rolled on these to expel moisture. Sheets are then removed by peeling them off the mould. Next they are placed on a separate table. When the hoop is rolled, the pattern of the mould appears clearly; when the hoop is not rolled, the mould pattern either fades or disappears altogether.

Between five and six hundred sheets are layered together and placed on

the table, with the spacers still in place. A heavy stone is placed on the 600-sheet stack, which remains pressed overnight. The process up to this point removes about 70% of the moisture from the sheets; nowadays moisture is squeezed out using a mechanical press or clamp. The optimum duration between pressing and drying is about 12 hours because this prevents decay of the hibiscus liquid contained in the paper.

Using a hoop.

Drying

Drying removes remaining moisture from pressed sheets, leaving approximately 8%-13% in the paper. Traditionally, paper could be ondol-dried, sun-dried, or dried on walls or wooden boards. When drying paper on an ondol, households would brush the sheets with a broomstick to remove excess water and ensure the surfaces dried as evenly as possible. This process allowed the paper to dry slowly and relatively evenly, which improved its durability. But it was also very time-consuming and produced a rough surface. Drying took place overnight. Wrinkles would be knocked out after drying with a stone hammer. Ondol paper rooms measure 8ja × 8ja (2.4m × 2.4m). They are increasingly rare nowadays.

Drying on wooden boards involves leaning the wooden boards against a

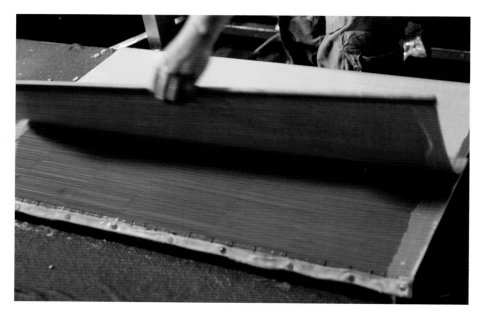

Placing a moist sheet.

Placing spacers.

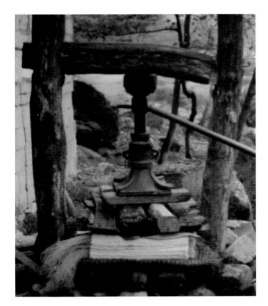

A compressor for moist sheets.

Drying moist sheets.

wall, hanging the paper sheets on it, and sweeping the sheets with a horse-hair brush. The pressed sheets are peeled carefully from the stack and draped over a wooden frame. The plate is then moved to a sunny, dry and dust-free spot. This method of drying was used when producing high quality paper.

Drying paper in the sun was often reserved for large sheets of paper or jangpanji. Jangpanji made near streams was spread out on gravel banks or hung up on a line. This method was most common in Gyeongsang Provinces and Jeolla Provinces. Wrinkles in sundried paper were hammered until the paper was creaseless. This method was soon superseded by Japanese iron-drying.

Iron-drying involves placing moist sheets on a steaming hot iron surface. This rapidly dries paper. The disadvantages are that rapid drying stiffens hanji, makes it heavier, and makes it harder. It can also oxidize the paper,

Peeling moist sheets from the stack.

leaving unwanted rust marks.

Calendering

Smoothing hanji is part of the final treatment process, and is conducted in a number of ways. The first method uses rice liquid: this is made from rice powder that has fermented for over six months. It is then applied evenly to the surface of the sheets (which are still not bone-dry at this stage). The sheets are layered in dozens. These are hammered until each surface is ironed out and compacted properly. Hammering adds strength and glossiness, too.

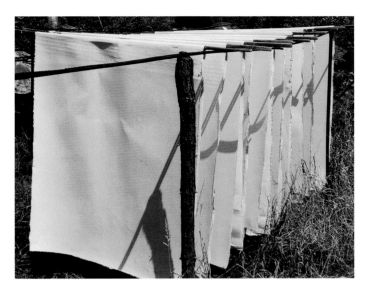

Sun-drying.

Drying on
wooden boards.

Drying on clay walls.

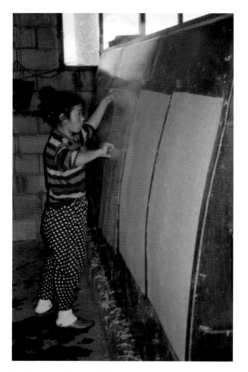

Drying on sheets of iron.

Incidentally, in centuries gone by, rose mallow leaf resin would also be spread on paper. After airing the paper for a short time, a large, heavy slate would be placed on the sheets. Paper made in this way had a faint blue tint and was noticeably glossy, drawing admirers (e.g. Bai Juyi of the Tang dynasty). Another method involved stacking 100 layers of paper, of which every tenth was soaked in alcohol. Afterward, a flat board and then a heavy stone were placed on top of the stack. This stack was hammered 200-300 times, before 50-sheet stacks were dried in the wind. Next the sheets were shuffled and the process was repeated three or four more times. When the operator confirmed that the sheets were no longer sticking together, the final round of hammering would commence, by which time the paper had become as smooth and as silky as oilpaper.

This technique was also adopted when producing *Mugujeonggwang daedaranigyeong*, the world's oldest woodblock printed book. The method spread because it dramatically improved the quality of paper produced. Hammering had been traditionally been conducted on a water-powered treadmill, driven by a water wheel. The water wheel was superseded centuries later by the motorized generator. The process involves beating stacks of paper that contain dry sheets in sets of threes, which are divided by single

wet sheets. The stack is dried and hammered about three times. Afterward, sheets are separated according to their smoothness and hammered one last time. The process is completed once 100-sheet stacks are gathered and dried on the hot floor of an ondol room.

A wooden calendering roller.

The smoothing process makes the paper denser, its surface glossier, and improves overall quality. The method is similar to the way that the blacksmith tempers an iron in a fire. Smoothing pushes the paper's rough fibrils to the surface, which thins the paper and fills many of the surface's holes and

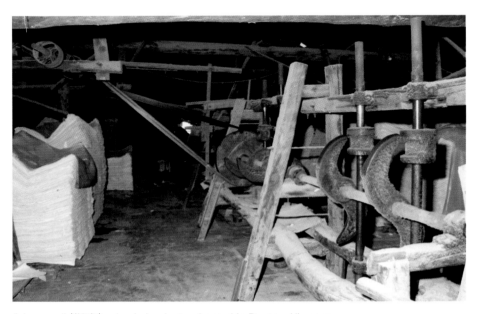

A jangpanji (壯版紙) calendering factory located in Bongsu, Uiryeong.

165

A calendering treadmill.

A calendering hammer.

cracks. By evening surfaces and filling in holes among fibers, smoothing prevents ink from running when printing, and produces the desired sheen on its surface. These advances enabled the development of a unique ink-based style of Korean painting, one which was very different from those that had originated in China.

Finishing (ironing, evaluating and selecting)

Any remaining wrinkled or uneven paper goes through the same smoothing process one more time, or is ironed (in the manner that cotton clothing is ironed). Damaged sheets are identified and set aside to be used later for other purposes.

Everyday use

Papermaking made easy

Even without professional equipment, anyone can try making hanji. The amateur papermaker or hobbyist can pick up everyday items to carry out specific processes. Needless to say, it is advisable to master the basics before investing in more sophisticated equipment.

Essential papermaking equipment and ingredients

The selection process.

will include a mould frame, nets (aluminum, stainless steel, or mosquito nets), fiber materials (paper mulberry, pulp, or used paper), dakpul (hibiscus liquid), a mallet or bat (to beat the fibers into pulp), clean water, and a vat to contain the pulp soaked in water (a paper vat). Plenty of space is also required. A kitchen, basement or clean laundry room corner will suffice. A backyard or porch could be used on warm days. Necessary equipment for making paper can be purchased and is readily available. Paper mulberry is the most important material needed to make hanji pulp. If it is unavailable, used hanji will do. A stationery store is the best place to look for supplies first. Plastic buckets or square containers can be used as vats. Darkroom suppliers often stock a wide selection of containers. Food blenders are perfect for grinding.

Essential equipment: moulds and mould frames

Key tools in papermaking are the mould and mould frame. Though designs vary depending on the type or production method of paper, the basic principle of creating a sheet of paper by draining water to produce sedimentary layers of thin fibers is the same. A mould is a tool for filtering paper. It is made of thin strips of bamboo packed tightly together with cotton thread. The traditional Korean single mould and its mould frame are unique, as is single-mould papermaking. As such, the moulds and methods require expertise and training. Hanji made using the single- mould method is also stronger and more durable. However, most people would struggle to make a traditional mould or a mould frame. So let's look at some feasible alternatives.

Constructing a mould and mould frame

Anyone with a rudimentary knowledge of carpentry and some common

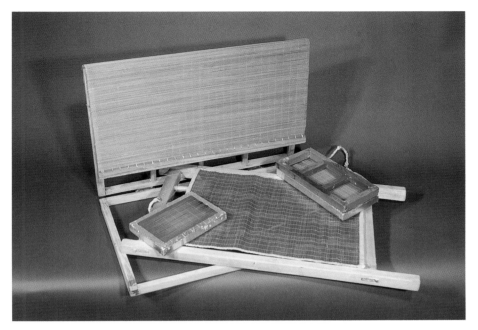

Moulds and mould frames for practice.

sense can make a mould and frame easily: the net should be cut to the appropriate size, and the mould and its frame need to fit together properly. The mould's underside should be checked to ensure that the strips are positioned, fixed, nailed and screwed in properly (at 90°, ideally using small nails and screws whenever possible). Rough or uneven surfaces should be rubbed down with sandpaper. The same principles apply when making the mould frame. In addition, the frame is lacquered to make it water-resistant. The shape and thickness of mould frames should be determined by the type of paper you aim to produce. Actually, paper can be made without a mould frame, though the paper stock would inevitably spill from the mould, and would inhibit producing paper of a regular size or shape. The fiber tends to slip under the mould frame during the formation process, which causes frayed edges resembling those in worn-out clothes. This is a clear characteristic of

handmade paper. The mould can be made out of various materials (cloth, bamboo screen, stainless steel, aluminum mesh for the net). Steel mesh is recommended because it can cope with the heavy paper stock. This prevents the net from coming loose. When using cloth for the net, it should be dense enough to prevent fibers from escaping, but loose enough to allow water to drain off easily. Nylon cloth should always be soaked in water and pulled tightly before use as it tends to sag after becoming wet. The following options are available if you don't have a mould or a mould frame:

Moulds in various sizes.

Tools that can be used instead of a mould or mould frame

- Window frame (pane removed; used as a mould frame)
- Photo frame (glass removed; used as a mould frame; cheap plastic or wooden frames can be used; various textiles can be used for covering the frame- cotton, net, or delicate silk)
- Embroidery frame (made out of metal, wood, or plastic; various sizes and shapes available; rust-resistant wooden or plastic types are recommended)
- Net frame (made of wire or plastic)

Papermaking made easy: method

1. Cut paper mulberry, used hanji, pulp or recycling paper into stamp-sized pieces.
2. Soak the pieces in warm water.
3. Half-fill a blender with water.
4. Pour a half-cup of wet paper into the blender.
5. Close the blender lid.
6. Start blending at a slow speed. Increase the speed as the paper starts to break down in order to cut fibers effectively.
7. Continue blending the mix until it has completely disintegrated. Afterward, take out a sample and check a length of the stock. Repeat the process until the paper becomes mush.
8. Fill the vat with a ratio of 4:1 clean water and pulp.
9. Stir the pulp and mix thoroughly with a wooden spoon. Then form the first sheet of paper, by sliding the mould frame slowly into the vat at an angle of 45°. Gradually reduce the angle as you submerge the frame. It should be horizontal by the time it is completely submerged in the pulp.
10. Slowly lift the frame while slowly rocking it horizontally. This should help the fibers to interweave better.
11. Once removed from the pulp, the mould frame should be left to stand on a vat corner for a maximum of 20 seconds. Remove the top frame and set it aside. At this stage, caution should be taken not to spill water on the moist sheet. If this happens, droplets will dent the surface of the recently-formed paper. The moist sheet that has formed is allowed to dry.
12. Place the moist sheet on top of a cloth on the floor. By pressing the up-

per part of the mould frame, you will be able to separate moist sheets from the mould frame more easily.

13. Before adding another moist sheet to the pile, place a wet cloth on top of the previous one. Each sheet should be separated in this manner until you have a stack of sheets. Any leftover pulp should be filtered with a fine net, and then poured in a sealed container. Put the container in a refrigerator. This will keep for two weeks or more.

14. Place the stack of sheets on a compressor board and press it to remove water. Slowly increase pressure by tightening the buckle. This will remove as much moisture from the pile as possible.

15. After the buckle has been fastened for about 30 minutes, unfasten it and remove the cloth sleeves from the stack.

16. Separate the moist sheets and dry them thoroughly by hanging them on a clothes line or window.

Saekji (色紙) in a range of colors.

Papermaking made easy: method

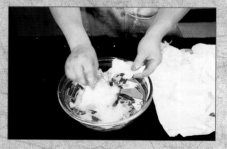

1. Cut paper mulberry, used hanji, pulp or recycling paper into stamp-sized pieces.

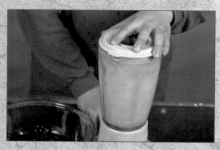

2. Grind the pieces in a blender.

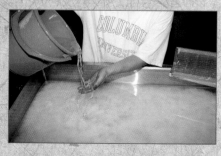

3. Mix the ground material in water.

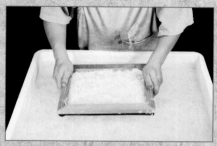

4. Form sheets.

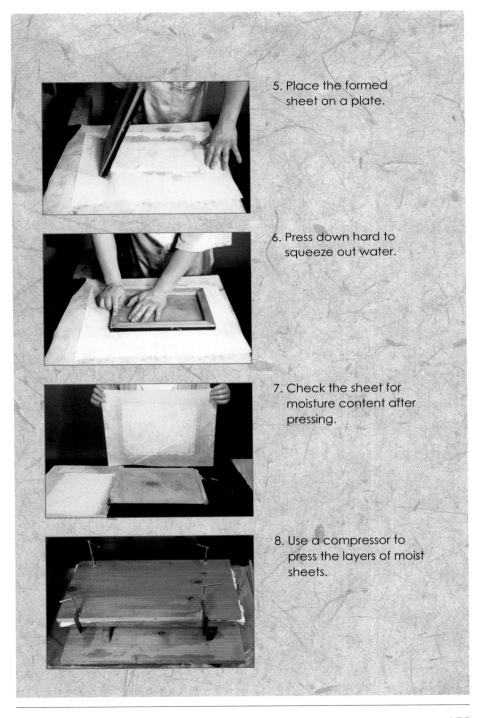

5. Place the formed sheet on a plate.

6. Press down hard to squeeze out water.

7. Check the sheet for moisture content after pressing.

8. Use a compressor to press the layers of moist sheets.

Fun papermaking

Petal paper

A variety of common flowers, leaves and seeds can be used in papermaking to create paper with wonderful textures and glorious colors. Plant materials are either dried (dry flowers), compressed, or used in their natural state. The form of dried or pressed flowers and leaves can be preserved even after the paper is dried, whereas unprocessed types can be used to extract pigment.

● Preparation: materials and equipment

Dried flowers (made with a silica desiccant); pulp

Use a mould frame

● Production process

1. Form a moist sheet using a mould frame.

2. Place some dried flowers on top of the sheet.

3. Form a thin, translucent pulp. Pour it over the paper.

4. Dry.

● Application

Natural plants and plant materials that haven't been dried can be used. Roses and chrysanthemums prove popular choices.

Petal paper

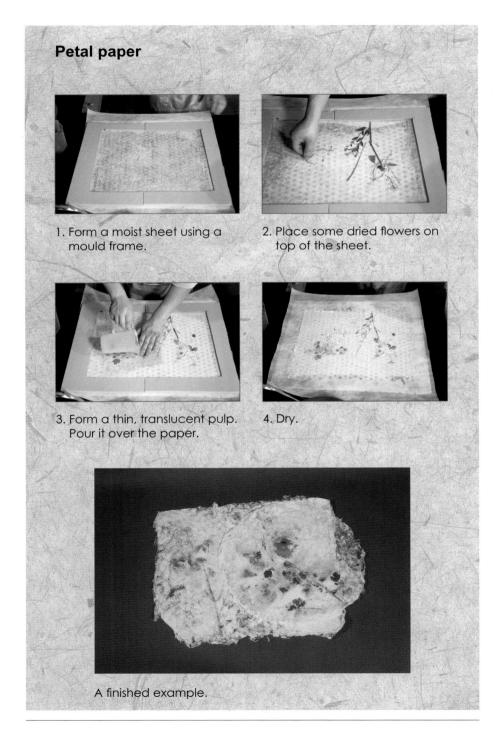

1. Form a moist sheet using a mould frame.

2. Place some dried flowers on top of the sheet.

3. Form a thin, translucent pulp. Pour it over the paper.

4. Dry.

A finished example.

Onion-skin paper

If onion is used in the production of paper, the gloss and color of the onion skin adds a unique texture and coloring. The skins are first heated in water to bring out the brownish coloring, before being mixed with pulp in a blender to form a paper stock.

● **Preparation: materials and equipment**

Onion skin, pulp, water

A blender, a stove or burner for heating, a vat, a pot

● **Production process**

1. Add and blend the raw materials and onion skin in a blender. Boil the onion skin beforehand. to prevent any discoloration later.
2. Place the materials in a vat and produce the first sheet.
3. Place the sheet on a plate and press it.
4. Dry.

● **Application**

Various plants that are used for dyeing can be mixed with the paper stock to give the paper unique characteristics.

Onion-skin paper

1. Blend the onion skin and other raw materials. Boil the onion skin beforehand to prevent discoloration later.

2. Place the materials in a vat and make the first sheet.

3. Place the sheet on a plate and press it.

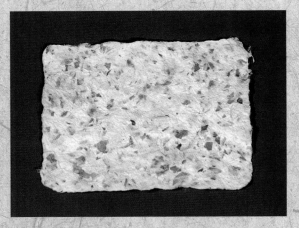

The finished product.

Paper from recycled jeans

• **Preparation: Materials and equipment**

Used jeans, water, bleach

Scissors, a vat, a blender, a mould frame

• **Production process**

1. Cut a pair of jeans into small pieces.

2. Soak the pieces in water for a day.

3. Pour some bleach on the soaked pieces. Leave for 1-2 days.

4. Dilute the pieces in water for a short while. Pour the mixture in a blender (or pound in a mortar).

5. Add the ground material to a vat filled with water, and stir thoroughly.

6. Add more than the usual amount of hibiscus liquid and glue (to increase adhesiveness).

7. Form a sheet with a mould frame.

8. Spend plenty of time compressing the sheets to ensure adequate quality.

9. Dry.

Paper from recycled jeans

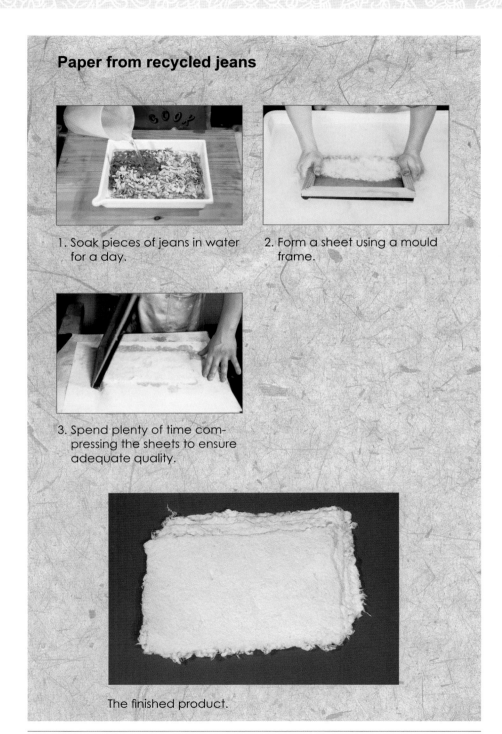

1. Soak pieces of jeans in water for a day.

2. Form a sheet using a mould frame.

3. Spend plenty of time compressing the sheets to ensure adequate quality.

The finished product.

Paper from recycled paper

● **Preparation: Materials and equipment**

Drawing paper, newspaper, A4 paper, milk cartons, water

Scissors, a vat, a blender, a mould, a mould frame

● **Production process**

1. Cut newspaper or other usable paper into small pieces. Soak the pieces in water.

2. Mix pulp or paper mulberry with the material (1). Blend it to make a paper stock.

3. Add hibiscus liquid or glue to the paper stock and form paper (to increase adhesiveness).

4. Dry.

Paper from recycled paper

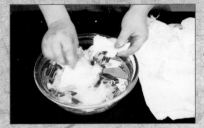

1. Cut newspaper or other us-able paper into small pieces. Soak the pieces in water.

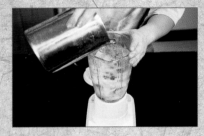

2. Mix pulp or paper mulberry with the material. Blend it to make a paper stock.

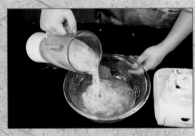

3. Add hibiscus liquid or glue to the paper stock (to increase adhesiveness) and form paper.

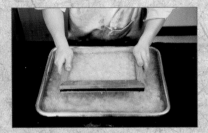

4. Form the sheets.

The finished product.

Western papermaking

Traditional handmade western papermaking is very similar to its Korean cousin, primarily because it is based on the same production techniques and technologies.

Production Process

Making paper stock

Linen and cotton have traditionally been the staple materials used in western papermaking; excess linen and cotton scraps are collected at textile fac-

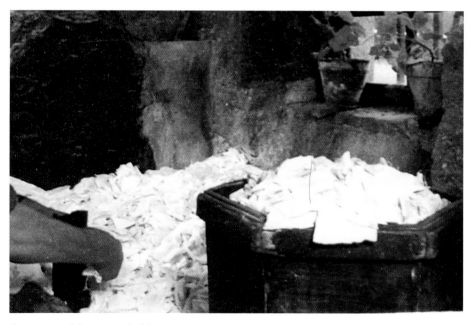

A western vat for raw materials.

tories and reused to this day. Cotton linter and Manila hemp are processed to make paper. Western handmade paper is produced by first cutting cloth into small pieces. It is then treated to loosen and soften the fabric's fibers. Afterward, the fabric pieces are beaten to a pulp (gohae). As the saying goes, "Paper is the product of beating". In other words, the beating process is the most important stage in western papermaking. One of the first tools used for beating was a mortar pestle. Water-driven beaters followed, to be superseded by the Hollander beater (invented in the Netherlands in 1750). This proved a breakthrough in the history of western papermaking: from this point on producers could beat millions of individual fragments every 10 hours.

Sheet formation

Sheet formation is the process of interweaving fibers in paper stock, gradu-

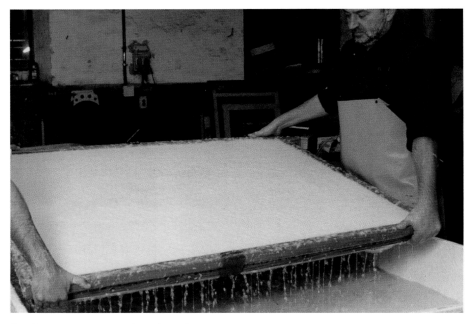

Traditional western–style sheet formation.

ally forming layers of paper, and drying these newly-formed sheets. Hand-made paper is good for drawing on because the sheets have a characteristically regular horizontal and vertical *flow* (whereby ink or paint is absorbed consistently). Mass-produced paper doesn't come close in this respect: it pulls liquid in one direction only, owing to *one-sided flow*, which makes the desired application of paints and inks more challenging.

The mould is the most important tool for making handmade paper. When paper stock gets drained on a mould, it becomes a sheet of paper. A western mould consists of three layers of iron net, placed on top of a wooden frame. It has wooden beams spaced every 4cm-5cm. *Deckles* (thin boards) run around the edges of the frame. These help to support the outer edges of the pulp that rest on the iron nets during the formation process. Deckle also describes the rugged edge of handmade paper. Paper made using a cylinder mould is sometimes treated to look as if it is handmade.

The artisan forms paper by submerging the mould (with deckle attached) into a vat at an angle of 65°. Once fully submerged, it is rotated back to the horizontal, and raised about 15cm-20cm out of the water. Excess pulp stock drains over the deckles, before the artisan begins rocking the mould sideways and lengthways repeatedly to even out the layer of fibers. As the water gradually drains through the nets, the residue forms a sheet. Each of these moist sheets is about 10 times thicker than a dried sheet of paper. After water is drained, the deckle cover is removed. This process is known in the trade as *couching*. Then the mould is slowly lifted off, leaving a sheet of paper. A rectangular pelt of cloth acts as a sleeve between each new sheet of paper as the pile gets larger. This pile of cloth and moist sheet is known as the *post*. Western handmade papermaking methods can produce between one and two thousand sheets, depending on the paper's thickness and size.

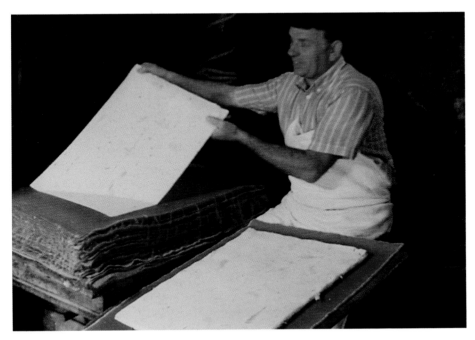

Separating sheets.

The draining process

Up to 200 tons of pressure is applied to the post. This squeezes it from its original height of 60cm down to 15cm. Such intense pressure leaves pelt imprints on the delicate sheets of paper. Paper and pelt can be separated easily because the pelt's long-fibred topside peels away easily from the paper's short-fibred bottom side, which proves essential during the separation process. This difference in the length of fibers can be demonstrated by comparing the front and back of any given sheet.

Drying

The moist sheet and cloth are separated once they have been through the draining process, and sent to a well-ventilated drying room. Special care should be taken to ensure proper ventilation during summertime to pre-

Drying.

vent paper from drying too quickly. During the rainy season or wintertime, rooms are heated to around 25°C. Sheets can be hung and dried separately or in sets.

Sizing

Tub sizing is the easiest method of sizing for cotton paper. Dried sheets of paper are dipped in a large, shallow tub of sizing liquid. Once the sheets have dried, they become stronger, more water-resistant, and more oil-resistant as a result of the sizing liquid evenly covering the surface of the sheets. This treatment enables papermakers to score, color-layer, and color both sides of the paper.

Paper has a pitted surface, which makes it absorbent. Pure, untreated cotton paper can be used for sketching or printing, but it is not suitable for

watercolor painting since the paint would absorb and spread excessively. For this reason, the gaps between paper fibers are often filled with adhesive, water-resistant substances that partially block liquids. This process is referred to as sizing; gluey materials used in sizing are referred to as a "size" or a "sizing material". Neither blotting paper nor filter paper goes through the sizing process. Printing paper is sized to prevent surface fluff occurring, and to improve ink absorption. Starching clothes could also be considered a type of sizing.

The most common sizing material for cotton paper is gelatin. Gelatin is a simple protein that belongs to a group of complex organic compounds, and consists of large molecules of carbon, oxygen, hydrogen, and nitrogen. Transparent gelatin can be obtained by boiling animal bone, cartilage, leather, or fish scale in 80-90°C water. Almost all of the moisture contained in gelatin evaporates when it is precipitated using alcohol or sodium. It is often used for making glue because of its viscosity. In Korea it is known as *agyopul* or *gatpul* (gat translates as "leather"). The sizing method incorporating glue was invented in Italy in the 13th century, and later superseded by the rosin-sizing method in Europe. Nowadays, glue-based sizing methods are only used for high-end products (e.g. cotton paper for watercolors), whereas rosin continues to be used in the sizing of everyday paper. It is created by obtaining pine-tree resin, distilling it, and then removing the turpentine content. Rosin-sizing was invented by Moriz Friedrich Illig in present-day Germany in the 1800s. It had become popular by the mid 19th century because it penetrated paper deeper and was more cost-effective than other sizing methods. Another key advantage is that rosin-sizing works well at various temperatures (unlike other methods), which means producers can use it all year round. These factors continue to make it the most common and

Sizing.

Drying after sizing.

popular method. However, there are some drawbacks: rosin-sizing is less effective than gelatin sizing and therefore requires greater volumes of liquid-extract to achieve the desired results. The increased volumes necessary can result in paper discoloration and excessive acidity because of additional alum content.

Additives

We all know that moist paper tears more easily than dry paper. This is be-

cause it normally has only 5%-10% the strength of dry paper. Papermakers call this *wet strength*. Paper with a wet strength higher than 15% is classified as *fortified waterproof paper*. Additives such as melamine resin and urea are used for strengthening and waterproofing paper by interweaving its fibers. In 1942, a method was invented that uses a melamine formaldehyde resin solution to considerably improve the wet strength of paper. Melamine form-aldehyde resin is restricted to prevent chemical damage: paper toweling consists of 0.5%, whereas high-end fortified waterproof paper consists of 3%-5%. Other common additives include urea resin, starch and plant gum. Synthetic rubber latex is often added for making high-end cotton paper.

Slime-combating agents are required, too. Microorganisms multiply during handpaper formation to create slime that subsequently causes cracks in paper. Chlorine, chlorinated phenol and mercury compounds are often added to prevent slime.

Whitening agents are applied to obtain requisite color and brightness in the paper. Without these, expensive raw materials would be required as well as extra care in papermaking. Given that paper stock is made using a combi-nation of fibers, various additives and water, it is highly impractical and very difficult to obtain the desired color. Pulp bleaching solves this problem, and is similar to the process when clothes are dyed.

Semi-automatic machines & paper-cylinder mould production

As casting machines appeared in the late 18th century, a large amount of machine-made paper became available. The technology has evolved to be-come a gigantic system, which can produce several tons of paper every day.

A hanji-making machine.

A typical papermaking machine.

Fiber paper stock is poured over a long screen (just as the mould is used in hand-made papermaking) to produce long lengths of paper. The paper is cut into appropriate lengths later. Though this modern technique enables manufacturers to produce reasonably-priced paper quickly, paper made in this way does not have any particular characteristics. Any texture or watermark is added later using a metal cylinder roller. During the process, a very delicate flow is created on paper as the metal net goes through the rollers several times. This results in paper that can be easily torn in one direction. All machine-made paper (even paper used for watercolor painting) has a tendency to flow in one direction, which handmade paper does not have because its fibers are evenly dispersed in all directions.

The cylinder mould was invented 19 years after the introduction of casting machines. A mould frame net is placed around the cylinder, and the cylinder rotates and scoops the stock, in effect doing the job of the operator. If the paper mould frame is continuously spun inside the vat, fibers sink onto the iron net owing to hydraulic pressure; water escapes into the inside of the cylinder through the net, which is collected and used later. The mass of fiber filtered with the net is pressed and dried as it goes through rollers. Next, the paper is dipped into a vat of sizing liquid. Watermarks are added if necessary using rollers. Papermakers can produce 100-ho paper using the cylinder-mould. Types made in this way are often called *cylinder mould paper* or *mould paper*. Since cylinder mould paper is made quite slowly, its flow and overall quality are superior to normal machine-made paper.

A comparison of hanji and western paper

Hanji is a handmade paper made from the bast fibers of mulberry bark. Yangji (literally "western paper") can be defined as either handmade paper made before the 19th century or machine-made paper. Machine-made paper refers to paper whose main ingredient is wooden pulp. Yangji was introduced to Korea in 1884, in the 21st year of King Gojong's reign. At this time, Kim Ok-gyun visited Japan, invested in western papermaking equipment, and returned home with it to Yanghwayul, in Hanseong (present-day Seoul).

Hanji's characteristics

- Light
- Pitted with many holes; breathes
- Long-fibrous texture; (owing to its main ingredient, paper mulberry)
- Glossy sheen (owing to its fibers' natural glossiness)
- Flexible and transparent
- Elastic and strong
- Organic fibers only
- Hibiscus liquid is used in the paper formation process. It evaporates soon afterward.

Western paper's characteristics

- Relatively heavy
- Tightly interwoven fibers
- Short fibers (owing to its main ingredients- cotton fibers or wooden pulp fibers cut

short)

- Uses non-organic additives (although main ingredients are fibers)
- Opaque and waterproof
- Hibiscus liquid is not used in the paper formation process.

Differences between hanji and western paper

Different materials, tools and production processes are used in hanji and yangji. Bast fibers from the mulberry tree are used for making hanji. Seed fibers are used for making yangji. Bast fibers are stronger than wooden pulp, especially because they inter-weave. This produces a durable type of paper. Hanji is made using a mould with tightly packed lengths of reed or bamboo. Yangji is made with a screen (tied wire or woven textile) that has been attached to a mould and deckle. The next difference is that hibiscus liquid is used in the production of hanji to help separate the moist sheets; hibiscus liquid is not required in yangji pro-duction, because the wool pelt used is sufficient to separate sheets. From a production point of view, hanji is made from baekpi (literally "white bark", from the paper mulberry). After the bark is boiled in caustic soda, it is washed

Western paper under a microscope.

Hanji under a microscope.

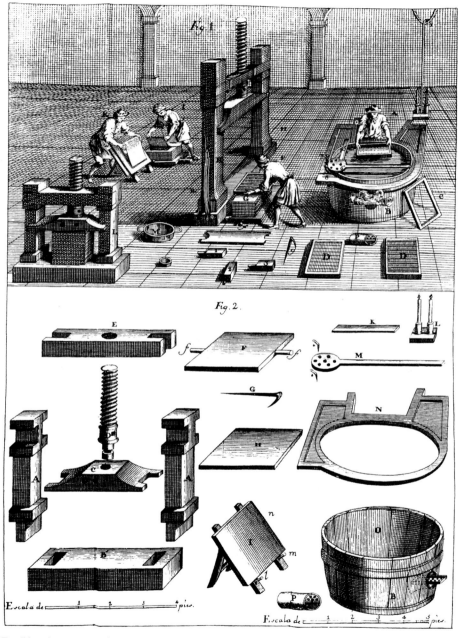

Traditional western-style papermaking methods and tools.

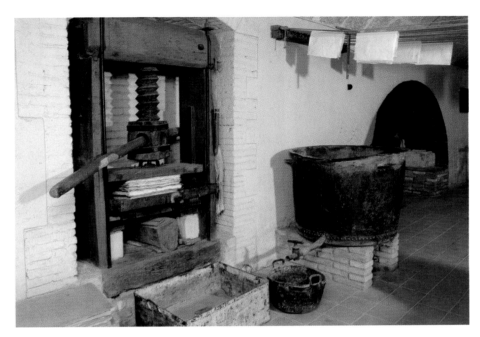

A workshop for traditional western-style papermaking.

in water and laid on a flat stone, before being pounded with a mallet. Afterward, the pounded fiber is poured into a vat with hibiscus liquid and mixed thoroughly. Then the artisan forms sheets using a single mould, and afterward hammers out any creases in the formed sheets. Conversely, yangji paper stock is hammered with the Hollander beater before it is placed in a vat. Some of the pulp is removed from the vat and poured into a papermaking mould. After it is stirred several times, water drains to leave residual fiber on the net. The amount of residue increases to form a moist sheet. This sheet is placed face-down on a wet pelt. A pile of about 100 sheets is then pressed to remove moisture. Afterward, these sheets are separated and dried in a drying room. If sizing treatment is required, sheets are dipped into a vat containing gelatin liquid and dried again.

In summary, hanji obviously differs from handmade yangi in terms of

materials and production methods used. At the same time, these differences constitute some of hanji's unique and essential qualities. Paper mulberry bark lends hanji its strength and durability, and caustic soda adds further durability. Yangji will survive in storage for 200 years; hanji will last for a millennium.

If long fibered materials (e.g. paper mulberry bark) are used for making yangji, the fibrous pulp tends to condense excessively. On the other hand, hanji production uses hibiscus liquid to prevent this kind of problem. Yangji uses adhesive additives to improve paper strength (starch or synthetic resin). These are unnecessary in hanji-making, because paper mulberry and hibiscus liquid combined give hanji sufficient wet strength. Hammering moist sheets of hanji produces a denser, softer, glossier paper that has a consistent and even thickness. Hanji can breathe, is soft to touch, and folds well. Moreover, ink and paint are absorbed quickly. Therefore, the artist or writer can achieve a more striking contrast using hanji. Last but not least, hanji provides a great barrier against the cold, to heat, and to sound.

Comparing Korean, Chinese and Japanese paper

At first glance, hanji doesn't seem that different from traditional Chinese or Japanese handmade paper. However, it uses different materials, different paper formation methods, and different drying and finishing methods. Concerning materials, traditional Chinese handmade paper is not made from mulberry fiber, but from the bast fibers of bamboo, hemp, and other plants, which are mixed with rice straw or wheat straw. Traditional Japanese hwaji is made with a combination of bast fiber of Japanese mulberry, wild paper mulberry and oriental paperbush, mixed in with hemp.

Hanji made by pressing two sheets together.

Japanese paper (和紙).

Hanji made using a single mould.

Chinese seonji (宣紙).

Traditional Chinese paper

The characteristics of Chinese paper

It is said that poetry, calligraphy, painting, and Zen converge in the Chinese arts, and are bridged by their representations on paper (paper, brush, ink, and ink stone). Chinese paper (華紙) demonstrates these characteristics. Seonji (宣紙) is another type of paper that evolved out of supiji during the Southern and Northern dynasties. Seonji is made from rice straw, bamboo bark, white mulberry and cheongdanpi. The paper is produced using a fermentation technique to create a paper stock of short fiber. The chengdanpi tree, which grows only in certain parts of China, is an ideal material for papermaking. Rice straw and oat straw are usually added as secondary ingredients. Seonji is delicate so it isn't particularly durable. The upside is that ink flows perfectly and marks clearly on this type of paper. Therefore, it suited the Chinese style of calligraphy and painting.

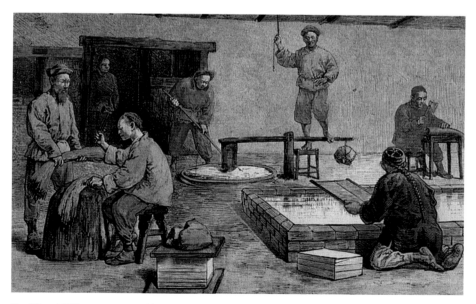

Traditional Chinese papermaking.

Traditional Chinese papermaking: the production process

Almost all types of Chinese paper are made in a similar way. The Fujian production method for making mobyeonji (毛邊紙, bamboo paper) is as follows:

Material- Bamboo ("juk" in Korean) is the main material, to which a little rice straw is added and mixed. In the spring (usually April) baekhyeopjuk (白夾竹), geumjuk (金竹), suju (水竹) and banjuk (斑竹) are collected. Jajuk and gwaneumjuk are harvested in September. Bamboo is best harvested after it has grown several branches.

Soaking- Each bamboo branch is cut into 4ja-5ja lengths. The lengths are soaked in a pond and then pressed with a stone. Water is poured into the pond and the lengths are fermented there for a month or more. At this point, the bamboo's bluish tint disappears and it softens. The bamboo is then beaten, the inside and outside of the material are separated, and everything is washed.

Preserving- A bamboo stock is made and covered with a layer of lime. The process is repeated several times. The lime should account for about 30% of the total weight of the material when dry. Water should be poured into the layers and left to stand for two to three weeks.

Boiling (1/2)- In the first of two boiling processes, the layers of bamboo and lime are placed in

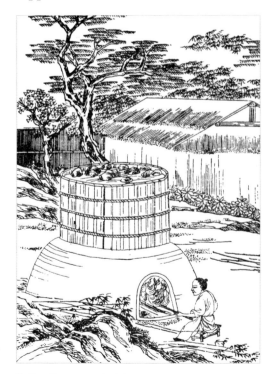

Boiling the raw materials.

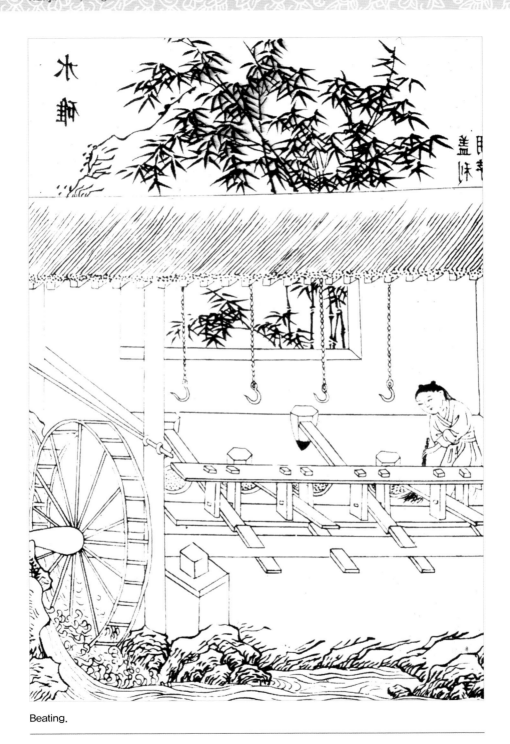

Beating.

a bamboo kiln, water is poured into it, and the contents are left to boil for three days. Mud is used to block any holes allowing steam to escape. The boiled material is removed after it has cooled down, washed in cold water, and pressed to remove water.

Boiling (2/2)- In the second boiling process, a mixture of water (93%-95%) and caustic soda (5%-7%) is first poured over the contents. Next, they are boiled in the kiln for four to five days. They are then removed and washed in cold water.

Fermenting- The materials can be allowed to ferment naturally (while they are being pressed), or raw bean juice can be used for enhancing and accelerating fermentation.

Picking and beating bamboo- Bamboo shoots are an ideal material for hard paper. After being beaten and pounded in a mortar, they should be used as soon as possible to minimize damage to the fiber.

Bleaching- The contents are tied together in rice cake shapes, measuring 1ja long and 6 pun thick. These are then left to stand on a bleaching stone step. They are flipped after 20 days so that the materials dry and bleach evenly. Once both the inside and outside have turned pure white (after about three months) the bleaching process is considered completed. The contents should be sheltered from exposure to wind or sand if possible. Bleaching powder can shorten the bleaching process if required. If additives are not used, the entire process of harvesting, boiling, fermenting, beating, and bleaching usually takes about three to four months.

Paper formation- The bleached bamboo, water and dispersant are mixed to make the paper stock. Cherry blossom leaves are beaten separately and soaked in water to form glue, which is then added to the paper stock. Excessive glue prevents paper from forming evenly. In Shannan, the contents were

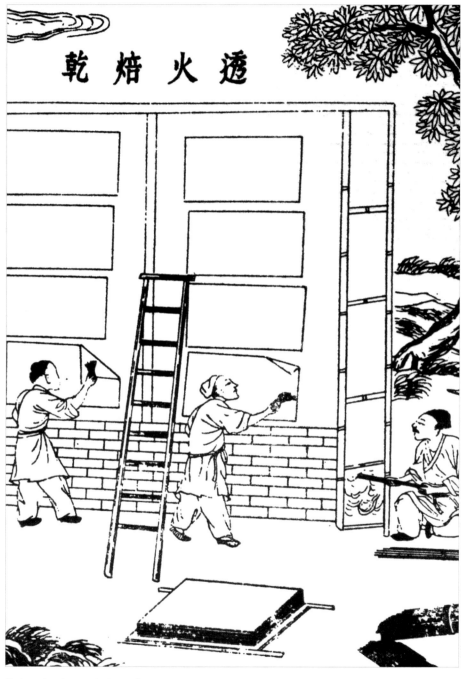

乾焙火透

Drying sheets on plaster walls.

traditionally soaked in water, and boiled for three days. Afterward, caustic soda or charcoal was added to the contents, before being placed over a low heat for a day. Lime was added to this and left for another day. Next, rice water was poured in and the mix was left to soften for another eight to nine days. The consistency and texture of the mush was tested by treading on it. Once deemed sufficient, the material was then ready to be used for making paper.

Pressing and drying- The sheets of paper are pressed to remove any moisture, and placed in a warm room to dry off the edges. Experienced artisans pick up the sheets by the edges with small copper tongs and paste them on the kiln.

Drying- The kiln is made out of bamboo. On the outside of the kiln, a mixture of hemp and lime paste should be evenly applied at a thickness of 4 pun-5 pun. Lime dries easily on the outside, whereas moisture on the inside will take much longer to dry. The kiln is dried by heating at a low temperature. After condensation forms on its outside, the paper should be buffed with a stone to make it glossier. Then, once the paper has completely dried, oil (dongyu) is added to further improve the sheen. Alternatively, a mixture of rice water and oil may be applied. This method was used by artisans in Sichuan regions.

Stacking- Sheets had to be stacked neatly. Recently, a natural formation process has been added.

Traditional Japanese paper
The characteristics of Japanese paper (hwaji)

Japanese paper (和紙) originated when Damjing of Goguryeo introduced pa-

permaking methods to the country. During the Joseon dynasty, paper made in Japan was referred to as *waeji*. Today it is known as *hwaji*. Japan started to mass-produce paper after it had adopted European-style papermaking machinery during the Meiji Restoration. Being an island on the edge of the Pacific, Japan has saltier air, which produces a denser, more durable paper. This may explain why the brushstrokes in Japanese painting tend to have a distinctively precise style. Although Chinese and Korean cultures certainly influenced Japanese culture and painting, Japan has developed its own unique culture. The same is true for its paper. It has adapted foreign paper-making methods over the years, and is now, proudly, the world's number-one paper producer. Japanese painting is characteristically sophisticated, neat and precise, as is Japanese paper.

Japanese papermakers treat hwaji's surface to make it water-resistant. This means that ink or paint forms layers on the surface rather than soaking deeper into the paper. This quality encouraged the evolution of the *yamato-namjonghwa* style (a painting style originating in China). From this point, Japanese-style colored painting could develop, which became the basis for a singularly oriental sense of beauty.

Today, hwaji producers are encountering similar problems to hanji producers. Some homegrown materials are reserved for the

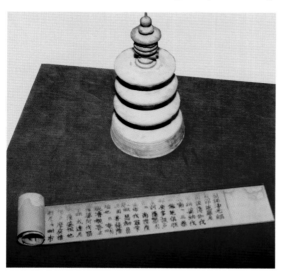

Baekmantap darani (百萬塔陀羅尼經, *The Million Pagoda Dharani Sutra*).

highest quality hwaji. However, the majority of materials used for making hwaji are imported (e.g. wild paper mulberry, paper mulberry and oriental paper-bush).

Hwaji production methods

Harvest the raw materials.

↓

Strip the bark and soak it in water.

↓

Boil it with caustic soda or slaked lime.

↓

Wash the boiled bark and bleach it.

↓

Beat the bark.

↓

Put the bark in a vat and stir it thoroughly.

↓

Prepare the hibiscus liquid.

↓

Form the paper. The double-mould papermaking method is used for making hwaji. (Korean-style papermaking methods are still used in a few places (e.g. Imadate).

↓

Dry the sheets on a wooden plate.

↓

Put the finishing touches to the paper (no beating).

Comparing traditional Korean, Chinese and Japanese production methods

Here is a comparative summary of the three countries' production methods:

• Materials: preparation and soaking

In traditional Korean paper production, paper mulberry was soaked in the cold running water of local streams for up to two days. Similarly, the Japanese soaked their paper mulberry bark in water in order to remove rough outer bark. Conversely, the Chinese prepared raw materials based on an ingredient's qualities: hard bamboo was soaked in water for 100 days; hemp was cut into pieces before soaking; bamboo shoot was cut into small pieces and soaked in a lime solution for five to six days. Soaking in water also softened raw materials, facilitated boiling, and helped to remove impurities from the materials.

• Boiling

Caustic soda was used by Korean papermakers to boil bark. Boiling paper mulberry took between four and five hours. The Chinese used caustic soda, but lime was preferred when material required more intense or longer treatment. Bamboo, for example, was boiled with lime for eight days, washed, and then boiled again repeatedly with several different types of lime. The Japanese opted to boil materials in liquid soda ash.

• Washing

This process was essential in all three countries to remove the agent used in the boiling process (e.g. caustic soda, lime, or ash).

Japanese hwaji (和紙) production.

• Bleaching

Korean papermakers used a combination of the sun and streams to bleach paper, whereas Chinese artisans bleached paper with chemical additives added to the vat. Japanese producers used similar methods to Korean producers, who have always aimed to create subtle, pure colors through bleaching.

• Beating

Korean papermakers beat mulberry materials instead of grinding them. The Chinese traditionally crushed their bamboo or ground their hemp and other ingredients in a millstone. Japanese artisans beat their materials on either stone or wooden plates.

Japanese hwaji (和紙) production.

•Paper formation

In Korea, hibiscus liquid was used as a dispersant. In China, different dispersants were used for different materials. One example is *jiyaksu* juice for making bamboo paper. However, Chinese producers tended to avoid using dispersants because they used short-fibered material only. In Japan, a pyo-mok juice (鰾木汁) additive was used, whereas hibiscus liquid was used in wintertime. In terms of moulds, the three countries all used screens made

A Japanese mould made in the 1920s.

out of cut bamboo (as well as reed or daylily during the Japanese occupation of Korea. Koreans used a single mould to make paper, and combined two layers to form a single sheet of paper. In Japan, a double mould was used for producing paper, such that the paper's fibers flowed in a single direction.

•Pressing

Traditional Korean papermakers pressed paper using a heavy stone placed on top of moist sheets to remove water. Japanese and Chinese producers used similar methods. In Japan, heavy stones on planks were used for pressing sheets, while both Chinese and Japanese producers pressed paper by first putting a stack of sheets on a plate (100s of layers per stack), placing another stone on top, and finally tying the stack with a string to squeeze out water and dispersant.

•Drying

The traditional Korean method involved using ondol flooring or sunlight to dry sheets thoroughly. A technique used by the Chinese was to build a

fire between wall cavities, heat them, and dry paper hanging on the other sides through conduction. The Japanese spread sheets across wooden plates, which was then left to dry in the sun.

• Hammering

Hammering was a technique adopted by Korean artisans to remove creases and bumps from the paper's surface. If any were identified after hammering, the sheets would then be ironed. Japanese papermakers avoided hammering: they evened out surfaces by rubbing paper with spindle tree leaves.

登多景樓　樓上無窮　景樓前正　落暉開軒

倒橋遠奇峰　南星峽　角嵐痕倒嶂　壹室煙末居　光總黏此秋　諸天滿目風　渾忘塵黑生

辭　竹塢須橫之　甲申前碶聊　悵兼多進賦

壽由仁也仁由　天多福妍翁有　是年良郎俗昕　活沭旦古喜勤　讀今名傳舊春　芝蘭超似漸偕

筹說于　菩薩剎　上僊人不　宿疝知　日修慶西　分明汝潮苗餘慶

此食曾作十檢前先　名白宴長三千七句　乙庠稀大壽倫偉令　笠又享午楊任妹傾

大夫人壽序韻　任次　趙友

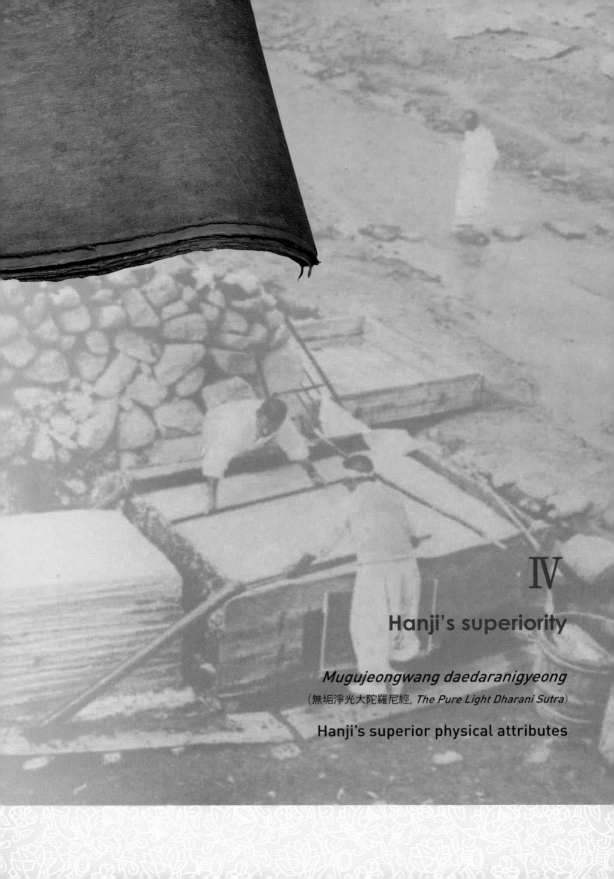

IV

Hanji's superiority

Mugujeongwang daedaranigyeong
(無垢淨光大陀羅尼經, *The Pure Light Dharani Sutra*)

Hanji's superior physical attributes

Mugujeongwang daedaranigyeong

(無垢淨光大陀羅尼經, *The Pure Light Dharani Sutra*)

Hanji's superiority is demonstrated in this sutra, the oldest woodblock-printed publication. *Mugujeongwang daedaranigyeong* was the scripture that Buddhists read aloud to seek enlightenment. Readings would normally take place after a pagoda had been constructed, and it was customary to put Dharani scriptures inside a pagoda. The sutra was discovered on October 14th 1966 in Gyeongju at Seokga Pagoda when part of the structure collapsed during renovation work, revealing a box containing the sutra, silk, beads and aromatic trees. It was made from a roll of paper mulberry measuring 6.228m long × 6.7cm wide, and was wrapped in a silk scarf in a corner of the box. The scripture was wrapped around a thin bar whose tips were

The sutra photographed soon after it was discovered.

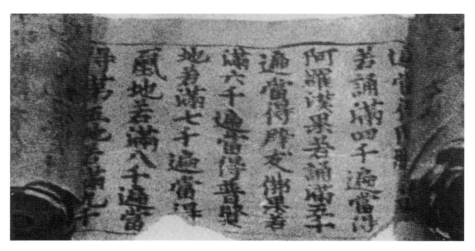

Mugujeongwang daedaranigyeong (無垢淨光大陀羅尼經, *The Pure Light Dharani Sutra*), before it was restored.

coated in red paint.

Experts agree that the sutra was probably produced somewhere between AD 704 and AD 751. The consensus was reached after concluding the following:

1. The sutra was produced at least 20 years before *Baekmantap darani* (百萬 塔陀羅尼經, *The Million Pagoda Dharani Sutra*), a woodblock print previously regarded as the oldest of its kind. We can assume this because Empress Wu Zetian's letters are included in the sutra, written during her reign (Tang dynasty, AD 690-705). This constitutes compelling evidence as to the age of the texts.

2. Maintenance records for Bulguk Temple and Seokga Pagoda exist in a Korean book on temple history called *Bulguksa Gogeumchanggi*. There is no mention in the book of placing the sutra in the pagoda, just as there is no mention of renovation work at the pagoda. In addition, the sutra was found in excellent condition, out of sight of extreme anti-Buddhist activists during the early Joseon dynasty, Qing invaders in the

17th century, and Japanese invaders in the 16th century. This suggests it was most likely hidden securely in the pagoda, where it remained untouched until 1966.

3. Records of Seokga Pagoda's construction (beginning in AD 751 and completed about 20 years later) are supported by independent documentary evidence, including Japanese texts. Furthermore, Mituoshan (彌陀山, a Tang dynasty monk) introduced the sutra in AD 704. A copy of the sutra is supposed to have been presented to another temple in Gyeongju in AD 706. Therefore, experts agree that the sutra was probably produced around AD 704-751, corroborating the authenticity of the Empress's letters.

Currently, academics are pinpointing the origins of the sutra. The publication year of the *Baekmantap darani* (previously considered the oldest printed script before the 1966 discovery) is recorded in *Jingang boreboluomiduojing* (金剛般若波羅蜜多經, *The Diamond Sutra*), a Chinese scripture found near Dunhuang in 1908 by Aurel Stein, a British archaeologist (and subsequently appropriated by the British Museum). The Japanese sutra it claims was created in AD 770, more than 20 years after *Mugujeongwang daedaranigyeong*. The Chinese woodblock was created 118 years later in AD 868 during the Tang dynasty. Scholars conclude that *Mugujeongwang daedaranigyeong* was most probably created AD 706-751, before the completion of Seokga Pagoda.

A Japanese Dharani Club member, who is also a published researcher, claims in an essay that:

"*Mugujeongwang daedaranigyeong* has such beautiful, graceful calligraphy, whereas our calligraphy is of slightly inferior quality. I assume that by the time they had created the woodblock print for this, the woodblock-printing technique would have been quite advanced. The hanji was a little discol-

A box used for storing a monk's ashes. Small crystals are sometimes found after cremation; these relics are regarded as sacred.

ored, but the vitality of the ink remains."

Mugujeongwang daedaranigyeong incorporates a margin and bleed, and is in remarkable condition considering its age and residence for the last 1,200 years. It has been argued that this is further evidence that Korean paper-making was more advanced than Chinese methods.

Scientific analysis and restoration

Mugujeongwang daedaranigyeong (National Treasure 126) is one of the world's finest cultural assets. Unfortunately, some parts required restoration owing to damage caused by moths. Therefore, the sutra was analyzed in minute detail (e.g. contraction, elongation and basis weight). Experts also factored in key criteria to create an almost identical type of thin mulberry paper, which was used to patch up the damaged sections by meticulously grafting the original and new fibers. The paper used was slightly wider and longer than the origi-

Key measurements:
Mugujeongwang daedaranigyeong

Single sheet	Length: 54.0cm-54.7cm; width: 6.5cm
9-12 sheets	Length: 205.9cm; weight: 8.4g
Average thickness:	0.080mm
Basis weight:	$8.73 \div 0.1338 = 65.2 \text{g/m}^2$
Density:	0.815g/cm^3
D (g/cm³):	$W / T \times 1000;\ 65.2 / 0,080 \times 1000 = 0.815115$

Mugujeongwang daedaranigyeong (無垢淨光大陀羅尼經, *The Pure Light Dharani Sutra*).

nal.

The restored sutra is a scroll measuring 6.228m long by 6.7cm wide. It consists of twelve attached sheets of paper, each 54cm long. The thin bamboo bar on which the paper was wrapped may be only 2mm in diameter, but it has remained intact for 1,200 years. When restoring the sutra, a wooden sleeve was fitted around the original to support it.

Restoration of *Mugujeongwang daedaranigyeong* and the *Silla baekjimukseo daebanggwang bulhwaeomgyeong* (新羅白紙墨書大方廣蓮華經, *The Avantamska Sutra*) was conducted by Japanese experts working for the National Treasure Restoration Center at Kyoto Museum, because Korean restorers lacked the necessary skills at the time. The sutras are now on display at National Museum of Korea and Hoam Museum, respectively.

Hanji's superior physical attributes

Having conducted a series of tests, I aim to prove conclusively that hanji is paper of the finest quality. The scientific experiments conducted to establish this also gave me an opportunity to learn more about hanji's qualities, so that I could contribute more to future projects. We compared three samples in the experiment (traditional hanji, traditional Chinese paper and traditional Japanese paper). The Chinese and Japanese samples were made using some modern papermaking methods. The tests results are as follows:

Experiment 1: testing physical attributes

Mulberry bast fiber is the main material used for making hanji. The type

(Top left and top right) Hanji under a microscope; (Bottom left and bottom right) Paper mulberry material under a microscope.

harvested in Korea is considered best. Fibers can be 3.33mm-17.08mm long (8.72mm on average) and 15.1μm-43.6μm wide (23.3μm on average). Lumen width is 3.4μm-29.7μm (11.7μm on average). The Runkel coefficient of mulberry fiber is 0.77; its expansion coefficient is 4%-8%, which is very high.

Mulberry fiber's three main constituents are lignin, pentosan, and holocellulose. The proportionate amount of each determines the fiber's physical characteristics: lignin acts as a bonding agent that stabilizes the structure of plant cells. Therefore, paper made from mulberry containing a large proportion of lignin tends to be strong yet rather course. For this reason, Korean producers ensure lignin levels are low by pruning one-year-old branches. On the other hand, a high level of pentosan has its own issues: the fiber extracted will be weaker, it will be less resistant to bugs, and it will be more susceptible to damage from additives.

Mulberry fiber can become softer or more flexible depending on the pro-

Physical attributes of paper mulberry fiber: a comparison of Korean and imported type

	Distinction	Freeness (°SR)	Thickness (mm)	Basis Weight (g/m2)	Wet Tensile Strength (g)	Water Absorption (g/m2)	Flexibility (g·cm)	Permeability (sec.)	Glossiness (%)	Whiteness (%H)
Korean	0	8	0.05	8.0	17.5	49.7	2.54	2.7	11.0	72.9
	0.1	8	0.04	12.0	12.9	59.5	2.54	2.7	10.8	76.3
	0.5	8	0.03	12.0	11.3	49.5	2.54	3.1	9.4	74.4
	1.0	8	0.04	15.0	24.3	65.0	2.54	2.9	9.0	78.7
Thai	0	8	0.04	14.0	29.5	56.0	0.64	3.0	5.0	79.1
	0.1	8	0.04	15.0	25.5	58.5	0.64	2.1	5.0	78.3
	0.5	8	0.04	15.0	23.9	54.9	0.64	1.9	5.0	78.2
	1.0	8	0.04	11.0	16.3	61.0	0.64	1.5	5.0	78.1

duction processes undertaken. Some processes can even form new layers. What is clear is that hanji has by far the longest fibers of the three types tested. The fibers extracted from the Korean mulberry are naturally longer than those from the Japanese oriental paperbush. Furthermore, the Korean method of beating fiber (instead of grinding it) helps to preserve individual lengths that make up the mass.

Tear Strength

Tear strength refers to the amount of sideways force paper can withstand before tearing. The paper is pulled simultaneously from each side. The more force withstood, the stronger the paper. Hanji's tear strength was measured at over 900; tests showed that other types (made from oriental paper bush or tree-rice straw blends) had lower tear strengths.

Tensile Strength

Tensile strength refers to the amount of lengthways force paper can withstand before tearing. The paper is pulled simultaneously from each end. Again, the more force withstood, the stronger the paper. Hanji withstood 62N and stretched 5mm before tearing. This contrasts with the results for paper made from oriental paper bush or rice straw mixtures. In conclusion, hanji was found not to tear or stretch easily.

Directional Property

The directional property test is conducted to assess how fibers have interwoven. The degree of directional property determines paper's strength. Paper made using the double-mould (the most common method used for making handmade paper) tends to have fibers pointing lengthways, following the mo-

Directional property test.

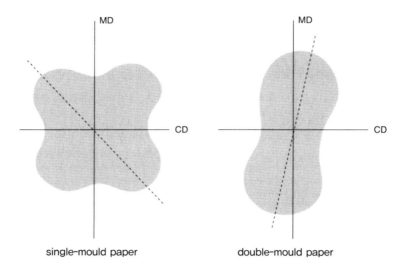

single-mould paper double-mould paper

Ink bleed test.

Hanji made by pressing two sheets together.

Gochi, a type of Japanese paper.

Hanji made using a single mould.

Imadate, a type of Japanese paper.

tion of the mould, which is designed to swing forward and backward only. As mentioned earlier, this differs from the single mould used in traditional hanji production, which can be swung sideways, diagonally, and lengthways. This means the fiber can interweave in many more directions, resulting in much stronger paper. Paper made using a single mould has a tensile strength of 9.8-11.3, has a stronger expansion coefficient, and has higher elasticity. This is superior to the type of a double-mould papermaking method prevalent in Japan today, whose long fibers are produced by swinging the mould sideways only. Double moulds use water contained in the mould, which encourages inconsistent, uneven paper formation that tears more easily. Japanese paper has a tensile strength of 7.8-8.6, significantly lower than hanji's.

Ink Bleed

Paper used for ink-painting and calligraphy should express the color of ink clearly, absorb the ink evenly, and should not bleed too much. A test was carried out to examine the degree to which ink would bleed on single-mould paper and double-mould paper. Results showed that ink spread further lengthways than sideways, such that characters appeared elongated on double-mould paper. This was caused by the paper's directional property as explained in the previous paragraph. Furthermore, the sample revealed occasional protruding large fibers, which might lead to unwanted ink spread. Ink written on seonji (a Chinese type) bleeds fast and evenly. Paper for calligraphy absorbs ink quickly because the paper used has short fibers. The downside is that short fibers produce paper that is far more delicate. Ink written on hanji does not spread much. This is because hanji goes through the hammering process after formation, which allows the ink to seep more and spread less. For this reason, bold coloring is possible on hammered hanji

without the paper having to undergo additional treatment. Essentially, because beating the long fibers creates a wonderfully even, consistently dense interwoven layer, the resulting paper proves very effective at restricting bleeding. This means hanji is an ideal material for all kinds of painting and writing. Tests do reveal inconsistent ink bleeding in hanji that hasn't been hammered though.

Absorption

The absorption and spread of ink was precisely measured. The purpose of the test was to establish the rate at which ink spreads on different types of paper. In other words, we measured how fast water was absorbed. Broadly speaking, hanji absorbs water more slowly but less consistently than hwaji or seonji. However, our tests revealed that hanji has both a higher dry- matter ratio and moisture-absorption coefficient than the other types.

Absorption test

Moisture-Absorption Coefficient		Dry-Matter Ratio	
Hanji	21.0–21.1	Hanji	27.0–34.3
Hwaji	16.5–20.1	Hwaji	28.5–29.7

Luminescence

The luminescence test assesses the glossiness of ink once it has been applied

Luminescence test

	Korean (Double Sheets)	Japanese Paper (Hwaji)
Paper Reflectivity	6.7	5.8
Ink Reflectivity	3.3	2.7

to each type of paper. Hanji performed best, recording a light reflectivity score of 3.0, significantly higher than hwaji and seonji (2.3 each). This is because Korean mulberry fiber is intrinsically glossy.

Additives

When magnified 200 times, hanji is free of impurities after being boiled in caustic soda. This contrasts with hwaji, which is littered with fragments of white lime. These leftover fragments may have been added on purpose: paper produced containing these fragments are more even and more opaque. It can also absorb ink better while withstanding acidification. However, the downside is that paper becomes weaker, and ink bleeds excessively.

We assessed the impact of leftover fragments of lime on ink bleed by measuring and comparing bleed rates: hanji took over nine seconds; imadate hwaji (boiled with soda ash) took 1.3 seconds; cochi hwaji (boiled with lime) took 0.1 seconds. This clearly demonstrates that lime that has been added to improve uniformity actually has detrimental effects (e.g. excessive bleed). This type of additive was introduced only quite recently, so we concluded that one of these modern techniques adopted for making hwaji uses this type of additive.

The right additive is essential to ensure the desired ink bleed. Okpanseon-ji, which is an additive originating in China, is a good option to achieve this.

Based on the experiment previously outlined, I have reached the following conclusions:

1. Current hanji production methods fail to take proper advantage of the superior qualities contained in the raw materials used in hanji.

2. Hanji should be promoted to draw public attention to its beauty and

artistic value.

3. Hwaji is much more popular than hanji. Hwaji mainly employs modern papermaking techniques, which has indirectly improved popularity and productivity. In order for hanji to compete and develop, it needs to adapt to the market. Superior quality doesn't guarantee success. It needs marketability, which can be achieved by improving hanji productivity. For this, we need to invest in new technologies and make better use of raw materials during production. These changes would also boost productivity of handmade hanji and low-volume operations.

Chemical tests

A chemical breakdown of hanji

We conducted tests to assess the proportion of bark extract, ash content, lignin, pentosan, and holocellulose in hanji. Results showed bark extract content was 5.60% in cold water, 7.18% in warm water, 3.86% in alcohol, and 38.09% in benzene (1% NaOH); ash content was 9.89%, lignin was 29.80%, pentosan was 16.89%, holocellulose was 75.36%.

We tested caustic soda made using burned buckwheat. Results revealed natrium, sodium and, interestingly, an optimum proportion of magnesium for boiling bast bark. Since magnesium has moderate alkalinity, it helps to maintain the strength of paper while not damaging its fibers. Hibiscus liquid, with its dense molecular structure, dilutes well in water, contains a lot of polysaccharide, and has neutral alkalinity. Therefore, paper made using hibiscus liquid can last for up to a millennium. We also concluded that the Korea's traditional single-mould papermaking method produces stronger paper than double-mould methods.

A chemical breakdown of baekpi

Mulberry Variety	Fiber Length/Width (mm/μm)	Extract Proportion (%) [In cold water/In warm Water/ In alcohol/ In benzene (1%) NaOH]	Holocel- luose (%)	Pentosan (%)	Lignin (%)	Ash Content (%)
Korean mulberry (Baekpi)	8.2/20.1	5.60/7.18/3.86/38.09	75.36	16.89	29.80	9.89
Thai mul- berry (Baekpi)	10.2/23.2	12.28/15.04/4.90/40.79	65.32	16.42	9.05	9.05
Oriental paperbush (Baekpi)	7.0/15.2	5.20/6.51/4.46/39.69	75.70	17.32	8.21	8.21

How hydrogen bonding facilitates hanji production

Many kinds of plants can be used for making paper. The basic method of papermaking is to form a plant-fiber solution, isolate and accumulate fiber by lifting and sifting, and then dry the fiber. Hanji doesn't require glue because its fibers interweave owing to the way hydrogen bonds at the molecular level. Fibers are made up of cellulose, a dense substance created through the polymerization of thousands of glucose units. Cellulose forms fibril, which combines with the hemicelluloses or lignin compounds that fiber cells contain. Paper production exploits this phenomenon with the way hydrogen bonds cellulose molecules. This bond occurs when oxygen atoms attract hydrogen nuclei. The incalculable number of hydrogen bonds helps the fibers to fuse and the paper to form.

How pH values change during production

One of the main advantages of hanji is that is has a neutral pH value. We tested alkalinity on different types of caustic soda (made from buckwheat, rice straw or cotton straw) used in hanji production. Results showed highest alkali

pH values

Alkalinity	Caustic Soda (buckwheat stalk/ rice straw/cotton stalk)	Production Process (washing/bleaching/mixing)	Hanji
pH	10.21/9.45./8.99	8.06/7.43/8.04	7.89

levels in the type made from buckwheat stalk; rice straw had the second most, and cotton stalk came third. When mulberry bark was boiled in each type of caustic soda, the pH gradually decreased until the bark became neutral. Hanji had a pH value of 7.89 after being dipped in (naturally neutral) hibiscus liquid during the formation process.

Chemical composition tests conducted showed that K_2O is the main constituent in each type of caustic soda. Traces of oxides were also present (P_2O_5, Na_2O, MgO, and CaO). Further tests revealed that the alkalinity of paper was affected most by K_2O. The constituents P_2O_5, N_2O and CaO also affected alkalinity, but to a lesser degree.

Chemical composition of lye water

Type	K_2O	P_2O_5	Na_2O	MgO	CaO	Fe_2O_3	Al_2O_3	TiO_2	MnO
Buckwheat Stalk	75.31	13.23	8.85	2.54	0.88	0.04	0.02	0.0007	0.01
Cotton Stalk	95.10	0.26	2.57	1.75	0.30	0.0007	0.005	0.0005	0.007
Rice Straw	91.27	4.08	3.49	0.57	0.53	0.03	0.003	–	0.004

How hibiscus liquid functions

Hibiscus liquid consists primarily of saccharides, which bond fibers, lending hibiscus liquid its adhesiveness during paper formation. After the paper has

Hibiscus liquid's constituents

Substance	Amount (%)	Etc.
Moisture	13.30	–
Ash Content	8.25	–
Glucose	10.35	Sugar
Starch	16.40	Sugar
Anabinose	9.65	Sugar
Rhamnose	8.96	Sugar
Galacturonic acid	6.71	Sugar
Galactose	6.22	Sugar
Lignin	4.59	–
Protein	3.20	–

formed and is exposed to air, the liquid's viscosity dramatically decreases. In this way, new sheets do not stick to one another when stacked.

A Comparison of acidity levels and fiber content in hanji and western paper

A line was drawn on samples of yangji and hanji using a pen-shaped acid indicator. The line on the yangji sample (western paper) reacted by turning yellow, whereas the hanji sample showed no change in color, revealing no reaction. Yangji's fiber weakens more easily because it consists of short-fibers; hanji is stronger because it contains longer, tougher bast fibers.

V

Hanji's applications

Hanji used for producing art
Hwaseonji
Hanji and other crafts

Hanji used for producing art

Painting is the most representative form of creativity and culture. Therefore, the development of painting is, like development in other fields of art, a good index to measure a nation's creativity, cultural maturity and cultural characteristics. Painting is based, in large part, on materials. Materials chosen are determined by their intrinsic characteristics and their availability. In other words, the basis of one's culture is determined by natural resources.

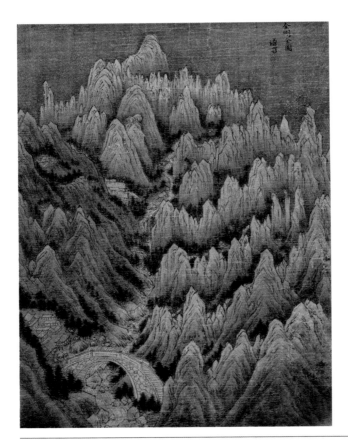

Gyeomjae Jeong Seon's
Geumgangjeondo
(金剛全圖).

The development of materials brings about new techniques in painting, which are part of cultural evolution. Therefore, materials are an integral part of all forms of painting. A sound understanding of any artistic field requires prior knowledge of the materials used. Artists always pay close attention when selecting materials. In addition, materials have significantly influenced a spectrum of popular art, in terms of the creative process and the end results. After all, a masterpiece could be discolored, damaged and depreciate rapidly as a result of misjudgment; careful scrutiny of appropriate materials at the outset is imperative.

Paper, brushes, ink and paint are required in western and eastern painting, and suitable tools to do the job have been introduced over time. It is important that we realize the differences between the paper and brushes originating in the West and East Asia: western brushes and paper tend to be harder and stiffer; eastern ones are thinner and softer.

Why is it that brushes and pens developed different characteristics when they were used for very similar purposes? The reason could be that the concepts of paper and brushes differ. Western brush and paper are made simply to satisfy specific human needs at a given time; they are purely inanimate objects. In contrast, eastern paper and brushes have vitality, and they are considered more than mere tools: the way that the paper breathes, and the manner in which the brush seems to careen. Furthermore, paper from East Asia is inextricably linked to sutras (sacred Buddhist scripture designed to record and reflect the human spirit). As such, paper has symbolized spirituality in east-

The author's hanji artwork.

Saekji (色紙) stacked in a range of colors.

A student's artwork.

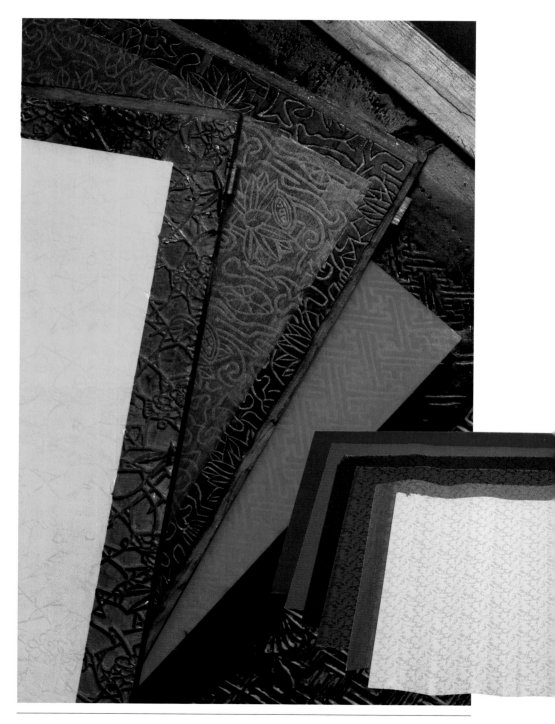

ern cultures. Residents in agricultural regions used paper talismans for protection. Guests at funerals and family members at *jesa* (a Korean ancestral ceremony) burned pieces of paper to guide the deceased to the afterlife. A substance is more than the sum of its parts; a brush or a sheet of paper is more than a tool. Each represents a source of life's deep-rooted principles.

Students attending a hanji class.

Materials may have similar functions and be used in similar ways, but the key difference between them is in the way they are conceptualized within the culture as a whole. Just as diversification of techniques and artistic expression grew, the uses of materials multiplied too. After several millennia, materials may begin to symbolize the spiritual side of culture. The conceptual origins, cultural significance and physical attributes of painting materials, such as paper and brushes, contrast dramatically in the East and West. For instance, the concept of *muk* (ink stick) doesn't even exist in the West.

Floral-patterned cardboard made of paper.

Hwaseonji

The most commonly used type of hanji today is hwaseonji. The question is whether or not we should treat hwaseonji as traditional Korean paper: the types of paper used during the Joseon dynasty are mentioned in *Dongguk yeojiseungnam* and *Sejongsillok jiriji*. Hwaseonji is not mentioned in either text. The name entered circulation soon after Korea's independence from Japan, when it appeared in records. It is assumed that hwaseonji got its name from the Chinese seonji. While some say seonji was originally used for transcribing the emperor's orders, this is not so. Seonji is a specialized product made in Sinseong (located in China's Anjing region). So the name is derived from the region where it was first produced and collected for national distribution.

Hwaseonji originated in Japan, where Japanese artisans attempted to copy Chinese seonji. It literally translates as "paper used by the virtuous", and is known as gaseonji, gasensi, seonwolji, hwaji, okpanji and okpanseonji.

Hwaseonji gained popularity among Korean artists after *Bukhakpa* ("the Pragmatists") exerted power and influence within the Joseon dynasty. Jang Seung-eop, an artist, was the first to use hwaseonji regularly in his works, and is now revered as a pioneer. Chinese paper was readily available, but once Bukhakpa had introduced aspects of the Qing dynasty's culture to the peninsula, Chinese paper took off in a big way, used by scholars, calligraphers and artists.

The ruling class admired literature but largely ignored the technological advances that made this possible. Aristocrats and scholars spent their leisure

Ink bleeding on hwaseonji (畵宣紙).

A range of ink colors on hwaseonji (畵宣紙).

Hwaseonji (畵宣紙) under a microscope.

time immersed in writing and drawing. Poetry, calligraphy and art fuelled interest in muninhwa, a style of painting adopted by scholars using monotone ink. Hwaseonji inspired the development of alternative painting techniques, demonstrated in works, such as *Hochwido* (豪鷲圖) by Jang Seung-eop (which used a bleeding technique), as opposed to *Geumgangjeondo* (金剛全圖) by Gyeomjae Jeong Seon (which used a traditional overlapping ink technique to paint rocks and trees black).

Hwaseonji originally exhibited characteristics typical of Chinese paper, and was made from fermented chengdanpi fiber. Today, a sheet of hwaseonji contains 90%-95% wood pulp, which is the main material used for making yangji (western-style paper). As such, about 5%-10% of paper mulberry is added for effect. Those who believe hwaseonji represents Korea's paper culture are misguided, since it is merely a bland imitation that has influenced Korean painting techniques and ideas. Many commentators question its merits and argue we should reevaluate its place in Korean culture.

Hanji and other crafts

Koreans traditionally made paper using high quality materials. From here, paper-based crafts emerged, whose artisans started producing a wide variety of quality everyday items. This is what I mean by *hanji craft* or *paper craft*. The mulberry paper items range from household essentials to large-scale artworks. The types of hanji used are also known as jigongye, hanji gongye, or jongi gongye.

Hanji craft can be classified according to its production method. For instance, jiseung gongye is a craft that uses a twisted type of paper; jiho gongyeo uses a crushed type for making frames; jeonji gongye uses colored paper for decorating objects.

Types of hanji craft

There is a wide variety of hanji craft and there are many subcategories, classified by production method, materials or use. Those types categorized by their production method are included here.

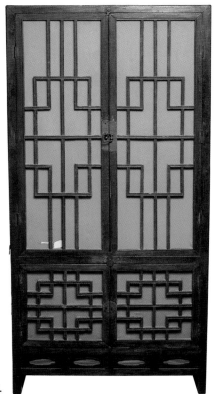

A wardrobe made out of paper.

Hanji craft categorized by production method

Colored paper craft (色紙 工藝)

In colored paper craft, the hanji is traditionally dyed, before being pasted on a frame made of several layers of hanji. Decorative patterns can then be added. Blue, red, white, black and brown are the basic colors. Typical examples and uses were boxes for storing thread, boxes for wedding presents and gifts, and boxes for storing dressmakers' tools.

Paper trimming craft (剪紙 工藝)

Paper trimming craftwork is made by cutting out hanji patterns with scissors or a knife, whereby each pattern is drawn on the hanji first, cut out, and then pasted onto objects whose surfaces have already been covered with hanji. Afterward, the surfaces are varnished. Well known types are five-colored and embossed ones. Typical examples and uses were boxes for storing thread, boxes for wedding presents and gifts, and boxes for storing dressmakers' tools. All kinds of boxes and closets for the home were traditionally made using this craft.

Paper trimming craft: small boxes.

Paper flower craft (紙花 工藝)

This craft specializes in creating imitation flowers out of hanji. They are often used at national ceremonies instead of real flowers and Joseon National Test winners often received them. Paper flower craftworks were traditionally used at temples, decorated biers, and featured in shamanic rituals.

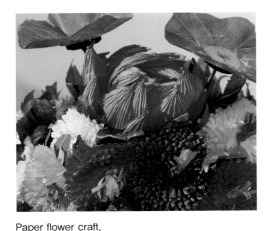

Paper flower craft.

Paper trimming craft: small boxes.

Wooden frame craft (紙纖 工藝)

This refers to artwork whose frames are made of wood or bamboo. Once made, the frame is always covered with several layers of paper. Sometimes plain paper was used, before receiving a bean water, persimmon water or lacquer varnish. Pictures or calligraphy might be added to the paper. Examples include containers for documents, arrows, glasses, hats and suitcases.

Wooden frame craft: jongiham.

Wooden frame craft: lamps.

Thick paper craft (厚紙 工藝)

Several sheets of paper are layered before being folded. This is created using thick, folded paper. The surface was sometimes decorated with concavo-convex patterns. Once decorated, huji craftwork was often mistaken for leather owing to its thickness and strength.

Thick paper craft: small boxes.

Paper mould craft (紙戶 工藝)

Paper mould craft refers to a technique where paper is torn into small pieces, soaked in water, and then either poured into a cast or layered. More paper is added, and then the surface is varnished with oil or paint. Artisans often made bowls and basins.

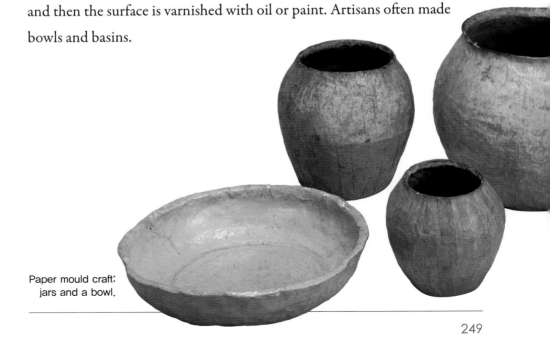

Paper mould craft: jars and a bowl.

Twisted paper string craft (紙繩 工藝)

This refers to the craft in which objects were made with interwoven strips of twisted paper. The shape of an object is formed depending on how the strips are placed. Twisted paper string craft incorporates various patterns and colors. Surfaces are varnished with oil or painted. Artisans made objects used at traditional Korean ceremonies, mesh bags, mats, tea tables, wallets and bowls.

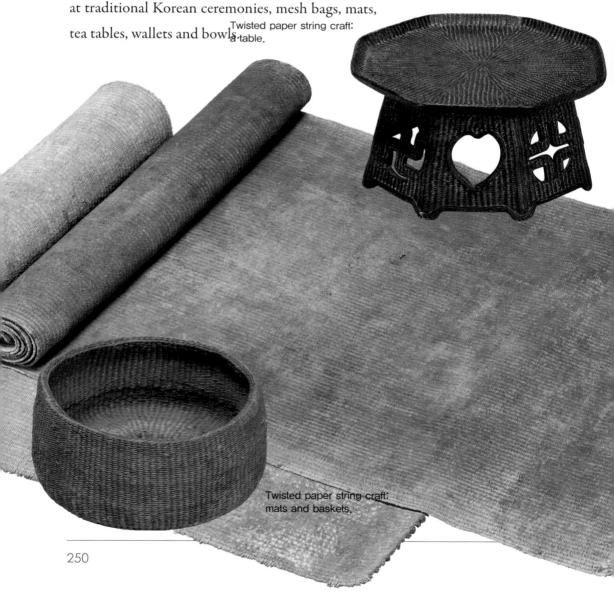

Twisted paper string craft: a table.

Twisted paper string craft: mats and baskets.

Paper embossing craft (jumchi gongye)

The paper used for this craft has a regular concavo-convex pattern across its entire surface. In spite of the fact that very few original exam-

ples remain, jumchi pouches, purses, and bags do still exist. Nowadays, this craft is widely used for making paper clothes and purses, given its sturdiness and durability.

Paper embossing craft: a box.

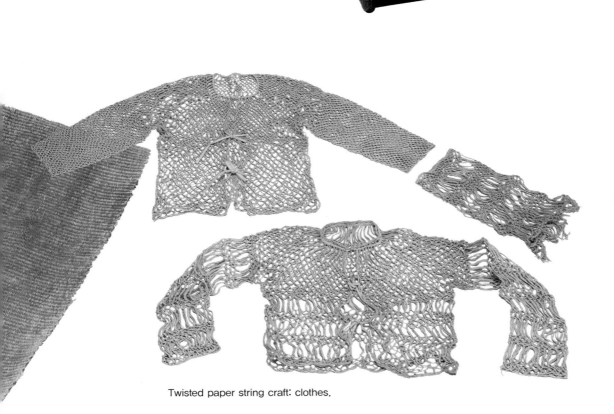

Twisted paper string craft: clothes.

Hanji craft categorized by shape

Flat

Objects with flat surfaces (e.g. cigarette pouches, paper pouches, boxes, types of floor cushions) are made using jiseung. Purses are made by folding layered paper several times. Beautifully-decorated paper cloths and paper envelopes use oilpaper.

Circular or oval

Circular items are particularly common in objects made using jiseung craft. Most examples are bowls and baskets, but also include small round tables and varnished portable bedpans. Washbasins use jiseung too, before being covered with paper and painted black. Oval items are less common, while most examples are sewing boxes or small containers.

A pencil case.

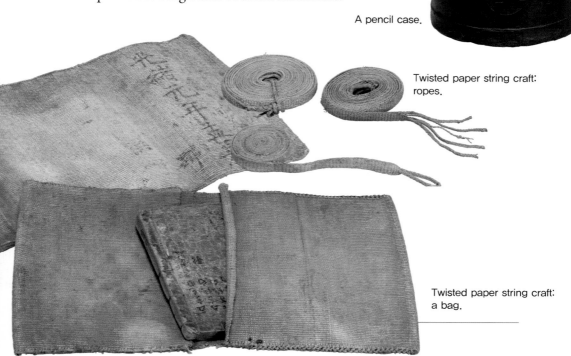

Twisted paper string craft: ropes.

Twisted paper string craft: a bag.

Quadrangular

Most hanji craftwork is either rectangular or square. Examples include thread containers and boxes; many of these contain smaller boxes. While there are many types, one that stands out is najeon jiham. The type's top, back and sides are covered in thick lacquered paper, while the front is decorated with beautiful shells. Applications include cabinets and boxes for filing paperwork, storing books, keeping stationery, and wedding presents.

A traditional suitcase used by officials.

Colorful boxes.

A chest of drawers.

Polygonal

Octagonal items proved more popular than hexagonal ones. Everyday examples include hexagonal baskets and octagonal dippers. Octagonal sewing boxes were often decorated with paintings. Original polygonal hatboxes also exist.

A sewing box.

Twisted paper string craft: octagonal trays.

Colorful octagonal boxes.

Other shapes

Applications include paperweights (stones covered in paper), Korean chess-piece pouches, dippers, water jugs (ceramic covered in paper), shoes, clothes, hats, and even umbrellas.

A fan.

Materials used in hanji craft

Hanji

Traditional Korean hanji is made from paper mulberry and is of excellent quality.

Natural dyes

Craft items used the same natural dyes as those used in the production of clothing. In the same way, craftwork painting used the same pigments (dangchae) as those used in traditional painting According to historical texts, the five major colors (red, blue, brown, white and black) representing the principles of *yin and yang* were often used; purple (considered a noble color) and other compound colors were used as well.

Lacquering

Refined tree sap served as the lacquer traditionally used for coating paper-based craftwork. The consensus is that this type of lacquer has probably been used for a long time, given that the same lacquer was found on Silla artifacts. Applying a coating of lacquer protects craftwork against damage caused by insects or moisture.

Hanji craft production techniques

The twisted paper string method

• Common production method

1. Cutting paper

For mulberry paper, cut into strips 2cm-5cm long; for goseo (old books), cut into strips with widths equal to the distance between the lines on lined paper. The size of the core will vary depending on the width of the paper you cut. Each strip should have its ends cut at 45° (making a diagonal). This will help later when the strips need to be connected.

2. Weaving the strips

A single strand is created by holding a paper strip between the thumb,

Craftwork made using twisted paper string craft techniques.

middle finger and ring finger, and then twisting the strip counterclockwise. A double-strung strip is made by holding two strands between the ring and little finger, and twisting them counterclockwise with the right hand. This technique should entwine the two strips.

3. Weaving the base (inside)

The shape of the base determines the shape of the entire object (e.g. circular, oval, etc.)

4. Weave the base's inside edges

5. Weaving the inside

Once the base's edges are finished, entwine a double-strung strip and a single strip. At this point, one of the strips should be longer than the other. Keep entwining the entire lengths.

6. Weaving the outside

Once the inside is finished, trim the inside edges and start weaving the the outside (in exactly the same way).

7. Weave the base (outside)

8. Add the finishing touches

When the object is completely covered in layers, push the core to the floor, twist in the opposite direction, and wrap it up.

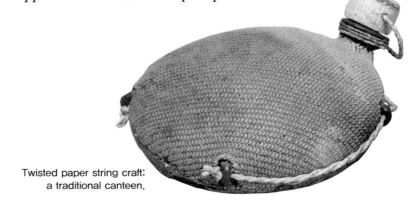

Twisted paper string craft:
a traditional canteen.

The twisted paper string method

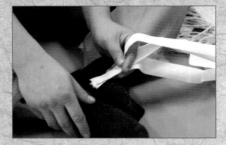

1. Cut hanji into appropriate lengths. Take three strips.

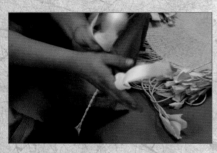

2. Braid string by placing the strips between palms and rubbing back and forth.

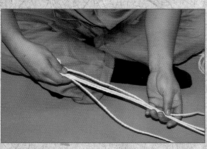

3. Lay out the strings to make the required shape.

4. Loop and tie the strings in a crisscross fashion.

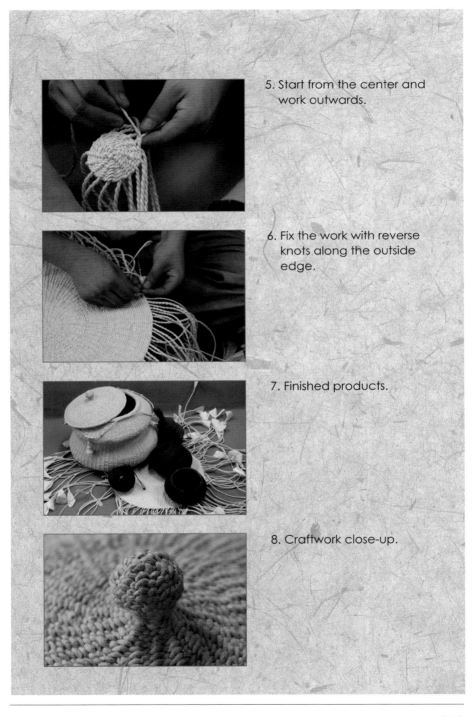

5. Start from the center and work outwards.

6. Fix the work with reverse knots along the outside edge.

7. Finished products.

8. Craftwork close-up.

Comprehensive method (jijangcheophwa method + jeopji method)

• Common production method

1. Cutting materials (based on shape and use)

 Use cardboard, bamboo, willow or bush clover wood. This will depend on the required shape and use of the item. Measure the material and cut it.

2. Creating objects by layering and gluing

 Glue the cut pieces together to create a desired item (e.g. a container). Once the item is completed, dry it in a shaded, well-ventilated room.

3. Decorating

 Decorate the finished item with goseo and sunji. Ensure that the previous layers are completely dry. Failure to do so could result in rough or warped surfaces.

A box made of colorful paper.

The process of making a paper box

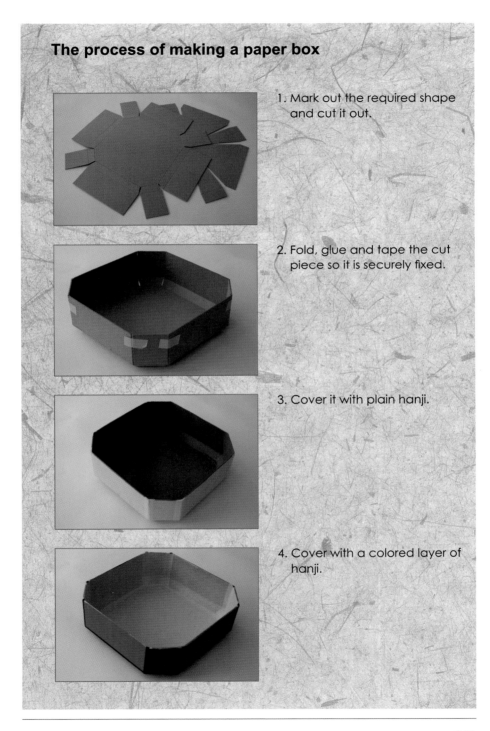

1. Mark out the required shape and cut it out.

2. Fold, glue and tape the cut piece so it is securely fixed.

3. Cover it with plain hanji.

4. Cover with a colored layer of hanji.

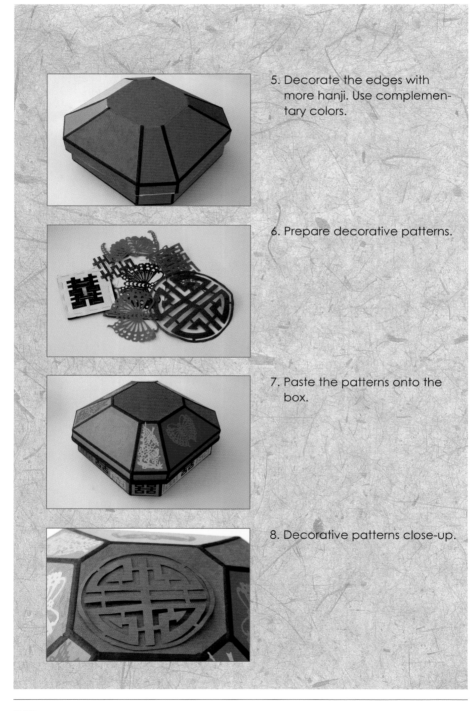

5. Decorate the edges with more hanji. Use complementary colors.

6. Prepare decorative patterns.

7. Paste the patterns onto the box.

8. Decorative patterns close-up.

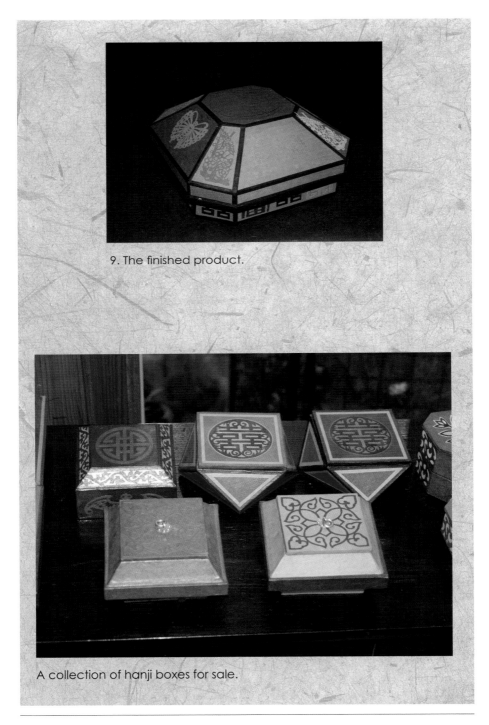

9. The finished product.

A collection of hanji boxes for sale.

The paper mould method

• Common production method

1. Fermenting paper

 Tear changhoji or used paper into small pieces. Put the pieces in caustic soda and allow the solution to ferment for two months. The caustic soda prevents the paper from rotting, while enabling it to disintegrate.

2. Filtering and rinsing caustic soda

 Once the paper has disintegrated completely, a sieve should be used for filtering and rinsing the mush, until the caustic soda has been completely removed.

3. Draining

 Drain the paper using a cloth or sack.

4. Pounding in a stone mortar

 After the paper has drained, place it in a stone motar and pound it into very fine pieces.

5. Preparing glutinous-rice glue

 Grind glutinous rice, boil it, and mix thoroughly with the paper stock.

6. Making the form

 Make the form by covering an object (e.g. wooden bowl, water jar, a pot) with wet paper. Add the paper clay.

7. Finishing

 After removing the form, allow it to dry in a shaded, well-ventilated spot (indoors or outdoors). Strong sunlight might chap the surface, or cause cracks to appear later. Remove the form from the paper clay.

VI

The future of hanji

Problems associated with present-day hanji

Hanji's current status and future

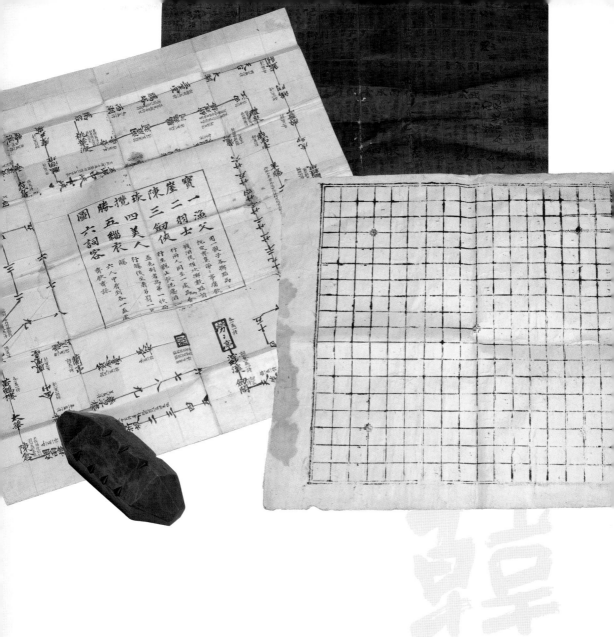

Problems associated with present-day hanji

Hanji today is considered commercially viable if modern tools and chemicals are used in the production process. The downside is that these approaches diminish its essential qualities. Most of all, its durability has decreased dramatically. The durability of paper is influenced by the amount of manmade additives present in its natural fibers. Air, sunlight, heat and temperature also affect durability; however, impurities in the fiber or low-quality additives can rapidly worsen the condition of paper even without a change in the environment. Paper produced before the 16th century could be expected to survive unless it was exposed at some point to adverse conditions, such as high humidity. In contrast, machine-made paper produced

A field of paper mulberry during winter.

from the beginning of the 19th century tended to disintegrate much sooner owing to the inferior materials used.

In 1929, John Murray discussed factors that impaired the durability of paper: damage to fibers caused by machines; the use of mineral bleaches; the use of alum for sizing, hydrochloric acid for removing alum bleaching powder; the overuse of bleaching powder. Other commentators highlighted the limited choice of pulp materials available. Esparto, wood fiber and ground wood all had low durability but were still viewed as viable sources. Britain first experimented with these in the 1850s. Over time, paper's conservative properties took a backseat to economic considerations. In 1898, Britain's Royal Arts Committee established standards by which fiber quality was classified according to its durability:

Class A: cotton, linen, hemp, bast fiber
Class B: wooden fibers (sulfite pulp, alkali pulp, craft pulp)
Class C: esparto
Class D: ground-wood pulp

The best Class A fibers are used for making paper that can be preserved almost indefinitely; Class D fibers are used for making paper for temporary use; Classes B and C are determined by levels of refinement or the amount and types of additives used. The standards applied to Class A depend on additives used; the following standards were proposed by the Royal Arts Committee:

- Fiber: Class A fiber should exceed 70% of the total.
- Sizing: rosin should account for less that than 2% of the total. Acidity of refined alum used for fixing rosin on paper should be carefully moni-

Sun-dried mulberry bark produced in Korea.

tored and meet established standards.

- Chemistry: mineral content should not exceed 10% of the total.
- Paper discoloration: paper rarely discolors as long as it is stored in a well-shaded area at moderate temperatures with humidity levels of 50%-65%. Excessive sunlight, heat, or humidity fades or yellows paper, mainly caused by the rosin, lignin or iron reacting. (Both iron and rosin contaminate paper during the sizing process). Therefore, yellowing is not caused by cellulose itself. Normal paper has an iron percentage of 0.002%-0.01%. Paper should be considered of superior quality when iron content is less than 0.005%.

Imported Manila hemp (abaca) steamed with caustic soda.

Imported paper mulberry treated with caustic soda.

A comparison of traditional and modern hanji

	Traditional Hanji	Modern Hanji
Mulberry material	Use white bark only (Korean paper mulberry)	Different mulberry or imported types of paper mulberry used (e.g. Thai, Chinese); pulp or recycled paper used
Chemicals used for boiling	Use ash (buckwheat stalk, cotton stalk, or rice straw) to maintain the appropriate pH	Boil using caustic soda (NaOH) (>pH12) instead of slaked lime ($CaOH_2$)
Bleaching	Bleach in running water for 3-7 days	Bleach using chemicals (e.g. hydrochloric acid)
Beating	Beat fiber with a mallet. Stir with a stick	Use a machine beater instead of a mallet (round beater/ knife beater)
Dispersant	Use hibiscus liquid	Use chemical dispersant (e.g. PAM)
Paper formation	Form by hand	Form semi-automatically/automatically
Drying	Dry in the sun, hang on a wall or use an ondol	Dry on a steel plate
Treatment	Hammering	No hammering. Sizing when necessary
Finishing	Ironing	No ironing

Problems associated with present-day hanji
Problems caused by lignin and resin

Lignin is the second most common highly-polymerized compound that exists (carbohydrate is the most common). Lignin content in plants varies depending on the type of plant. For example, timber from broadleaved trees contains 20%-25%, coniferous lumber contains 20%-30% and herbaceous plants have 15%-20%. Lignin comes from the Latin *lignum*, meaning timber. It is classified as a high polymer and is difficult to hydrolyze in acid. It resides mainly within the cell walls of hardened limbs (wooden trunks, branches, stems and twigs). While each species exhibits distinct characteristics,

roughly two-thirds of lignin resides within the cell walls. Timber from tropical species is noted for its high lignin content.

Plant tissues are loaded with amorphous, insoluble resin. The amount of resin contained again depends on the species and habitat. For instance, paper mulberry species indigenous to tropical and subtropical regions tend to contain a large amount of resin.

Recent studies have shown that calligraphy ink and paints do not absorb evenly on paper and sometimes form collections of white spots. Calligraphers and artists often complain that the paper they use is either too dry or contains paraffin; however they tend to overlook the root of the problem. There are two possible causes: first, the artist could be using an inferior type of paper, which is substandard and should be avoided because it was produced using timber from tropical or subtropical regions whose resin was not melted properly. If so, excess has compromised the quality of the paper's

Imported Paper mulberry.

surface. Alternatively, it could be that the dispersant PAM did not melt completely. This occurs especially with paper produced using paper mulberry from Thailand or Chinese regions south of the Yangtze River. Because the resin content in Korean mulberry is low, artists do not encounter these problems when using hanji made from pure Korean white bark. In other words, resin spots are caused by the quality of original materials instead of the paper being to dry.

Problems involving hibiscus liquid and chemical bleaches

Once moist sheets have been formed, they are placed on a support table, pressed, and separated so that they can be dried. Adding hibiscus liquid to paper stock makes it easier to separate sheets after they are pressed because it blocks hydrogen bonding in the fibers. Without hibiscus liquid, fibers will not disperse evenly. This will result in paper that has an uneven surface and an inconsistent thickness. Western producers of handmade paper place felt between sheets in order to separate sheets easily.

The most common industrial additive used instead of hibiscus liquid is PAM. This combines acrylamide and acrylic acid, which results in excellent dispersibility and durability. It works well with long fibers such as paper mulberry and hemp, enabling faster paper formation. In addition, it improves the strength of the paper. However, PAM does have its drawbacks: the additive can burn paper or leave blackened spots if it is not melted properly first. Furthermore, hanji made using PAM liquid is less durable because of premature acidification. Paint discoloration can also occur if traces of residual PAM react with paints.

Industrial bleaching agents cause considerable damage to fibers, making them less durable and increasingly susceptible to discoloration. In tests, pa-

Hibiscus in flower.

per that had been produced with bleaching powder turned gray after black ink was used. Other samples produced with bleaching powder turned an even darker shade after paints were used.

Problems involving beating methods

Fibers are damaged through beating primarily because the process cuts them. In the East, each sheet would have been placed on a wooden plate or flat stone, and then beaten with either a wooden mallet or a large mortar. Different tools and methods were adopted in the West: "wet beating" used a blunt metal bat or basalt bat; "free beating" used a sharp metal bat to cut the fibers more finely; "stamper beating" crushed fibers with a waterwheel. This method was probably invented by the Moors and introduced to the West, where it became commonplace from the 17th century. Sheets were first beaten with large wooden mortars featuring iron bridles, and then with

a lighter nailed mortar. A flat, wooden mortar pestle was employed next. The Hollander beater was invented in the 1680s, which became extremely popular among papermakers because of its unrivalled efficiency.

East Asians traditionally used the wooden mallet to beat fibers because the tool proved effective in forcing fine fiber to the surface of the paper mulberry. Consequently, this promoted hydrogen bonding in the sheet formation process. As mentioned earlier, good hydrogen bonding produces strong, durable paper. The desired results were achieved without damaging fibers. In contrast, the knife beater may have been more convenient, but it shortened and weakened fibers in the process, and reduced the paper's tensile strength.

Problems involving sizing

Ink bleeds excessively when ink is used on paper that has not been treated. Sizing is a method of treating the surface of paper to prevent this. Two methods of sizing are used: the first involves treating the surface of paper directly; the second works by filling the paper's air cavities with a sizing agent, which significantly reduces the amount of moisture absorbed.

The most common sizing agents are glue, rosin, starch and synthetic resins. Rosin sizing is a very simple method that was invented in the early 19th century in present-day Germany and soon took off. Essentially, rosin is a resin derivative, obtained by tapping the sap of coniferous trees. The sap is then distilled to remove turpentine. Sizing is carried out by adding the rosin sizing agent and aluminum sulfate to the paper stock before paper formation. The method is easy, cheap, and can be undertaken all year round. The downside is that the large quantities of rosin are required in order to provide the required quality for sizing. The excessive amount causes paper dis-

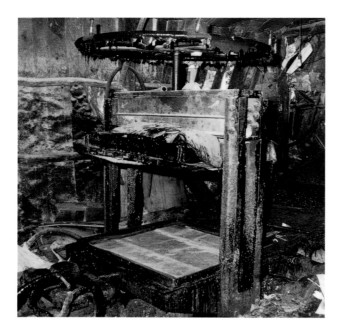

A sizing machine used for
jangpanji (壯版紙).

coloration. Aluminum sulfate causes damage too, which is why it has largely
been replaced by less corrosive, more neutral agents.

Alum compound is another common type of sizing agent that is very easy
to use. This too can impair the quality of paper through acidification. Using
alum when sizing is likely to significantly reduce the durablilty of paper pro-
duced.

The acidification of paper

Pulp used for making paper contains cellulose comprising many types of
glucose units. These units are damaged by hydrolysis, a reaction that oc-
curs if the pulp is too acidic. Alum compound is acidic and therefore causes
the majority of glucose damage. Western paper has considerable acidity in
part because kaoline, titanium oxide or resin sizing agent is added during
production to make paper more opaque and to create a smoother surface.

Chemically-bleached paper mulberry material.

However, the additives become electrically charged in water, which causes them to separate from the fiber layers. The acidification of paper can also be caused by the presence of aluminum ions, the result of aluminum sulfate being added. Hanji is also susceptible to acidification, caused by additives, air pollution and water pollution.

Hanji's current status and future

Hanji fell into decline with the introduction of yangji at the end of the Joseon dynasty, shrank further during the Japanese occupation, and had virtually disappeared by the industrial boom of the 1970s. Yangji was introduced to Korea by Kim Ok-gyun when he returned from Japan in 1884 (the 21st year of Gojong's reign). The consensus is that, even by this point in the late-nineteenth century, hanji production methods were far less efficient than yangji methods.

Traditional hanji was handmade so production could neither scale up nor become as efficient as machine-based industries. Because yangji was produced entirely by machine, it could be mass produced, and it could be made more cheaply and efficiently than hanji. Furthermore, hanji could no longer compete on quality owing to a shortage of decent mulberry. It wasn't long before yangji eclipsed hanji as the obvious choice of paper for everyday use.

A number of changes in production methods were introduced in an attempt to overcome commercial difficulties: instead of expensive domestic mulberry, imported mulberry, abaca, pulp, and recycled materials were adopted. Using these sources reduced quality along with prices. Next, producers started using chemicals (soda ash, caustic soda, bleaching powder) for boiling and bleaching, which did improve efficiency markedly. The machine beater then replaced the wooden mallet, after which the traditional single-mould/ sun-drying/ ondol-drying method made way for the double-mould/ steel drying plate method. These changes in production boosted productivity by saving time and money, although hanji did lose its organic purity and

intrinsic strength in the bargain. The days were numbered for single-mould and jangpanji-making traditions.

The continual chaos that plagued Korean society throughout the twentieth century also contributed to hanji's demise. The Japanese occupation, the social upheaval that followed Korean independence, the Korean War, the "5.16" military coup, and the South's relentless industrial growth thwarted any chance of a hanji revival. Hanji production was also impeded because drastic changes in the agricultural system meant most papermakers could only produce hanji in the farming off-season. This rapid fall in supply was accompanied by a dramatic fall in demand for changhoji and jangpanji (used for covering windows and floors in traditional Korean housing) as millions moved into modern accommodation.

In conclusion, there are three compelling reasons for hanji's collapse: the

Petal paper.

first is sluggish demand. Hanji is hardly used or needed in everyday life. It is seldom used in calligraphy or eastern painting. It may be part of Korea's cultural heritage, but hanji cannot be sustained by current levels of demand alone.

Secondly, national policy does not provide adequate support for hanji. Most decisions made concerning cultural projects (including hanji) are part of a piecemeal process, instead of a much needed coherent and continuous cultural policy. Furthermore, if we truly value Korean cultural assets, we must come up with solutions to use hanji in various ways. Isolated white elephants should be abandoned in favor of a campaign to create demand for and the development of hanji. And a concerted campaign could foster the necessary public awareness to achieve this. It would also ensure taxpayers' money well spent.

A hanji workshop for children.

Third, there are problems with regard to consumers and artisans. During the twentieth century the deteriorating quality of hanji followed the same trajectory as dwindling traditional hanji-making skills and knowledge. Present-day consumers are so used to low-quality hwaseonji (a blended type of paper) that they may question whether it is worth investing in better quality hanji. We know the quality of products is driven by consumer expectations and

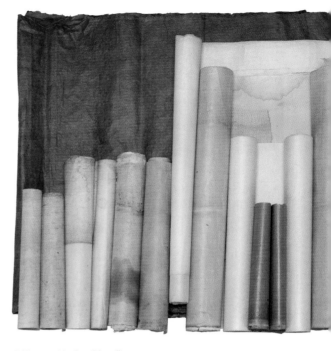

Different kinds of hanji.

spending habits, so what does this mean for hanji and its producers? To begin with, most hanji producers run modest operations out of small factories, and they get paid on a per sheet basis. This encourages many to cut corners in order to boost volume and turnover. Papermaking itself is not an easy job, so finding qualified, skilled workers is becoming increasingly difficult. This shortage is exacerbated by the problems of limited demand and compromised quality already mentioned. It is imperative that we support and nurture more artisans who can drive the hanji industry.

Maybe traditional hanji just isn't marketable? I, for one, am optimistic that there is an unlimited yet untapped global demand for it. A glance at the Japanese paper industry should instill confidence. Japan adopted and adapted papermaking methods introduced by Koreans, developed unique

products using them, and then gained international recognition and market share. Korean hanji is better quality paper than Japanese hwaji, so it has a lot of potential. We need only review some of the hundreds of types of hanji available during the Joseon dynasty to see that our heritage could also be our future. The following suggestions give an overview of ways to promote awareness of hanji and to enhance its development:

Improve quality and change consumer habits

In order for hanji to become competitive in today's global market, Koreans should leverage traditional hanji methods and specialize in niche markets. Currently, the East Asian handmade paper market is dominated by Japanese hwaji. Hanji, despite its quality, is either unknown or dismissed as a cheap alternative to hwaji. This misconception has led art supply shops in Paris and New York to shun it. Hanji's intrinsic strength adds real value as a material for woodblock printing, painting and crafts. Upmarket types could also be marketed for floor coverings (jangpanji), quality wallpaper, books, ornaments, and paper for painting. Each of these would help to revive hanji through everyday usage.

Develop education programs

With the right education programs in place, children would be able to access hanji much more easily. This could involve workshops in which students made paper lamps, flower-petal paper or paper dolls. The classes could generate interest in hanji, and regular trips to museums could raise awareness. There should be a drive to deliver suitable books and programs on the subject in the near future.

The author's hanji artwork.

A paper dress.

Colorful hanji made with natural dyes.

Indigo-colored hanji; lacquered hanji.

Develop new industrial applications with hanji

New materials should be developed that exploit hanji's physical properties, mirroring the way Japan developed its hugely successful semiconductor insulation paper based on hwaji (and went on to claim more than 80% of global market share). Other applications could include bulletproof vests, disposable surgical gowns and underwear. A new PR campaign pushing hanji's traditional applications would also serve to spark interest (sheets, page covers, watermark paper, paper for restoring old relics and natural-dye paper).

Support hanji institutions and commercialize hanji culture

R&D precedes the development of all successful new products. Piecemeal projects and token support rarely work. The government should regularly assign research projects to individuals and institutions dedicated to hanji research in order to build on results and achievements. This should take place before hanji is commercialized. After all, effective strategies and promotional ideas flow from a foundation of expertise and experience.

The Japanese success story with hwaji should serve as a template, by showing us how to overcome practical issues, how to invest in a cultural asset wisely, and how to make this asset commercially successful. In Japan, there is a large pool of professional artisans and apprentices in place, supported by a backbone of government-sponsored institutions devoted to paper and papermaking (located in every famous hwaji-producing region). These institutions get involved in every aspect of paper production: they develop, review and distribute new tools and technologies. They oversee promotion and monitor both domestic and overseas markets. The Japanese model combines the artisan, the consumer and government policy seamlessly, complemented by frequent lectures and programs run in all prefectures. In addition, there are

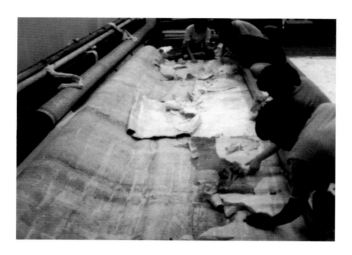

All hanji pieces that acquire cultural heritage status are treated with preservatives.

over 40 hwaji museums dotted across Japan. As the saying goes, "Culture belongs not to its creators, but to those who engage in and cherish it." Korea has a long and rich cultural heritage of hanji-making, which can only continue if we acknowledge its importance and value. The hanji industry should see a renaissance once we begin to make the most of its merits and qualities in our everyday lives.

Appendix

Glossary

Gaeryangjibal: The double mould mainly used for producing hwaseonji or jangjaji. Known as damezuki (だめずき) in Japan.

Geopumjil: The process of steadily providing paper with moisture during hammering.

Geonjobi: The brush used for drying paper or spreading moist sheets on a steel plate. The brush is made with reed ears that have been boiled in salted water. Pokeweed or horsehair can also be used. (Dimensions: 50cm long × 30cm-35cm wide; handle length: 6cm).

Gunggeuldaechinda: The process of removing moisture from sheets with a wooden roller. Rolling is carried out several times. Korean *gungeuldae* translates as "wooden roller".

Kalmo: The cloth placed between sheets and the plate. It was traditionally made from straw bags or burlap bags.

Namba: A laborer engaged in papermaking chores.

Dareum: The process of drying paper on an ondlolbang (jibang) floor.

Dareumhanda: A method of warming rooms. The term is derived from *dalgumjil*, meaning "heat treatment".

Dakchaegyeoruep: Paper mulberry fiber located directly beneath the trees peeled bark.

Dakpuleul: The process of crushing hibiscus roots to extract liquid.

(Alternative sources: elm roots, bracken roots, other tree leaves).

Daemakdaegi: The stick used for stirring paper stock.

Dochim: A treatment to smooth surfaces and prevent excessive ink bleeding. It also prevents the protrusion of fine fibers.

Teunda: The paper-formation process using a mould. It is also known as *chojihanda*.

Mulnamu: Wooden tongs made out of mulberry. The arms are connected by a tie.

Muleul teonda: The scoop-drain method using a mould to form paper.

Muljilhanda: This refers to the process of forming paper by scooping water and tilting the mould sideways to drain off water and form paper. The modified method scoops water at the front and drains water during both forward and backward swinging motions; the traditional method scoops up water at the front that drains off the back. The mould is swung lengthways and sideways, although paper thickness is controlled through the sideways

swing alone). The process is repeated several times.

Badag: The degree of uniformity on the surface of paper. If the surface is very even, it is referred to as being *badagi gopda*.

Batang: The process of placing and squeezing sheets on a plate.

Bege nonneunda: A string spacer placed between the edges of moist sheets to aid layer separation is a *bege*. The action of placing the bege between sheets is known as *bege nonneunda*. Nylon thread is used today; tall flat sedge grasses were traditionally used.

Soepangan, Cheolpangan: The rack used when drying paper on a steel plate. The paper was traditionally dried in ondol rooms, known as *jibang*.

Seure (Haeri): The process of stirring paper stock in a vat with a bamboo stick. Short sticks extend along the length of the bamboo stick every 5cm. This process of preventing lumps from forming in paper stock is also known as *haerihada* in Korean, and referred to as *sabu* (さぶ) in Japanese.

Uibaljibal: The mould used for making traditional Korean hanji (e.g. changhoji, baekji, and bunbaekji). The Japanese equivalent is *nagasijeuki* (ながしずき).

Ilgunda: The process of separating a sheet (or sheets) from a moist stack.

Indae, Iraetdae, Irajidae: The stick used for separating moist sheets. It is usually made of paper mulberry or slim bamboo.

Jongjaeji: A large bowl

Jimchanda: The method of pressing moisture from a stack of moist sheets.

Cheolpanjaengi, Bibyeokjaengi, Bibyeokkun: A person responsibe for drying paper.

Tong: The vat containing paper stock.

Tonggan: A type of papermaking workshop or factory that contains vats.

Tongkun: A person who makes paper.

Tongmul: Paper stock contained in the vat.

Tireul jupneunda: The process of removing impurities from material. This is usually carried out three times during the entire papermaking process.

Pulguyou: The trough used for collecting hibiscus liquid.

Puldaechinda: A method of stirring materials to prevent lumps from forming. It also refers to the method of adding hibiscus liquid to the pulp and mixing thoroughly. The mix

is stirred 100-200 times in one direction.

Puleul naenda: The method of filtering crushed hibiscus liquid through a fine hemp cloth.

Haegigan: An area allocated for drying paper in the sun.

Haegijul: A laundry line used for drying paper outdoors in the sunshine.

Types of hanji

Gakji (角紙): The thickest type of hanji.

Ganji (簡紙): Thick, fine quality paper for letters. Made with jangji (壯紙).

Gamji (紺紙): Indigo-colored paper. *Gamnigeumeunsagyeong* (紺紙金銀泥寫經, *a Buddhist sutra*) was written on indigo-colored gamji with gold and silver powder. The Chinese refer to this type as *jaramji* (磁藍紙).

Gapuiji (甲衣紙): A type of paper used for making warm underwear worn by soldiers stationed on the northern borders under their winter clothes. Used instead of padded underwear. It also acted as a protective vest.

Ganggaengji: Thick, wide hanji.

Gyeonji (繭紙): Hanji made during the Goryeo dynasty. It was silk-white, strong, and enabled artists to produce beautiful, intricate works.

Gyeongjangji (京壯紙): A term used for differentiating mijangji made at Jojiso (in Segeomjeong, Seoul) from paper made elsewhere in Korea. The latter was called *hyangjangji*.

Gyeongji (慶紙): Hanji made in Gyeongju, Northern Gyeongsang Province.

Gyeongji (經紙): Hanji used when copying or printing Buddhist scriptures.

Gyerimji (鷄林紙): The Chinese word for hanji.

Gyemokji (啓目紙): A type of hanji used for producing documents submitted to the king. Gyemok and gyebon refer to documents submitted to the king for official business purposes.

Gyesaji (啓辭紙): Hanji specially made to document legal matters for the king to review.

Gyesaekji (繼色紙): From *Jeomyeopjangsabon* (粘葉裝寫本).

Gojeongji (藁精紙): Hanji made from rice straw, barley straw or oats in rural areas. Long-fibered materials (e.g. paper mulberry, hemp, white mulberry) are mixed in to compensate for its short fibers. Hanji made in northern areas from oats was known as bukji or bukhwangji.

Gokji (穀紙): Paper made from mulberry bark. It is also called *miji* or *gajiji*, and is used for Buddhist scriptures.

Gongmulji (貢物紙, 胡尺紙): Paper used during the Joseon dynasty to wrap gifts destined for the Qing dynasty.

Gongsaji (公事紙): Paper used by administrators at the local level to record official business.

Gyojiji (教旨紙): Fine-quality paper used for official business (e.g. appointments).

Gwangyoji (官敎紙): Hanji used for documenting the king's orders or official business at the central administration.

Gungjunji (宮箋紙): Hanji used for documenting fortune telling for the king.

Gweonseonji (勸善紙): A bag used by Buddhist monks to collect donations. It is also called a *kwonseondae* or *kwonji*. Monks handed the bag around after new temples were constructed, during harvest, or during Buddhist festivals.

Geumji (金紙): A type of hanji made by gilding anpiji or seokgyeonji. If silver was used instead of gold, the paper was called eunji.

Namji (藍紙, 紺紙): Indigo-blue colored hanji. Buddhist scriptures were transcribed on it after gilding the paper with gilt, silver powder or other materials; sometimes presented to the king.

Nohwaji (蘆花紙): An inferior handmade hanji made from reed. It was mainly produced in Gyeonggi Province.

Nongseonji (籠扇紙): The hanji used for making hapjukseon (a traditional fan with spokes made of bamboo). It was produced in Yongdam, Jeolla Province.

Danmokji (丹木紙): Hanji dyed red using danmok extract (an indigenous tree).

Danji (檀紙): One of the original types of hanji. It is characteristically thick and white, mainly used for official reports, and known in Korean as *bongseo* and *bongseoji*.

Daemaji (大麻紙): A durable type of hanji made from hemp bast fibers. Mostly used for wrapping paper. It was also used as insulating tape.

Daebalji: The largest type of hanji made in a changhoji mould (2ja × 3ja7chi; 0.6m × 1.1m).

Daehoji (大好紙): The largest type of hanji, daehoji is very wide and slightly rough. It was used in national tests during the Joseon dynasty, and employed as a form of tribute to pay China. It is made in the same way as jangpanji.

Dogwangji (塗壙紙): Hanji used for wallpapering tombs.

Doryeonjeojuji (擣練楮注紙): Hanji used for making paper bills. It was traditionally softened by beating it with a smoothing stone.

Doryeonchojuji (搗練草注紙)/Doryeonji (搗練紙)/Dochimji (搗砧紙): Hanji with a glossy appearance and a soft, smooth texture (after it was beaten with a smoothing stone). It was often used as tribute to pay China.

Dobaeji (塗褙紙): Used as wallpaper.

Dochimbaekji (搗砧白紙): A glossy type of paper often used for copying Buddhist scriptures. Wooden rollers were traditionally used for smoothing and buffing the surface.

Dohwaji (桃花紙): Hanji dyed red using safflower extract.

Dongyuji (桐油紙): *Dongyu* (a type of oil) was applied to the surface of paper and dried. This paper was mostly used for wrapping, umbrellas and lamps.

Deungji (藤紙): Paper made from rattan bark.

Duengpiji (等皮紙): Also known as *udunji*, this type of hanji was originally used for making paper drums. It resembles leather.

Maji (麻紙): Paper made from hemp bast fibers or hemp linen. Delicate and similar to paper produced during the Tang dynasty. It has a slightly rough surface that reveals joins.

Magolgi (麻骨紙): Hanji made from a mixture of crushed hemp stalks.

Manyeonji (萬年紙): A type of hanji that has been dyed or coated with oil.

Manji (繭紙)/Gyeonji (繭紙): A fine-quality, durable type of hanji made during the Goryeo dynasty. It is also known as *goryeoji*.

Myeonji (棉紙): Paper made mainly from the cotton of rags. Other materials (e.g. paper mulberry) could be added to the mix.

Myeonji (面紙): Multicolored paper (5 colors) used at funerals to cover names of the deceased.

Bangoji (反古紙): Used, nonrecyclable hanji. Also known as seolji (scraps), goji (故紙), pyeji (廢紙), guji (舊紙), baeji (排紙), nanji (爛紙), changjeo and pagoji.

Baejeopji (褙接紙): Additional sheets of paper pasted onto the backs of paintings to protect and preserve them.

Baekroji (白露紙): Hanji made in Yeongbyeon, Pyeongan Provinces. It is also called yeongbyeongji.

Baekmyeonji (白綿紙): A fine-quality, white hanji. It was often used as a tribute. A guild was even devoted to this type.

Baekji (白紙)： A large, white-colored type of hanji. It was mostly used for making books.

Baekchuji (白硾紙)： The oldest type of paper among those recorded in the book *Gyerimji* (by Sonmok of the Silla dynasty). It is characteristically white and glossy.

Byeolbaekji (別白紙)： A top-quality, white-colored type of hanji. This name is sometimes used outside of Korea to refer to hanji.

Bongmulji (封物紙)： Hanji used for wrapping tributes.

Bubondanji (副本單紙)： Hanji used when making copies of documents.

Bunbaekji (紛白紙)： A white-colored type of hanji sprinkled with fine, white powder.

Bunjuji (紛周紙)： A hanji scroll, made by hammering scattered rice powder on the surface of paper. It was produced mainly in Northern Jeolla Province.

Sagoji (四古紙, 恒用紙)： Hanji traditionally used in schools for writing practice.

Sagoiji (四俁紙)： A large, thick type of hanji, based on baekji.

Sarokji (紗熝紙)： A type produced by placing a silk cloth under the mould when forming paper. This method avoids indentations caused by the mould's weight. It is also called *mis-arasiji*.

Samcheopji (三疊紙)： A type of hanji that is thicker and wider than baekji.

Sangji (桑紙)： Hanji made from the bark of white mulberry. It is also called *sangpiji*.

Sangji (橡紙)： A type of paper made from paper mulberry dyed with oak-tree extract. It was mostly used for copying Buddhist scriptures using gilt or silver paint.

Sangji (常紙)： An inferior type of hanji.

Sanghwaji (霜華紙, 霜花紙)： A glossy, robust type of hanji. It was produced near Sunchang, Northern Jeolla Province.

Saekganji (色簡紙)： A superior, multicolored hanji traditionally favored by noblewomen for writing letters. It originally came in seven colors (jade, navy, soft pink, pink, yellow, green and purple), and measured 28cm long × 55cm wide. Each page consisted of 33 lines (spaced 1.5cm apart), and was often decorated with sprinkled powder to depict silver stars in night-time skies.

Seogyeji (書契紙)： Hanji used for diplomatic correspondence with Japan during the Joseon dynasty.

Seobonji (書本紙)： Used for initial drafts, to be copied up later.

Seonji (扇紙): Hanji used for making fans. It is also called *seonjaji*. A thick and durable type used for making paper kites. It was produced mainly in Yongdam, Jeolla Provinces.

Seonikji (蟬翼紙): Hanji as delicate as dragonfly wings.

Seolhwaji (雪花紙): Baekji made in Pyeonggang, Gangwon Province. *Seolhwaji* translates as "paper as white as snow".

Sehwaji (歲畵紙): Produced by the royal court and distributed to officials as New Year gifts, this type was decorated with hand-drawn pictures. These pictures often portrayed Lao-tzu, or depicted young boys carrying elixir plants on their backs.

Sobalji: Hanji made using a small mould. Its dimensions are 1ja7chi × 3ja.

Soji (燒紙): Hanji burned when praying to gods. It is also known as *cheonji*.

Sohoji (小好紙): Similar to daehoji, but smaller and of inferior quality.

Songyeopji (松葉紙): Hanji made with crushed pine leaves.

Songpiji (松皮紙): Hanji made from pine-tree bark.

Sijeonji (詩箋紙): Rectangular hanji used for correspondence or writing practice. Sometimes simple woodblock-printed pictures were stamped in the corners.

Siji (試紙): Hanji used during the Joseon era when issuing national-test answers.

Sichukji (詩軸紙): A hanji scroll used for writing poetry.

Simhaeji: A narrow, delicate hanji.

Acheongchojuji (鴉青草注紙): A delicate hanji dyed indigo-blue.

Anpiji (雁皮紙): Hanji made from the bark of wild paper mulberry (anpi). It is strong, transparent and fine, making it ideal for copying and tracing.

Yeolpumbaekji (劣品白紙): Baekji of inferior quality.

Yeomseupji (殮襲紙): Hanji used for shrouding corpses.

Yeomji (染紙): Dyed Buddhist scripture.

Yeongji (影紙, 井間紙): Hanji used as guide-line paper when writing.

Oksaekjeojuji (玉色楮注紙): A type of hanji dyed jade.

Wanji (完紙): Hanji made in Wanju (present-day Jeonju), Northern Jeolla Province.

Usanji (雨傘紙): Paper used for making umbrellas.

Unmunji (雲紋紙): Hanji with patterns resembling moving clouds. The paper is made by placing a sheet in a bowl of water. A few drops of ink are added. The paper is removed as

the ink begins to disperse. This creates beautiful effects, and the method can combine different colors.

Unmoji (雲母紙): Hanji made with mica powder. This type is also known as *unmoipji*. It is referred to as *unmogamji* when dyed indigo-blue.

Wolryeokji (月曆紙): Paper used for making calendars.

Yudunji (油苞紙): A thick type of oilpaper comprising joined sheets of mulberry paper. It was used for making tents during wartime, and had numerous uses on wet days.

Yumokji (柳木紙): Hanji made with crushed willow mixed into the paper stock.

Yuyeopji (柳葉紙): Hanji made from willow bark.

Eunmyeonji (銀面紙): A soft, silver-colored type of hanji.

Uiiji (薏苡紙): Hanji made from adlay.

Inji (印紙): Used for making rough sketches during the production of seals or stamps.

Ipmoji (笠帽紙): Oilpaper worn on top of a *gat* (a traditional hat) when it rains.

Jamunji (咨文紙): A strong, thick hanji used for diplomatic correspondence with China.

Jangji (壯紙): A large, thick and glossy type used for bookkeeping, measuring 3ja8chi long × 2ja9chi wide. It was produced in Jeolla Provinces.

Janggyeongji (藏經紙): A thick and glossy hanji used for making Buddhist scriptures. It was either yellow or white; yellow was more common.

Jangpanji (張板紙): Hanji used for flooring. It was either coated with a mixture of ground bean and oil (kongdaem) or smoked.

Jeojuji (楮注紙): Hanji used for making bank notes during the Joseon dynasty. It is made from mulberry bark, and measures 2ja5chi long × 1ja4chi wide.

Jeoji (楮紙): This term refers to all types of hanji made from mulberry fiber.

Jeonmunji (箋文紙): Hanji used for announcing important national news.

Jokboji (族譜紙): Hanji used for making family-tree books.

Jubonji (奏本紙): Hanji that would be used by or presented to the king.

Juyuji (注油紙): Hanji used for making umbrellas. It was also called *yudunji*.

Juji (周紙): Hanji made for scrolls.

Juji (注紙): Paper used by officials to write down the king's orders.

Jukji (竹紙): Hanji made from the fine, inner fiber of bamboo.

Jukcheongji (竹青紙): A very thin, durable and strong type of hanji.

Jungbalji: A medium-sized hanji, measuring 1ja9chi × 3ja3chi.

Jigap (紙甲): Armor made of paper. It was considered weaponry. Its use is documented in *Seojong sillok* (*The Annals of Seojong*).

Jideungji (紙燈紙): Hanji used for making lamps. It is also known as *deungrongji*.

Changjakji (倉作紙): Hanji used as a commission on rice tax during the Joseon dynasty.

Changhoji (窓戶紙): Hanji for covering doors and windows.

Chaekji (册紙): Hanji for making books.

Cheokji (尺紙): Small hanji for writing manuscripts and letters. It is also known as *cheokso*.

Cheomji (籤紙): Hanji for appending additional content to books. It is also referred to as *bujeonji*.

Cheopji (疊紙): A type of hanji that is layered and folded to make containers and bags.

Chukmunji (祝文紙): Hanji for transcribing prayers during traditional Korean memorial services.

Chodoji (初塗紙): Hanji used for lining-paper.

Chorokji (草綠紙): Hanji dyed using locust-tree flowers.

Choji (草紙): Hanji used when writing a first draft.

Chuiji (翠紙): Hanji dyed azure.

Taji (打紙): A smooth and glossy type of hanji. It is also known as *danji*.

Taejangji (苔壯紙): Hanji made with soft mosses or seaweeds.

Taejangji (苔狀紙): Strong, beautifully-patterned hanji made with laver. It was often used for bills and was mainly produced in Jeolla Provinces.

Taeji (苔紙): Hanji made with extremely soft moss. It is also called *cheukriji*.

Pomokji (布目紙): A type of hanji made by covering the mould with a cloth during paper formation. This method prevents indentations.

Pyomunji (表文紙): Hanji specially made for diplomatic correspondence with foreign emperors.

Pyojeonji (表箋紙): Hanji specially made for official correspondence with the king.

Pyoji (表紙): Hanji used for book covers.

Piji (皮紙): An inferior-quality hanji made from the rough outer bark of paper mulberry.

Honseoji (婚書紙): Hanji placed inside letters sent by engaged couples to each other's homes. It comes in many colors.

Hongjeojuji (紅楮注紙): Hanji dyed red.

Hongpaeji (紅牌紙): Hanji used for wrapping *hongpae* (the certificate awarded to successful examinees after passing their finals in the Joseon dynasty's most prestigious national exam). The recipient's name and grade were written on the red background; gilt glitter was sprinkled on to lend elegance. It is a very thick type of hanji comprising three layers of jangji.

Hwaji (火紙): A thin type of hanji used for cigarette papers.

Hwanji (還紙): Recycled paper.

Hwanggukji (黃菊紙): Hanji dyed yellow with gardenia.

Hwangmaji (黃麻紙): Hanji made from hwangma (jute). It was was used mostly for copying Buddhist scriptures, and varnished with Amur-cork tree sap to prevent insect damage.

Hwangji (黃紙): A yellow-colored type of hanji that was produced in Hamgyeong Provinces. It is also known as *gojeongji*.

Huji (厚紙): A thick type of hanji. It was often used for writing poetry.

Hwangyeomchojuji (黃染草注紙): A thin, yellow-colored type of hanji. It was dyed using Korean barberry.

Heukji (黑紙): Paper dyed black.

Hanji categorized according to criteria

Criterion		Name
Raw materials and additives		gojeongji (薰精紙), gokji (穀紙), geumji (金紙), nohwaji (蘆花紙), daemaji (大麻紙). deungji (藤紙), maji (麻紙), magolji (麻骨紙), myeonji (棉紙), sangji (桑紙), songpiji (松皮紙), anpiji (雁皮紙), unmoji (雲母紙), yumokji (柳木紙), yuyeopji (柳葉紙), uiiji (薏苡紙), jeoji (楮紙), jukji (竹紙), taeji (苔紙). piji (皮紙), hwangmaji (黃麻紙), etc.
Use		ganji (簡紙), gyeongji (經紙), gyemokji (啓目紙), gyesaji (啓辭紙), wonseonji (勸善紙), myeonji (面紙), seogyeji (書契紙), seonji (扇紙), sehwaji (歲畫紙), siji (試紙), ipmoji (笠帽紙), jamunji (咨文紙), janggyeongji (藏經紙), jangpanji (張板紙), jeojuji (楮注紙). jubonji (奏本紙), juji (注紙), jideungji (紙燈紙), changhoji (窓戶紙), cheomji (籤紙), cheopji (疊紙), chukmunji (祝文紙), pyojeonji (表箋紙), hwaji (火紙), etc.
Color		gamji (柑紙), gyesaekji (繼色紙), danmokji (丹木紙), dohwaji (桃花紙), namji (藍紙), sangji (橡紙), acheongchojuji (鴉青草注紙), oksaekjeojuji (玉色楮注紙), chuiji (翠紙), hongjeojuji (紅楮注紙), hwangji (黃紙), hwangyeomchojuji (黃染草注紙), heukji (黑紙), etc.
Origin		gyeongjangji (京壯紙), gyeongji (慶紙), baekroji (白露紙), sanghwaji (霜華紙. 霜花紙), seolhwaji (雪花紙), wanji (莞紙), etc.
Size/ Thickness		daehoji (大好紙), sohoji (小好紙), sagoeji (四塊紙), seonikji (蟬翼紙), jangji (壯紙), huji (厚紙), etc.
Form	Production method	bunbaekji (粉白紙), bunjuji (粉周紙), sarokji (紗漉紙), pomokji (布目紙), etc.
	Quality	baekmyeonji (白綿紙), byeolbaekji (別白紙), sangji (常紙), yeolpumbaekji (劣品白紙), eunmyeonji (銀面紙), jukcheongji (竹青紙), etc.
	Final treatment	doryeonji (搗練紙), dochimbaekji (搗砧白紙), tagi (打紙), dongyuji (桐油紙), mannyeonji (萬年紙), yudunji (油芚紙), etc.

Websites providing information on hanji

Site Name	Contents
Wonju Hanji http://wjhanji.co.kr/	Offers online information about the annual Wonju Hanji Festival, plus information on Hanji Museum.
Wonju Hanji Theme Park (Wonju Hanji Museum) http://www.hanjipark.com/main.php	Focuses on the origins of paper, hanji's characteristics, the hanji production process, and the different hanji crafts.
Jeju Mulberry–Paper Doll Museum http://www.dakpaper.com/	Shows artwork made with traditional mulberry paper on display at the museum.
Sinpung Hanji Village http://www.koreahanji.kr/	Features a hanji craftsman, the hanji production process, and other useful information. Hanji-making workshops can be booked through the website.
Jeonju Hanji Museum http://www.hanjimuseum.co.kr/	Provides lots of information on hanji (craftwork, production tools, and ancient texts), plus details on the museum and other interesting venues showcasing hanji.
Andong Hanji http://andonghanji.com/	Features traditional hanji from Andong. Hanji-making workshops can be booked through the website.
The Traditional Paper Artists Association http://hanjiart.or.kr/	Gives anoverview of hanji craftwork, and offers information on paper-craft certification. It features a craftwork gallery.
Hanji Workshop Doori http://www.doorihanji.co.kr	Sells hanji-craft products, ready-to-decorate products, materials and patterns. It also offers hanji classes.
Kim Yeong–Ji's Hanji Craft http://www.hanjicraft.com	An educational site, discussing various products (e.g. small tables, containers and fans) and production methods.
Traditional Hanji http://www.hghg.co.kr	An educational site, discussing a variety of products, including chanhoji and jangpanji. It produces hanji as well.
Yesarang Craft http://www.yeasarang.com	A hanji-craft association that provides useful education and courses. It sells hanji craft products and materials.

Hanji websites (online shopping malls)

Kyeongil Hanji Store

http://www.khanji.co.kr/

Hanji Story

http://www.hanjistory.com/index/index.php

(Hanji craft) Hanuri

http://www.hanjilove.co.kr/

Doori Hanji Craft

http://www.doorihanji.co.kr/

Hanji Love Hanji Craft

http://hanjisarang.com/

Hanjiro Craft and Furniture

http://www.hanjimanse.com/

Jeonju Traditional Hanji Center

http://www.hanzi.co.kr/

Hanji Shop Hanji Craft

http://www.hanjinara.co.kr/

Sinpung Hanji

http://sphanji.co.kr/

Primary references

GANG, MAN-GIL: *Joseon Jeongi Gongjanggo* (朝鮮前期工匠考, *Early Joseon Dynasty's Handicraftsmanship*); *Sahak Yeongu* (*Historical Research*) (12), 1961.

GUKSA PYEONCHAN UIWONHOE: *Joseonwangjo sillok* (朝鮮王朝實錄, *The Annals of the Joseon Dynasty*), photographic edition, 1968.

GWON, DEOK-JU: *Jungguk Milsul Sasange Daehan Yeongu* (*A Study of Chinese Philosophy of Art*), Sookmyung Women's University Press.

GEUM, DU-JONG: *Hanguk Goinsae Gisuls* (*A History of Korean Traditional Printing*), Tamgudang, 1981.

KIM, BYEONG-JONG: *Jungguk hwoihwaui Johyeonguisik Yeongu* (*A Study of Formative Art Expressed in Chinese Painting*), Seoul National University Press, 1989.

KIM, BU-SIK: *Samguksagi* (三國史記, *The Chronicles of the Three States*), photographic edition. Classic Publishing Committee, 1931.

KIM, SANG-WON: *Gwahakgwa Gisul* (*Science and Technology*), *Hanguksa* (*Korean History*) 8, National History Editorial Committee, 1981.

KIM, SUN-CHEOL: *Jongi Iyagi* (*Paper Story*), Monthly Magazine Wrapping Industry, 1992.

KIM, WON-RYONG: *Hangukhwaui Yeongu* (*A Study of Korean Painting*), Yeolhwadang, 1985.

MORRIS, F.H: *Jejihak* (製紙學, *Studies on Papermaking*). Translation: LEE, BEOM-SUN. Parkgyeongmunhwasa, 1963.

COURANT, MAURICE: *Hangukui Seojiwa Munhwa* (*Korean Paper and Culture*). Translation: PARK, SANG-GYU. Singumunhwasa, 1974.

MIN, HYEON-GU: *Goryeoui Daemonghangjaenggwa Daejanggyeong* (*The Goryeo Dynasty: Resisting the Mongolian Invasion and Tripitaka Koreana*), *Hangukhaknonchong* (*Korean Studies*) 1, Korean Studies Research Center, Kookmin University, 1979.

PARK, JE-GA: *Bukhakeui* (北學議, *An Essay on Travels through China*), *Hanguk Saryochongseo*, National History Editorial Committee, 1971.

PARK, JI-WON: *Yeonamjip* (燕巖集, *A Collection of Stories by Yeonam Park Ji-won*), Yonsei Uni-

versity Library.

PARK, JI-WON: *Yeolhailgi* (熱河日記, *An Essay on Travels through China*), *Gojeongukyeokchong-seo*, translated, photographic edition. 18-19, National Culture Committee, 1966.

SEO, KYEONG: Goryeo Dogyeong, National Culture Committee, 1979.

SEO, MYEONG-EUNG: *Bomanjaechongseo*, Gyujanggak Library, Seoul National University.

SEO, YU: *Imwonsipyukji*, photographic edition. Classic Publishing Committee, Seoul National University, 1966,

SONG, EUNG-SEONG: *Cheongonggaemul*. Translation: CHOI, JU. Jeontongmunhwa-sa, 1997.

SONG, EUNG-SEONG: *Cheongonggaemul*, *Gukhakgibonchongseo* 146, photographic edition, 1968.

SONG, CHAN-SIK: *Gwancheongsugongeopui Minyeonghwa Gwajeong* (*The Process of Privatizing the Handcraft Industry*), Seoul National University Press, 1973.

SONG, CHAN-SIK: *Ijohugi Sugongeope Gwanhan Yeongu* (*A Study of Late-Joseon Handcraft*), Hangukmunhwayeonguchongseo 10, Seoul National University Press, 1983.

AN, HWI-JUN: *Dongyangui Meyonghwa* (*Masterpieces of Eastern Painting*), Samseongchul-pansa, Japan.

YE, YONG-HAE: *Ingan Munhwajae* (人間 文化財, *Human Cultural Assets*), Eomungak, 1969.

YUN, YONG-HYEOK: *Goryeo Daemonghangjaengsa Yeongu* (*A Study of the Goryeo Dynasty's Resistance against Mongolian Invasion*), Ilgisa, 1993.

LEE, GYEOM-NO: *Munbangsawu* (*Four Precious Types of Stationery*), Daewonsa.

LEE, SU-GWANG: *Jibongyuseol* (芝峰類說, *Comprehensive Encyclopedia*), photographic edition. Joseon Research Society, 1912.

LEE, GYU-GYEONG: *Ojuyeonmunjangjeonsango*. Editor: Classic Publishing Committee, Donggukmunhwasa, 1959.

LEE, GI-BAEK: *Hanguksangdaegomunseojaryojipseong*, Iljisa, 1987.

LEE, MUN-AE & JEONG, DONG-SUK: *Hangukui Jeontong Pyogu* (*Traditional Picture Mounting*), Cheongachulpansa, 1986.

LEE, JAE-CHANG: *Goryeosawongyeongjeui Yeongu* (*A Study on the Economic Activity of Goryeo*

Temples), Hangukhakchongseo 9, Dongguk University, Aseamunhwasa, 1976.

LEE, JUNG-HWAN: *Taekriji*, Daeyangseojeok, 1972.

LEE, HO-YEON: *Jejigonghak* (製紙工學, *Papermaking Engineering*), Daegwangseorim. 1977.

LEE, HUI-GYEONG: *Seolsuoisa*.

IM, HEUNG-BIN: *Suchaehwa Jaeryohak geurigo Mulgamseokgiui Silje* (*A Study of Watercolor Materials and Paint-Mixing*), Sulcheahwa, 1990.

JEONG, TAE-HYEON: *Hanguksikmuldogam* (韓國植物圖鑑, *The Illustrated Book of Korean Plants*), Sinjasa, 1987.

JEONG, TAE-HYEON: *Hanguksikmuldogam* (韓國植物圖鑑, *The Illustrated Book of Korean Plants*), Gyoyuksa, 1962.

JO, YONG-JIN: *Chaesaekhwa Yeongu* (*A Study of Painting*), Mijinsa, 1992.

CHOI, SE-JIN: *Hunmongjahwoi*, photographic edition, Oriental Studies Society, Danguk University, 1971.

SEIGO, KIMBARA(金原省吾): *Dongyangui Maeumgwa Geurim* (*Eastern Thought and Painting*), Translation: MIN, BYEONG-SAN, Saemunsa, 1977.

HAN, CHI-YUN: *Haedongyeoksa* (海東繹史, *Korean History*), photographic edition, Gyeonginmunhwasa, 1982.

HEO, SIN: *Seolmunhaejaju*. Annotated by DAN, YOK-JAE, Nandaeseoguk, 1977.

HONG, BONG-HAN: *Dongguk munheonbigo* (東國文獻備考, *Traditional Culture*), photographic edition. Myeongmundang, 1981.

HONG, SEUNG-GI: *Goryeosidae Gongjang* (*Artisans in the Goryeo Dynasty*), Jindanhakbo 40, 1975.

Gyeongguk daejeon (經國大典, *Laws of the Joseon Dynasty*), photographic edition. Joseon Governor-General's Advisory Board (Jungchuwon), 1934.

Gwangjaemulbo, Seoul National University's Gyujanggak Library.

Sinjeung dongguk yeojiseungram (新增東國輿地勝覽, *An Anthropogeographical Record of the Jeseon Dynasty*), Seoul National University's Gyujanggak Library.

Junggukmunhwachongseo (*An Overview of Chinese Culture*), Sookmyung Women's University Press.

Hangukui Jongimunhwa (*Korean Paper Culture*), the National Folk Museum of Korea, 1995.

Korean theses and dissertations

KIM, BYEONG-JU: "Research on the Formation of Paper & Dyeing Handcrafts" (Jiyeo-mgongyeui Johyeongseonge Gwanhan Yeongu); Master's thesis, Jungang University.

KIM, BONG-TAE & LEE, BEOM-SUN: "A Study into the Development of Specialized Hanji" (Teuksuhanji Gaebale Gwanhan Yeongu). National Engineering Research (Vol. 23), 1975.

KIM, SAM-GI: "The Papermaking Industry during the Fifteenth and Sixteenth Centuries" (15-16 Segi Gwanyeong Jeji Sugongeop Yeongu); Master's thesis, Gongju University.

LIM, SAM-GI, JEONG, HONG-JIN & LEE, JONG-CHEOL: "Four Precious Types of Stationery: A Detailed Report on the Production Processes" (Munbangsawu Josabogoseo – Ji, Pil, Muk, Yeon Jejakgwajeongeul Jungsimeuro). National Folk Museum, 1992.

KIM, SEOK-HUI: "A Regional Breakdown of the Papermaking Industry at the End of the Joseon Dynasty". Busan University's Thesis Collection (Vol. 19), 1975.

KIM, A-YEONG: "Traditional Painting in the Late-Joseon Dynasty" (Guhanmal Ihu Jeon-tonghwohwaui Yangsang). Major: East-Asian Painting, Seoul National University Graduate School.

KIM, YEONG-HO: "Hanji Craft: Historical Development and Future Advancements" (Hanjigongyee Byeoncheongwajeong Mit Geu Gaeseone Gwanhan Yeongu); Master's thesis, Hanyang University, 1988.

KIM, JAE-HUI: "Research on Hanji Papermaking" (Hanjijejie Gwanhan Gochal), Yonseieo-munhak (Issue 6), 1975.

KIM, JEON: "The Origins of Modern East-Asian Painting" (Hyeondae Dongyanghwaui Won-ryu). Major: East-Asian Painting, Seoul National University Graduate School.

KIM, CHEOL-WU: "Research on Oil Painting Tools" (Yuchaejaeryoe Daehan Yeongu). Major: Art Education, Hongik University Education Graduate School.

KIM, HWA-JA: "A Study into the Development of Korean Paper as a Transcription Tool" (Seosajaeryoroseo Hangukjiui Baljeone Gwanhan Yeongu); Master's thesis, Ehwa Women's University, 1968.

PARK, SANG-GYUN: "Ancient Transcription Tools: Four Precious Types of Stationery"

(Godae Seosayongue Daehan Gochal), Doseogwanhak 1, 1983.

PARK, SEONG-TAE: "A Qualitative Analysis of Hanji and Ink when Expressing Forms" (Sumukgwa Hanjiui Jilryojeok Teukseongul Tonghan Hyeongsangpyohyeon Yeongu); Master's thesis, Seoul National University, 1993.

PARK, SE-YEON, LEE, GYU-SIK, HANG, SEONG-HUI, AN, HUI-GYUN: "Imperfections in Paper: A study of the Causes" (Jiryue Balsaenghaneun Ulrukbanjeomui Seongbun Bunseoke Gwanhayeo), Bojongwahak Yeongu Hwoibo.

SEO, SU-SAENG: "A Study of the Tripitaka Koreana's Boyujanggyeongpan" (Palmandaejangyeongui Boyujanggyeongpan Yeongu), Eastern Culture Study (3), Eastern Culture Research Center, Gyeongbuk University, 1976.

SONG, TAE-HO: "A Study of Trade between Korea and China in Ancient Times" (Godaehanjungui Munmulgyoryue Daehan Yeongu), Andong Education University's Thesis Collection (1), 1968.

O, BYEONG-IN: "A Study on the Modern Characteristics of Art" (Yesure Geundaejeok Seonggyeoke" Gwanhan Yeongu). Major: Art Education, Dongguk University Education Graduate School.

O, YEONG-MO: "Craft Industry in Jeolla Provinces during the Joseon Dynasty" (Ijosidae Jeolladoui Sugongeopgwa Mulsan). A Collection of Theses in Commemoration of Dr. Jo Gijun's 60th Birthday, 1977.

ON, DU-HYEONG: "A Study into the Current Status of Hanji Factories in Northern Jeolla Province, and Suggestions for Improvement" (Jeonbukjibangui Hanjigongjamgui Siltaejosa Mit Gaeseonbangan). Issue 8, The Engineering Research Center, Jeonbuk-University, 1978.

ON, DU-HYEON: "A Study of Korean Pulp Resources" (Hanguksan Pulp Jawone Daehan Yeongu), 6th Collection of Theses, Jeonbuk University, 1964.

YU, GYO-SEONG: "A Study on Economic Activity at Goryeo Temples'" (Goyeosawongyeongjeui Seonggyeok). A Collection of Buddhist Theses in Commemoration of Dr. Baek Seong-wuk, 1959.

LEE, MYEONG-GI: "A Qualitative Analysis of Hwaseonji" (Hwaseonjie Daehan Teukseong Josabunseok), Wongwangdae Graduate School Forestry.

LEE, SU-GYEONG: "A Study into the Symbolism of Paper" (Jongiui Pyosangseonge Gwanhan

Yeongu). Major: Western Painting, Seoul National University Graduate School, 1991.

LEE, SEUNG-CHEOL: "The Impact of Hanji on Korean Painting throughout History" (Urinara Hwoihwasae Hanjiga Michin Yeonghyang). Major: East-Asian Painting, Seoul National University Graduate School, 1994.

LEE, AE-JA: "Research on Handmade Paper" (Suje Jongie Gwanhan Yeongu), Hyoseong Women's University Graduate School, 1988.

LEE, JONG-SANG: "Modern Research on the Murals of Ancient Korea" (Hanguk Godae Byeokhwae Daehan Hyeondaejeok Yeongu), A Collection of Notable Theses.

LEE, CHUN-NYEONG: "A History of Agricultural Technologies during the Joseon Dynasty" (Ijonongeopgisulsa), Hangukyeonguchongseo 21, Korea Research Center, 1964.

LEE, HYE-YOK: "Goryeo Sidae Gongbuje Ilyeongu", Hanguksayeongu 31, 1980.

LEE, HONG-JIK: "A Study of Woodblock Printing in Silla Culture" (Mokpaninsaereul Jungsimeuro Bon Sillamunhwa), Hanguksahwoigwahakronjip (8), Korea Society Science Institute, 1968.

JANG, HYE-JEONG: "A Study of Paper Crafts during the Joseon Dynasty" (Joseonjo Jigongyee Gwanhan Yeongu), Master's thesis, Hongik University, 1980.

JEON, RYANG: "Pollutants Created during Paper Formation" (Chojigongjeonge Iseoseo Baeksuoyeom Seongbun), Ph.D. dissertation, College of Agriculture, Seoul National University.

JEONG, SEON-YEONG: "Research on Chaekji Made during the Early-Joseon Period" (Joseon Chogi Chaekjie Gwanhan Yeongu), Science Department, Yonsei University Library, 1987.

JEONG, JEONG-SU: "A Study of Hanji's Evolution and its Intrinsic Qualities" (Hanji Byeoncheongwa geu Teukjile Gwanhan Yeongu); Master's thesis, Education Graduate School, Hongik University.

JO, YOK-SU: "An Experiment in Hanji Dyeing" (Hanjiyeomsaeke Gwanhan Silheom Yeongu); Master's thesis, Seoul Women's University.

CHEON, HYE-BONG: "Naryeo Insaesului Yeongu", Ph.D. dissertation, Seongyungwan University.

CHEON, HYE-BONG: "The Pure Light Dharani Sutra at Seokgatap, Bulguk Temple"

(Bulguksa Seokgatalui Mugujeonggwang daedaranigyeong); key notes from the seminar "The Pure Light Dharani Sutra" given by the National Museum of Korea, 1990.

CHEON, HYE-BONG: "Hanguk Insaesului Namsang"; A Collection of Theses, Seongyungwan University 19, 1974.

HAN, GYU-SEONG: "A Study of Jiseung during the Late-Joseon Period" (Joseonsidae Malgi Jiseunge Daehan Gochal); Master's thesis, Hongik University, 1976.

HO, SE-HUI: "Research on Traditonal Korean Paper Craft Production" (Urinara Jeontong Jongi Jakeope Gwanhan Jakpumjejakyeongu); Master's thesis, Seongsin Women's University, 1988.

HWANG, SU-YEONG: "Gamjigeumjasagyeongui Sinrye" (Gogomisul); II (11), Ancient Art Society, 1964.

HWANG, SU-YEONG: "Goryeo Gamjigeumni Daebanyagyeong" (Gogomisul) VI (8), Ancient Art Society, 1965.

HWANG, SU-YEONG: "Goryeo Gamjigeumni Beophwagyeong in Kyoto, Japan" (Gogomisul) V 8th issue, Ancient Art Society, 1964.

HWANG, SU-YEONG: "Baekjumukseo Hwaeomgyeong during Silla King Gyeongdeok's Reign" (Silla Gyeongdeokwangdaeui Baekjimukseo Hwaeomgyeong), History Journal (83), 1979.

HWANG, SU-YEONG: "Baekjumukseo Hwaeomgyeong", Art Data (24), National Museum of Korea, 1979.

HWANG, SU-YEONG: "The Reconstruction of Baekjumukseo Hwaeomgyeong" (Silla-sagyeongui Balgyeon, Baekjumukseo Hwaeomgyeong Ichuk), Beopryun (120), 1972.

Bulletins and magazines

GO, GYEONG-SIN, PARK, SA-RANG: "Development of Korean Papermaking Technology" (Hangukjejogisului Baljeon), 40th Bulletin of Jungang University's College of Liberal Arts and Science, February 1982.

GO, SEUNG-JE: "Historical Research on the Adoption of Korean Paper Overseas" (Hangukjiryuryuchului Yeoksajeok Gochal), Gegigye (102), 1974.

GU, JA-UN: "Southern Forestry Test: Seminar Material for May", 1992.

KIM, BYEONG-JONG: "The Sense of Space in Korean Painting" (Hangukhoihwaui Gongganuisik), Gonggan, September 1988.

KIM, HAE-JONG: "Introduction to Ancient Donga Culture" (Donga Godaemunhwa Bogyoe Gwanhan Seoseol), Hangukhakbo (7), Iljisa, 1977.

NAM, PUNG-HYEON: "Jei Sillajangjeok", Milsuljaryo (19), the National Museum.

DOYEOPJEONGMAN: "The Deterioration and Restoration of Paper Used for Painting" (Misuljakpume Sayongdaeneun Jongiui Yeolhwawa Bojon); Translation: HWANG, CHAE-GEUM, Restoration Research Society Newsletter.

PARK, JI-SEON: "Preservation and Restoration of Ancient Paper Relics" (Godae Jongi Yumului Bojon Subok), Seokjihakhoi, June 1998.

PARK, JIN-JU: "Hanji: Research on Korea's Intangible Assets" (109), Cultural Heritage Administration.

BAE, YEONG-GYU: "Research on the Hanji Industry in Northen Jeolla Province" (Jeonbukhanji Gongeope Daehan Gochal), Nokuhoibo (3), 1961.

SEO, BYEONG-GUK: "Trade between the Goryeo, Song and Liao Dynasties" (Goryeo, Song, Youi Samgakmuyeokgo), Baeksanhwabo (15), 1973.

SONG, JE-CHEON: "An Introduction to Painting Tools" (Seohwajaeryoui Giljapi), Songibang, 1991.

AN, HUI-GYUN: "Scientific Techniques to Preserve Fibers in Remnants of Paper" (Jiryu Seomyujil Yumului Gwahakjeok Bojon), Gomunhwa (22), 1983.

AN, HUI-GYUN, LEE, PIL-SUN, & HAN, SUNG-HUI: "A Study of Pyogu Tools" (Pyoguyongpume Gwanhan Yeongu), Bojongwahak Yeonguhwoi, 1983.

EO, HYO-SEON: "Traditional Chinese Paper and Goryeoji" (Yeokdaejungguk Jongiwa Goryeoji), Jejigye (80), 1968.

EO, HYO-SEON: "Government and Hanji" (Hanjiwa Jojiseo), Jejigye (81), January-March 1969.

YU, TAK-IL: "Hanji Papermaking Methods in the 15th Century" (15 Segi Hanjijojisule Daehayeo), Gyeganseojihakbo (2), 1990.

LEE, GWANG-RIN: "Papermaking at Temples during the Early-Joseon Period" (Ijochogiui Sachaljejieop), Yeoksahakbo (17), 1962.

LEE, GWANG-RIN: "The Papermaking Industry during the Early-Joseon Period" (Ijochogiui Jejieop), Yeoksahakbo (10), 1958.

LEE, BYEONG-GI: "Research on Paper Used for Korean Painting" (Hangukseojiui Yeonguha), Dongbanghakji (5), 1961.

LEE, BYEONG-DO: "The Jungwon Goguryeo Tombstone" (Jungwongoguryobie Daehayeo), Sahakji 13th issue, 1979.

LEE, SANG-SEON: "A Study on Economic Activity at Goryeo Temples" (Goryeosawongyeongjee Daehan Gochal), Sungsilsahak (1), 1983.

LEE, JONG-SANG: "Hanji's Historical Value and Intrinsic Qualities" (Hanjiui Yeoksaseongwa Geu Teukseonge Daehayeo), "Korea" magazine, August 1993.

LEE, HONG-JIK: "The Pure Light Dharani Sutra at Seokgatap, Bulguk Temple" (Gyeongju Bulguksa Seokgatal Balgyeonui Mugujeonggwang daedaranigyeong), Baeksanhakbo (4), 1968.

JEONG, JUNG-HWAN: "Three Histories of the Baekje cited in *The Chronicles of Japan*" (Ilbonseogie Inyongdaen Beakjesamseoe Dahayeo), Aseahakbo (10), Asia Scholarship Society, 1972.

JE, HONG-GYU: "A Perspective on the History of Hanji" (Hanjisa Sogo), Doseogwan (159), April 1974.

JO, UK-GI: "Non-wood Pulps" (Bimokjae Pulpe Gwanhayeo), Jejigye.

JO, HYEONG-GYUN: "Research on the Internationalization of Korea's Traditional Technologies" (Hangukjeontonggisului Gukjehwae Gwanhan Yeongu); (Hanji: Research No.95-04, Korea Science Foundation).

JO, HEUNG-YUN: "Materials Used throughout Korean History" (Hanguk Janghwangsaryo),

Dongbanghakji (49).

CHAE, IL-GYUN: "A History of Paper" (Jongiui Yeoksa), Jejigye (137), January-March 1983.

CHOI, BEOM-HOON: "The History and Production of Hanji" (Hanjiui Yeoksawa Jejo), Chulpangye, 1977.

"Papermaking Books from the Joseon Period", Paper Industry Magazine (Jieopjapji), July 1932.

"Applications for the Development of Traditional Technology in Hanji Production"; Commerce and Industry Ministry, 1996.

"The Paper Crafts of Korea" (Hangukui Jigongye), Museum piece, Deokseong Women's University Museum, 1988.

Magazines: "Gyeganmisul", "Gongganji", "Sinmuk", "Imeoptonggyeyeonbo", "Jeji" and "Jejigye".

Articles: A collection of articles referring to the Korean papermaking industry.

Foreign theses and dissertations

加藤晴治, 「和紙」, 3册, 東京：電機大學出版局, 1966. (歷史篇 I, II, 枝術篇).

關根康喜, 「紙」, 東京：成史書院, 1939.

金子量重, 「アジアの紙の造形」, 和紙の造形, (昭和 59(1984). 11). 東京：中央公論社.

潘吉星, 「中國造紙技術史稿」, 北京：文物出版社, 1979.

壽岳文章, 「日本の紙」, 東京：吉川弘文館, 1969. -(日本歷史叢書；14).

申莫山, 「紙の畵」, 文房四寶, 昭和 16年.

田中敬, 「高麗繭紙と苔紙」, 紙業雜誌 第 29 卷, 3 號 (昭和 9(1934). 5). pp.5-6.

Jane m. Farmer, 「New American paperworks」, 1982.

陳大川, 「中國造紙術盛衰史」, 台北：中外出版社, 1979.

村井操, 「紙及加工紙」, 工業圖書株式會社版.

厚木勝基, 「パルプ及紙」, 丸善株式會社, 昭和 26年.

Introduction to "Outline of Ink Painting I" 「中國の場合」, 米澤嘉圃.

「朝鮮總督府中央試驗所報告」, 1回ハの 1-36. (大正 4(1919). 3).

「紙パルプ 技術協會編」, 和紙の製造 板紙の抄造 昭和 43年.

"Korean Paper", "The Korean magazine", Vol.2, no.1 (November 1918).